Colour Psychology
Today

D0068011

Colour Psychology Today

June McLeod

BOOKS

Winchester, UK
Washington, USA

First published by O-Books, 2016
O-Books is an imprint of John Hunt Publishing Ltd., Laurel House, Station Approach,
Alresford, Hants, SO24 9JH, UK
office1@jhpbooks.net
www.johnhuntpublishing.com

For distributor details and how to order please visit the 'Ordering' section on our website.

Text copyright: June McLeod 2016

ISBN: 978 1 78535 304 8
978 1 78535 305 5 (ebook)
Library of Congress Control Number: 2016949858

A CIP catalogue record for this book is available from the British Library.

Design: Stuart Davies

Printed and bound by CPI Group (UK) Ltd, Croydon, CR0 4YY, UK

We operate a distinctive and ethical publishing philosophy in all
areas of our business, from our global network of authors to
production and worldwide distribution.

CONTENTS

Acknowledgements

Dedicated to my family – life is a game, play it well with colour. Colour is the key to happiness and success. 'Feel' it to transform your life.

With love and thanks to Richard for his beautiful book cover designs on my titles: *Colour Therapy A–Z*, *Mandalas*, *Colour Numerology: The Karmagraph* and *Colour Psychology Today*. For the input of various skills, love and support of close family and dear friends. The team at John Hunt Publishing, not forgetting the main man, John Hunt, the creator of the platform we all springboard from. Thank you.

Previous Book Titles
Colours of the Soul
Colour Therapy A–Z
Mandalas: For Personal Growth and Business Success
Colour Numerology: The Karmagraph
Discover Your True Colours – with 23 colour cards
Colours of the Soul CD – available digitally
With more titles to follow.

June McLeod

Colour Consultant – Colour Trends Forecaster
Motivational Trainer – Author – Intuitive

"To pursue excellence through the intelligent appliance of colour."

June believes that creativity is fundamental to innovation and innovation depends upon creative colour thinking. With an esteemed colour career spanning more than thirty years, June's dynamic and innovative work with colour is legendary. An original thinker and a leading colour authority, with an international client base that reflects her substantial knowledge and continuing success. The use of colour in global business has changed; June not only keeps pace with that change, she drives it.

- Colour Endorsement – holds the first colour endorsement in the UK
- Innovator – drives new colour thinking, she can rightly claim many firsts in the colour world
- Motivational Trainer – the inventor and developer of inspirational interactive practicals used worldwide
- Original Thinker – continues to push the boundaries of colour
- Pioneering Methods – many firsts in colour research
- Proven – colour has positive transformational impact
- First in the colour world to work and teach exclusively within the circle and with circles of colour

With a deep love of the earth and the natural world, much of her inspiration for her work comes from the natural beauty surrounding us all. Her specialist expertise is secured by a truly diverse range of corporations; a small selection of former clients

includes:

Royal Parks Foundation, London Half Marathon, Angels at Play, Magnet, Hong Kong Jockey Club, Maybelline New York, Ladbrokes Sporting Casino, L'Oréal, AkzoNobel, Lanes Health, Fashion, Textiles, Packaging, Branding, Colour Organisations, Tourist Boards, Hoteliers, Spas, Perfumeries, Cosmetic Houses, Hair Colouring Brands, Retailers and Manufacturers

Colour is powerful; it can alter a space, enhance a particular mood and excite the senses. Purchasing choices are made within seconds, driven by colour alone.

The correct colour palette will support self-development and well-being in the individual, create a sanctuary and harmony in the home, and drive sales, expansion, productivity and success in business. Colour is the visionary key to success in all areas of life; transform your life and business with colour.

Services

Corporate – Small Business – Groups – Individuals
"Each of us has the power within to do more than we can imagine, but without a key to unlock our inherent gifts, we remain blissfully unaware of all that we can be. I believe colour is the key. The more we work with colour and seek to understand its profound and transformative qualities, the greater the benefit." June McLeod

Corporate – Colour, Design and Branding Consultancy
For all areas of business, the correct colour choice and placement is vital to success. Interiors, Environmental colour schemes, Design and Branding, June creates colour palettes with hues that are fine-tuned and perfected – guaranteed to attract the target audience, in order to distinguish and best position the brand from competitors.

Colour Trends Forecasting
Her colour trends forecast is proven, accurate and eagerly awaited.

Corporate – Colour Profiling
June McLeod invented the unique Colour Personality Profiling system. With an understanding of how the brain responds to colours in specific ways, the profiling method is an insightful colour system to analyse and to profile people. This expertise supports employers in decision making, personnel ongoing assessment, and people awareness.

Corporate Training – Motivational Colour Workshops
To increase productivity in your organisation through effective teamwork and communication and to reduce sustainable loss. June McLeod's programmes will feed your people's creativity to

help them excel at whatever they are already good at. Your business will benefit from their renewed enthusiasm and focus. June takes them through a process of self-discovery and personal development to achieve your goals and your vision. This programme will motivate your people to rise to everyday challenges and strategic changes in a healthy and productive way. June is passionate about colour and applies innovative, interactive training techniques.

June has extensive experience; she understands the issues faced by people and organisations in this very fast-paced and competitive world. In order to produce a tailored training programme, June will meet with you to carry out a full training needs analysis. All of your people will benefit from the training irrespective of age, gender, educational background or preferred learning style.

Small Business Development

Understanding the reasons behind colour choices are key to growing your business and keeping it going in difficult times. We have all been shocked by witnessing some big, long-established names in business fall in recent times.

The choice of colours has a profound effect, either positive or negative. By getting them right first time you ensure your business will be more productive, and ultimately more successful. In a global market, you will have an edge. June will fine-tune your colour choice or choose the appropriate colours for your business.

Groups – Interactive Creative Workshops

For all levels of expertise and understanding, National and International. The workshops are experiential, fun and inter-active, showcasing her expertise and unique 'take' on colour. She excels in her field. Her method is renowned; everyone will leave inspired and informed.

Groups – Talks

June will share colour information relevant to your group genre, guaranteeing an inspiring, fun, and educational format for your listeners.

Individuals – Private Consultations

One to one private appointments for healing and intuitive colour consultations by appointment in London. International consultations are also available upon request.

Contact:
June McLeod
Suite 521
Wey House
15 Church Street
Weybridge
Surrey
KT13 8NA
Website: www.colourpsychologytoday.com
Mobile: 07933389305 – text only

Testimonials

"June expresses and expounds in beautifully plain language the hard to grasp technical colour stuff that blocks most minds, coupled with her innovative practicals and experiential teaching method to cement the information. Her level of understanding is unsurpassed. Unequivocally gifted with the ability to articulate and share profound colour information so that everyone understands."
– A. Samson

"It is only now, many years later, that I can fully appreciate (and may not even fully yet!) what you taught and the space you provided for us. The experience is profound. Something significant for my whole life and beyond. And I am truly grateful. With much love."
– Leigh Osborne

"I have witnessed and experienced the positive results and benefits of her work. June's ability, professionalism and eye for colour and design is superb. Not only has she helped my business and my staff over the years, she continues to support me on a personal level with integrity and grace."
– A. Cohen

"I began with the intention of learning and exploring the art of colour, planning to use the colour knowledge as an addition to my work, it would be as simple as that... I was in for a very big surprise! Early on in the course I realised my foundations were being shaken to the core with the dynamic delivery, content and exercises. I was pushed and encouraged to look at the world in a totally different light; it has quite simply changed my life."
– K. Took

"One promise can certainly be made. The undoubted gifts which June has to offer her students will leave an indelible and unforgettable impression on the rest of their lives."
– A. Steele

"The most profound and life-changing course I had the pleasure to attend."
– Dr G.

"My recommendation came from a friend who completed a course with June and described it as exciting, awakening, enlightening and life changing. I've learnt so much, so many new techniques and skills and it has deepened my awareness to levels I didn't even know were possible."
– M. Lee

"Her teaching is based on her philosophy if it's fun we retain and learn. She teaches how to feel colour, believing this to be the key to working with colour. I found her courses so different from anything I have experienced before. Challenging in part as the knowledge is in depth and immense, but great fun all the same. I loved it, and her."
– S. Jamieson

"The workshop began in the most exciting but unconventional way, by singing together in a circle, to the words of *Search for the Hero* by M People then dancing and moving around the room to music carefully chosen by June, *Dancing Queen* by Abba a favourite. Clapping, stamping feet, bending knees, swinging arms to the beat of the music. No boring name introductions here."
– I. Jackson

"She epitomises and embodies all that is good and true about

colour, it has been and is her life."
– P. Burn

"A gifted intuitive, a forward-thinking innovator and a lovely person. A winning combination."
– R. Mandelshon

"Her complete mastery of her subject, skill, down-to-earth approach and sense of humour make learning about the importance of colour a life-affirming process."
– J. Flower

"Sometimes we are blessed at pivotal points in life by meeting one of those very special people who will make a real and deep difference to the course of our lives. Some 20 years ago it was my great good fortune to find my way to June McLeod, one of those rare and wonderful people, and to benefit from her powerful gifts. Giving most generously of her wisdom and insight, she has been an inspiration to so many of us, enabling access to levels of learning and understanding that may have remained closed. June is a true innovator, and there is a great need for wider access to her wisdom and knowledge."
– M.K., Professional Musician

Products

Colour outside the lines.
June McLeod

Books
Available online and from high street bookshops.

Colour Therapy A–Z
A comprehensive book on colour therapy. Brimming with practicals, interactive exercises, colour divining and new colour information for every level of expertise and sector. Includes a selection of course materials and two-day CPD colour workshops with handouts, course structures, lesson plans, diagrams and interactive practicals. A 'must have' for everyone interested in or working with colour. Use in conjunction with the best-selling *Colours of the Soul* book and the *Colours of the Soul* CD.

Colours of the Soul
The best-selling colour book, a colour classic, continuously in print since 2000 by popular demand. For students of colour and individuals interested in the wider aspects of the subject, packed with reams of colour practicals and colour information. Use in conjunction with the *Colours of the Soul* CD, *Colour Therapy A–Z* and *Discover Your True Colours* books.

Mandalas: For Personal Growth and Business Success
Includes 160 blank mandalas. Bursting with information it comes with a selection of blank mandalas to copy for classes/workshops to colour in. Use in conjunction with *Colour Therapy A–Z* and *Colours of the Soul* book and CD.

Colour Numerology: The Karmagraph
Rediscover your soul colour, number and musical key. Using

June's unique and successful method, working with colour and number. She first created the 3 number system, and then further developed the system to 4 numbers to reveal the soul number and the attributes to be brought in.

Using her system, she rightly predicted a girl for the Beckhams' fourth child many months prior to Harper's birth, and Obama to win his second term in office. She continues to fine-tune her system, far beyond its original use. She acknowledges how difficult it is to be exact and precise for any system of divination, yet she perseveres to fine-tune the system. Only someone of June's calibre and with her colour knowledge can successfully attempt such a feat.

Numerology is not new; combining colour with number in this specific way IS new. Her system is new and unique. June holds all rights to her invention. Often copied, never bettered. Her system reveals fortuitous times to commence any endeavour such as a new relationship, a move, career progression or business start-up. Her system benefits everyone by highlighting the possibilities and opportunities as they arise, and noting the pitfalls. Use in conjunction with the best-selling books *Colours of the Soul* and *Colour Therapy A–Z* and the *Colours of the Soul* CD.

Discover Your True Colours – with 23 colour cards
To support the practicals in training and for the individual user. Packed with more interesting and revealing colour information with practical suggestions on how to use the cards. Use as a motivational colour tool, a divining pack and in conjunction with the books *Colour Therapy A–Z*, *Colours of the Soul* and *Colours of the Soul* CD.

CD – Colours of the Soul (available digitally)
June collaborated with professional musician Jeff Cutmore to bring you the very first coloured music CD, taking you through the colour spectrum key by key in a very beautiful way, coupled

with colour information and practical exercises.

Vocals are by June McLeod. The CD contains 14 musical masterpieces with specific exercises. When listened to and carried out, they will help everyone to achieve upliftment and well-being. Pure vibration is sound, when created as music in 'colour' compositions and specifically chosen for the right outcome, the music has the most powerful effect on the mind, body and spirit whilst boosting every cell in the body.

Research undertaken using the CD has far-reaching and positive results

- Proven to lower blood pressure, calm heartbeat, aid relaxation and uplift mood
- Stress reduction
- Clearer thinking and improved concentration
- Helped people to enjoy a more restful sleep and in some cases longer sleep while regulating disturbed sleep patterns and reduce snoring
- Release from emotional baggage
- Self-development and self-empowerment
- Relief from symptoms and ailments
- Hyperactive children benefit
- Aids recovery, convalescence and after care
- Antidepressant
- Strengthening the immune system
- Positive results with all ages and conditions

The CD is found online in digital format to purchase and download. Everyone has a soul colour number, and musical key. To find yours, refer to the best-selling books *Colours of the Soul*, *Colour Therapy A–Z* and *Colour Numerology: The Karmagraph* by June McLeod.

Your soul number identifies your soul colour and musical key:

Number	Colour	Key
7	Violet	B
6	Indigo	A
5	Sky Blue	G
4	Green	F
3	Yellow	E
2	Orange	D
1	Red	C

Chakra Silk Collection – New

The Chakra Silks are a set of NEW colours and design, beautifully packaged in one gift box. There is one set per box. Choose your colour to wear to enhance an outfit whilst supporting the chakras, well-being and upliftment. For use as part of a fashionable wardrobe or stand alone as chakra silks. The silks are of the highest quality and come with care instructions. Available wholesale and retail. The wholesale minimum order is 10 sets. Further information on chakras and colour is found in the best-selling books *Colours of the Soul, Colour Therapy A-Z* and on the *Colours of the Soul* CD.

Introduction

The secret of change is to focus all of your energy, not on fighting the old, but on building the new.
Socrates

Colour is balm to my soul. I have trained many thousands of students and trainers over the years, under my own name, and under my previous Colours of the Soul banner. The colour course materials that I developed and wrote were certificated and recognised as the best in the market at the time. I am thrilled and proud that my students are using the materials, tools and methods they were taught at that time, to deliver colour to individuals, groups and a few small to medium sized businesses.

It is a personal pleasure to work with the blue chips and corporations, working with and developing their colour ranges, to see the advantages and impact colour has made on their business (knowing my colour decisions reach many millions) and impact on their lives. It is refreshing to know that they are achieving maximum results, inspired by colour. Big businesses are taking the golden opportunity to increase margins and stand out in the marketplace with the colour choices I have chosen. The bottom line for all business is profit and loss, and colour delivers.

Each of us has the power within to do more than we can imagine, but without a key to unlock our inherent gifts, we remain blissfully unaware of all that we can be. I believe colour is the key. The more you work with colour and seek to understand its profound impact and transformational qualities, the greater the benefit.

Science explains colour as electronic waves, moving at different speeds, the knowledge of the universe is received through electronic radiation, or light; perhaps this is why we describe someone who is intelligent as 'bright'.

Although we recognise seven separate main colours, it is important to remember light is always moving therefore creating many differences of colours within each colour, known as hues, tones or shades of colour.

We exist in a world of colour, and we are colour; yet how many of us truly take on-board and understand what colour is? Or what can be achieved with knowledge and understanding of how colour affects us on so many levels?

During every waking moment we interact with many hundreds even thousands of differing hues of colour. Colour plays an undeniable and significant role in our quest for business success, happiness and health.

To deny the importance of colour is akin to denying the value of water to our existence. We experience the difference colour makes every day, but do we register it? Do we understand what is happening and why?

In the main, we do not, yet with an understanding of how colour affects us, we can grow our knowledge base to become colour savvy and colour aware. Wearing colours for major impact has been highlighted in the media for a while. In my thirty plus years of working with colour I have contributed to many pieces over the years, yet still today many are not making full use or taking full advantage.

Corporations use colour to entice sales, and numerous studies prove the energy of an environment is changed by the choice of colour. For example, the choice of orange over blue completely changes how we feel and react.

On a personal note, colour can increase understanding and pave the way to reaching personal best. When colour is worn remember the golden rule of colour. The colours seen, the visible colour, is what is being reflected outwards for all to see, and affecting everyone out there. It is the complementary colour that is affecting the physical body of the wearer. Always remember the duality of the colour when you choose a colour to wear.

Imagine a world without colour; every day we take for granted the kaleidoscope of colours that surround us. Colour illuminates, inspires and is a guiding force that helps us to express ourselves by colouring our thoughts, feelings and language. With colour we can find new solutions to old problems in our personal lives and in business.

Colour permeates deep into our being and reaches us on a subconscious level, yet its powerful transformational ability is so often underestimated. I will share with you some of my many colour discoveries, with examples taken from my own thirty plus years of working with colour, to reveal 'how' colour touches upon every aspect of our existence, illuminating the way forward, whilst releasing us from the burden of carrying whatever is holding us back.

Colour is as complicated as you want to make it. Every answer to every question is all there waiting to be discovered. I stand in awe at the apparent simplicity, masking the complexities of colour combinations, meaning and attributes.

As I delve ever deeper investigating my beloved colour, I am made aware and am continuously inspired by all I discover at every turn.

Colour is amazing. Come inside my colour world and let me share some of my findings with you, and offer you the key.

June McLeod – 2014

Such power is held by few.
Such gentleness is held
by only the very powerful.
To have both traits is rare.
So rare, they are recognised
by only a few.
Red Feather

Chapter 1

The Beginning – Building Blocks

Do not follow where the path may lead. Go instead where there is no path and leave a trail.
Harold R. Mc Alindon

We are surrounded by exquisite, and beautiful colour combinations in the natural world. A master class in colour. When we look at colour, how many colours can we see? Is it hundreds, thousands or millions? It is millions, and each with its own meaning, dual personality and associations. Confusing, complex, potent and erotic, colour is awesome. As Julie Andrews sang… "Let's start at the very beginning, a very good place to start…"

The basic building blocks of colour are divided into just three sections: the primaries, the secondaries, and the tertiary. The primary colours are red, blue and yellow, and they are the basis of all other shades. When all three are mixed together in equal parts they will make black. The secondary colours are orange, green and violet; by mixing two of the primary colours together we get a secondary colour. Mixing red and yellow in equal parts results in orange. Mixing yellow and blue in equal parts results in green. Mixing equal parts of red and blue results in violet. There are six tertiary colours, and mixing equal parts of one primary and one secondary colour results in a tertiary colour. So what are the six colours? They are amber, lime, turquoise, lavender, purple, yellow. Mixing red and orange together gives yellow. Yellow with green gives lime. Yellow with orange creates amber.

Colour is a powerful and engaging medium, a visual element unsurpassed. Colour will impact customers' decisions long before they have rationalised the purchase. Global business cannot rest on their laurels in mediocrity; the focus on excellence

must start with colour. Correct colour choice is imperative and will perfect business advantage in global markets.

In all aspects of our life, history confirms the extremely important role colour plays in affecting our evolution. It is the bedrock of our lives. It guides how we rest, work and play, interact, engage, communicate, network, purchase and sell. Empires are built on colour savvy business. Millions are spent perfecting, launching and marketing new products and brands. I know the fundamental and most important aspect of every product success or launch is colour, and must be the number one reason behind decision making.

Conversely, the use of colour, with no understanding of colour properties, dual personality or associations is akin to failing before you have started. Colour is an area that demands perfection. One shade out leaves the project lacking and it shows; people will feel something isn't right, even if they are unable to place their finger on what's wrong, voice their opinion, they will know, leaving business leaders wondering why colour isn't working for them. Yet colour does work.

Unfortunately, success depends upon the ability and expertise of the person or team allocated the task of the colour scheme, as colour can only be as good as the person choosing the colour. It continually surprises me, as there appears to be a naivety in some quarters, of the profound impact and transformational ability colour has; a fuller understanding is needed as colour is pivotal, the vital visual element that attracts the required emotive response while being aesthetically pleasing and unsurpassed and comfortable holding a multifaceted role. Colour is the peak; everything else, design, marketing, branding etc., must follow the leader.

Throughout history, the way colour is used has evolved internationally. The country, culture and religion all play a part in colour acceptance, meaning and understanding. Shades of colour must be tweaked and changed, dependent upon the audience,

product type, culture and design. A one-colour-suits-all cannot work with international business, and the associations we make with every colour is dependent upon where we have been raised in the world. Colour provides non-verbal effective communication, the most powerful and underused business tool available.

Colour choice can magnetise and attract a target audience or alienate them. It is that simple. With the best marketing and advertising in the world if the colour choice is not spot on and exact, expect sales not to reach sustained targets, or worse, offend the target market. Colour, with its own unique set of variants and meanings, when even a tweak to one colour has far-reaching implications, the task may appear daunting and enormous.

When immersed in international trading, it is vital to be colour savvy to survive. A cursory glance at the history of colour will reveal the historical and economic impact colour provides. Pre-war we see mainly dull bland colour, post-war, colour becomes a guiding light to brighten and to uplift. During austerity, fashion is ablaze with colour and pattern to reignite our senses, to lift mood and to brighten outlook. The most recent crash saw a blaze of colour and pattern on the catwalk spilling out on to the high street.

Chapter 2

A Glance at Ancient & Modern History

All truth passes through three stages. First it is ridiculed, second it is opposed and third it is accepted as self-evident.
Arthur Schopenhauer, 1788–1860

The study of colour is as old as the hills. Colour affects us all far more deeply and profoundly than might first be imagined. Colour has played a vital part in human lives, health, survival and culture since ancient times. Long before the many theories of the effects of different colours on the human body were established and shared through writings and passed down through word of mouth. Our primitive ancestors used the healing properties of colour before language was established, proven by cave drawings and artefacts found. Certain attributes were linked to certain colours; some are still in use and appropriate today.

From living close to nature, observing changes in plants, trees, animal behaviour, weather and seasons they built a strong and workable proven colour catalogue to help themselves and each other eat, live and survive. Coming forward and closer to modern times, the history and scientific background can be interesting, I shall share a potted version then cover interesting aspects of this extraordinarily deep and expansive subject.

It all began with 'Let there be light' and thus began the great explosion and process of colour into the world. Colour is the manifestation of different wavelengths of light and pervades every part of our being, the earth and the universe. It is a vital and important part of our lives. Discoveries of ancient cave paintings show man's use of colour was from very early times and restricted to just a few colours: red, black, brown and yellow. This was a reflection on his very physical life at the time, very

much about self-preservation: hunter-gathering, sleeping and eating.

As man and life evolved the great worship of the sun began across many cultures in many different countries such as Ancient Greece and Egypt. They used colour as a form of healing, coupled with crystals, stones, dyes and coloured minerals. Outdoor coloured temples in particular colours were constructed where people could take responsibility for their own health by choosing a particular colour to sit and be bathed in with sunlight pouring through the colour on to their skin. Also, in Greece, they discovered the importance of the elements: earth, fire, water and air, and they associated them with the qualities of cold, heat, wet, dry and linked them to bodily fluids. Blood was red, bile was yellow, phlegm was white and melancholy was black. These linked to the four corners of the earth and to the four organs: spleen, heart, liver and brain.

They used this system to determine the physical condition of the patient. They believed that good health and well-being demanded the correct balance of all the elements, and colour was intrinsic to every part of healing to restore well-being and balance. They also used different coloured oils, different ointments, and in Ancient Greece, different garments. With the coming of formalised religion, Christianity, all that was seen as pagan and druid like was not talked about; in fact it was ostracised from society. Most of the ancient healing practices were effectively halted and those who tried to carry them on were persecuted and often called witches. After the Middle Ages science took hold. It was rational and left brain and had to be proven. They allowed no leeway for anything esoteric. So therefore anything esoteric or unexplained disappeared from scientific view and went underground – being passed only by word of mouth.

Historically, colour has influenced man from ancient times. Early civilization used colour for ceremony, healing, religious

purposes and rites of passage. It is believed to date back before records began. We know the Ancient Greeks and Egyptians' use of colour was extensive and colour has played its part, successfully, in all cultures. Ancient man was occupied by his physical surroundings and survival, taking colour directly from the earth in the form of crushed stones and minerals. Cave paintings were created, using red, yellow, brown and black. Symbolically, these colours can be attributed to our basic instincts and the grounding of our physical energies.

Instinctively, ancient man created paintings in these colours to energise their next hunt and continue their physical existence. Thousands of years later, in Ancient Egypt, man worshipped the sun, the source of all life, light and warmth. In the ancient city of Heliopolis, the sun god was worshipped in many guises. Khepri, the rising sun. Horakhty, the midday sun; Horus, the horizon; and Atum the setting sun. History informs us many Eastern cultures and also Native North Americans followed the four directions and formed the foundation of the Chinese Feng Shui and Geomancy methods.

The temple of Heliopolis had a quartz crystal in the dome that split sunlight into the seven spectral colours. These coloured rays of light filled seven healing chambers, where people received colour healing. Herbs, dyes and coloured minerals were also used. The ceilings of the temples mirrored nature; they were usually blue with a green floor, like the meadows of the Nile.

Their temple floors were often green, just like the grass running along the Nile and blue the colour of the sky. Symbolic hieroglyphics and imagery were used for tomb painting with some dating back as far as 3000BC.

In the healing temples they used coloured gems and crystals for light to be refracted by the sun into different rooms so people could sit or stand in the colour of their choice. They copied nature in many aspects of their lives. Having the different rooms for colour we could perhaps relate our present methods of colour

using light to this ancient practice, and on papyrus dating back to 1500BC there were a number of cures listed.

So their deep knowledge and understanding of the healing powers of the colour rays was so nearly lost when later on in history the Ancient Greeks considered colour in part as a science. Many abandoned the metaphysical side of colour, concentrating only on the scientific aspect. Thankfully, despite this, the knowledge and philosophy of colour was handed down through the ages.

Egyptians recognised the therapeutic benefits of wearing coloured gemstones and crystals. They believed that certain coloured stones would protect them from unwanted energies or attract good luck and prosperity. Ancient Egyptians understood the relationship of form, colour and sound. The two colossal statues of Mammon, in the Valley of the Nile, gave out a sound every morning to greet the sun. Today, the statues have become so weathered that that original form is lost, so there is no sound.

Ancient Egyptians and Native Americans wore headdresses displaying many different colours to symbolise the many colours that we naturally radiate. Jewels, crystals and gemstones worn often to enhance the wearer's energy. Hermes Trismegistus, known as the greatest master, was believed to have come three times to earth to bring us knowledge of who we are. Scrolls found in the Valley of Hebron talk of him. He left an Emerald Tablet inscribed "as above so below". The tablet is associated with the true meaning of the Holy Grail, which is really the Holy Ghost.

Archaeologists discovered numerous surgical and medical works including the Ebers Papyrus dating back to 1500BC. The ancient manuscript is beautifully preserved and unrolls to 68 feet in length, and includes various medical prescriptions, some of which are still used today. Red was used to heal smallpox and yellow for jaundice. Today, following much research, we find blue used in hospitals to treat jaundiced newborns. The Persians practised a form of colour healing, using the emanations of light,

and were also noted for their wonderful silks of vibrant colours. Silks are used as part of ceremony, dance and for healing to cover parts of the body, as they are sometimes used today for the purposes of colour healing. The 'Chakra Silks', a perfected combination of specific colours, in the very best high quality silk (see Products for purchase), used for dance, yoga and healing.

The great philosopher Aristotle, in the fourth century BC, considered blue and yellow to be the true primary colours, they relate to life's polarities: sun and moon, male and female, stimulus and sedation. He also associated colours with the four elements, fire, water, earth and air. Aristotle from his study of how light travels arrived at the theory, which remains close to current thinking. Light travels in waves. There was much scientific debate about the wave versus particle over the following 2,000 years until physicists Max Planck (1858–1947) and Albert Einstein (1879–1955) laid the foundations for the currently accepted quantum theory.

The current theory is that light energy moves in discrete packages or quanta, known as photons, and this movement is a waveform and a wave with a long wavelength and has a low frequency. Red has the longest wavelength and slowest frequency, whereas violet has the shortest wavelength and fastest frequency. The healing effects from wavelengths, which we perceive as colours, are greater than from white light. Red stimulates and boosts healthy cell renewal, while blue calms and reduces inflammation. There are 7 accepted colours in the spectrum today, yet the number of colours in the spectrum must be open to question and depend upon on how the overlapping colours appear.

In Ancient Greece, Hippocrates, a contemporary of Aristotle and Democritus, made colour into a science and between them they abandoned the metaphysical side of healing in favour of logic. Hippocrates used colour extensively in medicine and recognised then a slight difference in hue made a considerable

difference to outcome. They laid the foundation stones of orthodox medicine. Paracelsus led man back to spiritual and divine things, but he was ridiculed and had a very hard time. Today he is known as one of the greatest healers. He lived from 1493 to 1541. He introduced herbs, sound, colour and many of the complementary alternatives we have today. He was hounded throughout Europe and died in his forties and sadly most of his manuscripts were burnt.

The Ancient Chinese practised colour, the *I Ching*, Yin-Yang and ancient Feng Shui stay with their traditional meanings of colour and direction. The ancients have a great respect for the ancestors' interpretations of colour.

The Arab physician Avicenna believed that a person's colouring would indicate a person's predisposition to various diseases. In diagnosis he always took account of a person's colouring. In later years, Eastern medicine followed the same method. Avicenna wrote the book entitled *The Canon*, and developed a colour chart detailing many uses. It made references to the effects primary colours can have on an individual. One discovery found that red stimulates the blood and blue cools it; he discovered this without modern scientific experimental equipment. In 1958 the US scientist, Robert Gerard, proved that red light could raise blood pressure and blue light will lower it.

The wealthier Romans and those in high office would wear purple robes indicating power, nobility and authority. Looking back in history, see the colours that are being reflected at different times. During times of severity and proprietary, the code of dress was very much dominated by black and grey. The Victorians mainly wore black and grey influenced by the Queen's long period of mourning no doubt, and were in many ways quite austere. The Victorians gave us the term 'green is unlucky', but it was only unlucky because of the amount of lead in the paint. Painted on to babies' cots when they were teething and chewing the sides of the cot, some ingested the lead paint and died. Green

was then seen as unlucky.

The colourful Baroque styles with elaborate decoration took over. In Victorian times the most significant colour development was the use of aniline dyes which were made from coal tar. They were first used in fabrics before being used in wallpaper and paint. In the later part of the 19th century the arts and crafts movement brought with it a simple palette of colour such as pale grey, olive, green and ivory. The oil based paints we use today include a wide range of colours that are made from artificial dyes alongside a complete birth of natural paints flooding the market which is refreshing to see. We see through history that after World War II, blue was worn while previous to that red was worn denoting the possibility of war. Today all colours are worn and have specific meanings that will be explained throughout this book.

The German philosopher, Goethe, published his scientific and esoteric thoughts on colour in *Die Farbenlehre* (*The Teachings of Colour*):

> Since colour occupies such an important place... we shall not be surprised to find that its effects are at all times decided and significant, and that they are immediately associated with the emotions of the mind.
> Goethe, 1940

In later life he declared he wanted to be known for his colour findings above all else; his work influenced many people, including the great artist Turner. Goethe, one of the better known persons from more recent history, identified six spectrum colours. The primary colours of red, yellow and blue plus the secondary colours of orange, green and violet. Mixing together two primary colours will produce a secondary colour. As an artist, six colours suited Goethe's practical purpose of mixing colours. Goethe used 6 colours adding violet and orange; orange

and yellow – positive, bright, warm and active. Violet and blue – dark, cool and passive. According to Goethe, violet is the strongest colour and the centre of the whole colour spectrum. Green is neutral, reconciling and soothing, the midpoint of all the colours. During the 19th century, several studies were performed to prove the healing qualities of colour and light; research continues today.

The Luscher Test was invented by Swiss psychologist Max Luscher using four colours as a tool for psychological assessment. To the three primary pigments he adds the colour green. As he sees it:

- Red – Self-Confidence
- Blue – Contemplation
- Yellow – Freedom
- Green – Self-Respect
- Red – Colour red brings excitement and activity thus self-confidence, the feeling of personal power
- Blue – Brings peace and satisfaction thus contentment and integration
- Yellow – Brings release and change thus freedom and self-development
- Green – Brings firmness and perseverance thus self-respect and identity

Isaac Newton, when asked how he could see so far into the Cosmos, replied he could only do so because he was "standing on the shoulders of giants". At this time in our history when we seem to know so much, the realisation is we know so little. We need to be open to the wisdom of the ancients who have journeyed long before us. Colour is weaved into our language and we use colour language mostly without thinking. The very basic and well known are 'like a red rag to a bull', 'yellow belly', 'green with envy', and 'I'm feeling blue'. Yet colour is more than

language; it makes formidable impressions and drives every area of our lives, never more so than in the important areas of health, self-development and business. Different cultures and religions throughout the world have colours with special symbolic significance in their ceremonies, their religions and mysticisms. Black can give us the space sometimes needed for reflection and inner searching. It can indicate inner strength and the possibility for change, and I also would defy any woman who doesn't love and adore her little black dress. Black is certainly a very important colour and has secured its rightful place. In Ancient Egypt black was linked to black cats: powerful, positive and sacred.

In the West white is used for wedding dresses, because it stands for purity and innocence, and yet in other cultures and religions it stands for death.

In Christianity, the Virgin Mary always wore Madonna blue. It is seen as the colour of God and is used during Lent. For Buddhists, blue is a sign of calm, like the heavens and waters, and purple is traditionally worn by priests for ceremonies and by royalty. Green is the colour of growth and rebirth in Europe and Chinese tradition. In Islam, green is the sacred colour because Allah is never depicted as a personified being but is believed to be present in nature.

Yellow for Buddhists is a sacred colour, and the monks wear saffron coloured robes. For Christians, yellow represents something that is sacred and divine. For Hindus bright yellow is for truth, life and immortality. Orange in China and Japan is the colour of happiness and love. The Chinese symbolise this by blessing fruit that resembles the hand of Buddha. Buddhists see red as the colour of life and creations, and the Egyptians saw Ra the Sun God as yellow.

The Zulus' coloured beadwork is usually worn as a head or a neck band. To men it was always passed down by word of mouth because the male warriors depended on the female relations to explain the colours and the symbols and the code, and then the

patterns and codes would speak about what region they came from and their social standing. The Zulu bead in bright colourful circles interspersed with straight lines. Indian clans bead and weave in circles, zigzags and line patterns, women adorned themselves with copper and brass rings worn on arms, legs and neck and in some tribes, through the nose, symbolising faithfulness to their husbands. The rings have strong ritual powers; husbands adorn themselves with jewellery and ornaments beaded by their wives. A palette of blues, reds, yellows and greens or muted earth colours obtained from ground ochre and natural clays in colours yellow, pinks, white and browns with black sourced from charcoal. The colours used to adorn the body and the home. Most body blankets were dyed in the colours red, blue, yellow and purple. Tribes globally wear bright colours with pride. They like to look and feel good.

One African tribe adorn newborn babies with beaded pearl necklaces to represent the purity of new life and to give protection. Whereas the older women, post sixty, wear copper bangles and necklaces made of shell. As the babies are adorned with pearl at the beginning of life to protect them on their journey through life, the elderly are adorned with shell to protect them on their journey to and through death. Younger women, post puberty, cream their bodies daily with ochre powder, butterfat and herbs. Most ancient tribes globally believe colour is beautiful, adorn themselves with colour and accept that it has symbolic meaning. In my teachings I encourage the use of shells coupled with crystals; crystals are used widely, yet shells seem to me to be forgotten. It is such a shame that the treasures from the ocean are not used more, as they play an important role. Use shells in the most logical place, where water flows, possibly in the utility room, bathroom and cloakroom. Ochre symbolises the red of the earth, the red of blood, therefore red represents life force, the symbol of life. Most beading is done in three colour ways: red, blue and yellow. Headdresses signify place in tribe, with face

painting supporting place. Colour is a visual element and one of the most important communication tools from earliest tribes to modern day. Worn in modern times they make an impact in social occasions, to attract a mate or attract new business. In retail we know that a customer's choice is made firstly on colour.

The Cherokee Native Americans also had their meanings for the different colours. Their colour association linked to the four directions. Blue for North – cold, distant, trouble; White for South – peace, warmth and happiness; Red for East – blood, success, fire; Black for West – death and problems. The natural world displays what appears to be a glorious and random selection of clashing colours. Closer inspection and research proves that this is the case. As an original thinker with an enquiring mind, I take much inspiration from the natural world and encourage everyone to do the same.

Bernice Kentner published *Color Me a Season* in 1978, describing four personality types. She writes about each individual personality being best supported with a specific palette of colours. Today there are a few people in the colour world who still follow her work by using the four season system. Personally I do not feel comfortable confining colour. I feel colour, like water, will always find its way and cannot be confined to any particular system. Spectacular colour combinations in the natural world work so beautifully, yet seemingly fall short of the four colour palette system that I believe is incomplete.

Not too long ago a handful of colour schools taught that 'blue and green should never be seen', looking outside, the earth is green and the sky and oceans blue, mixed together reveals glorious teal blue. When in doubt, seek outside; many years of evolution compared to our three score and ten must be relevant. I have always taken my inspiration from the natural world and allowed the exquisite colour combinations the freedom to inspire and to reveal, and have yet to be disappointed.

We are now seeing a colour resurgence. People want to reinvestigate the effect of colour. The interest in colour for business and personal use is rapidly growing in popularity around the world as its wonderful benefits are being rediscovered. During my own thirty plus year colour career, I have seen some wonderful results that can only be attributed to right colour choice. I give an array of real life examples in my book *Colours of the Soul,* with a mixture of life and business case studies and examples in this book.

With the rise of allopathic medicines and surgery, we saw the decline in natural ways of healing, especially the use of colour. But you cannot always hold something so good down for long. Gladly we see its popularity rising once more. A blue light is used for premature babies in hospitals as blue light penetrating the skin destroys excess bilirubin that the immature liver cannot handle. The treatment is now given in preference to a blood transfusion as it is proven successful. They lay the baby under the blue light, protect the eyes and bathe the body in that blue light for a set time and until the liver regulates.

Colour throughout history and economical ups and downs has played its part magnificently, following major wars. The brighter colours have emerged to raise the spirits of the nation, and during the latest banking crisis and austerity measures, fashion led the way by displaying an array of the brightest jewel colours on the catwalk. Burberry had a glorious show of the bright metallic colours in pink, magenta, violet and more. Cosmetic companies brightened their ranges; colour, colour everywhere to be seen, to be worn, used and be embraced.

Pottery and accessory companies went colour dotty. Emma Bridgewater led the trend; Cath Kidston revels in colour, her colourful ranges soared in popularity. Marks and Spencer had success with their colourful ranges and in particular their turquoise sofa. Fashion handbags in colour ranges of red, green, blue and orange found an ever-increasing market as the demand

for colour leather rose. The modern trend for getting back to earthy colours in interiors has not quite gone to plan in some sectors, as we see on the high street with the more muted interior and branding colour schemes emerging.

They are unforgiving and placed incorrectly in some cases. Many smack of 'follow the leader'. Correct colour choice and placement is vital and especially so for the high street. Abbey National made the mistake of colouring different branches different colours and paid the price as customers were confused and they lost a marked loyal following. Customers voted with their feet. Fads and marketing can be spiel and hype, with everyone jumping on the bandwagon of the 'latest' trend. Colour, however, has other ideas, being stable, exact, and constant. By its very nature, colour awaits to be placed by careful considered hands, then it will do its job, far exceeding results and expectations.

I believe commercial competitiveness, greed and monetary gain has sadly driven changes to colour association and meaning, to fit the outcome, rather than building on proven ancient knowledge and know-how. To appear innovative and new, some of the changes have wreaked havoc and possibly damaged interpretations of colour associations and meaning.

We can purchase part percentage essentials oils, such as 50% pure, sold as essential oils in stores on the high street, yet 100% pure is the only true essential oil and effective oil to use to gain any benefit from. It is the same with colour. Each hue has its own personal qualities that have stayed true throughout history; man should not be interfering with colour DNA to suit fashion, trends or otherwise.

Yet, regardless of changes made on its behalf, colour remains a formidable force, screaming to be heard and determined to takes its rightful place at the top, by refusing to 'work' when used in commercial settings when chosen from a 'new' palette, as if goading the 'new' predictions to bring it on. When the correct

colour appropriate for the environment, product or arena is chosen, sympathetic to the market or product, colour reigns supreme.

Also by remembering interiors demand that the architecture and light must take precedence when choosing the colour scheme, as highly pigmented colours change in different lights. When placing all the pieces of the jigsaw together to discover the colour palette, colour absolutely works, and beautifully so.

In times of job insecurity, we see the rise of the natural earthy colours, grey and brown for interiors and soft furnishings. Brown in part represents the colour of financial security, money issues and also commitment to profession. A dependable, durable colour, that will portray stability, whereas tan and the lighter browns tell another story that I will explain later in the book.

We know for certain that colour affects our mood, the way we feel, our self-esteem, confidence, the way others respond to us and physiological responses. Colour is a powerful medium, a visual element unsurpassed and the root of our existence. Looking back into history we find confirmation of the vital role that colour plays in our evolution; it is the foundation on which we work, rest and play, interact, engage, network, communicate, purchase and sell. It is the foundation and bedrock of our relationships, both personal and in business.

Chapter 3

The Colours

The greatest danger for all of us is not that our aim is too high and we miss it, but that it is too low and we reach it.
Michelangelo

Red

To demonstrate the dramatic effect of red, it takes 2/100ths of a second to register red yet 25/100ths of a second to register 3 words of this text. 'In your face', 'bring it on', 'come and see me sometime', glorious, wonderful, erotic red. Red is literally the Olympic winner, a smash hit in the colour realm. Like all of the colours, red has a dual personality. I aim to offer a balanced viewpoint and will reveal the side of every colour throughout the text.

Most cultures have names for white and black, seen as light and dark; the third colour to be named globally is red. With tremendous emotional impact red affects us on every level of our being – a boost for the metabolism, promotes adrenalin release and produces feelings of warmth. Red stands out from the crowd. A number of companies use red for their corporate image, one of the major players being Coke. The most iconic. Coca-Cola is the most well known and one of the most valuable brands in the world. Coca-Cola sells more than one and a half billion servings in a day in more than two hundred countries worldwide. Vodafone, one of the UK's most valuable brands and Virgin Atlantic have also had success with the red branding, yet in different ways. McDonald's latest makeover has not been successful in my opinion, yet their online presence is spot on, tweaking their logo and use of red, dependent upon the country where they advertise their wares.

When McDonald's changed their colour scheme from the bright primary colours to what we see on the high street today, many were initially confused, and there was a distinct feeling of disappointment from both children and adults. The teens expressed delight as they felt they could blend into the décor colours and felt a sense of hiding away in the dark, cave-like interior. Yet some customers felt they had lost their 'feel good' factor with the introduction of the new colour scheme. A small customer survey found people disorientated on first entering the premises. On the whole views were strong with the majority based on the colour scheme rather than the new layout and design. "Felt cave like and dull", "felt sombre, not nice", "I preferred the old colours", "where have the happy colours gone?", "feels depressing". As a young people's eatery it could be argued that McDonald's got it right from the positive comments of teenagers. Yet the survey highlighted a majority negative response overall. Note: McDonald's had a recent logo change from red/yellow to yellow on shopfronts. Latest news prior to going to print: McDonald's sales slump with a 28% drop in sales.

Whereas Sainsbury's online presence leaves a lot to be desired; overdoing orange online is a mistake. Yet I hasten to add that their iconic orange works beautifully as logo and as store signage. Unfortunately, another 'make-under' of late leaves a lot to be desired by replacing their iconic and highly recognised orange with nappy brown, chocolate and burgundy colourings – more on Sainsbury's in the orange section. Let's stay with red by mentioning a few more red companies:

Red Bull, Diesel, Nintendo and Levi's all use red with great success. Lego with red and a small amount of yellow is a family-owned business and the most profitable toy company in the world. Where does one start relaying the many virtues and accolades of red, as the ultimate power colour. Red commands our every action. The colour of physical self, survival instincts, procreation and connection to the earth. There is nothing half-

hearted about the colour. Red activates, creates movement and arrests attention. Red envelops, expresses passion, danger, anger, sex, joy and celebration. Red creates heat and excitement, red stimulates our senses, keeps us awake, alert and aware. Red gives rise to determination and increases libido, the boost to circulation comes from red and the will to move forward to push through barriers, breaks free from the past, innovates and generates and demands we live in the here and now. Red stands proud and in your face. Red wagers, red dares... 'he who dares wins' is perfect for understanding the initial impact of red. Yet, if substance can't back up the initial impact, forget it. Red dies a death quicker than all the other colours combined.

The fire colour, "feeling hot, hot, hot..." the perfect song for red. It has been suggested red is the first colour recognised by babies, other camps disagree. I stay open on this one as I have never been a part of a study to discover the outcome. Red light is used in air traffic control centres at night as it allows the air traffic controllers to see into the night sky more clearly than with any other colour. An energising and full-on colour, there are few boundaries with red, and a little goes a long way. Like a hyperactive child you desperately want to calm, to secure some peace and quiet. Red will make itself heard. Red has long signified danger in society, yet when working daily with colour one finds a discrepancy. It is used to identify fire equipment and to stop vehicles at traffic lights and signs.

When working with colour on a daily basis, you will notice you automatically differ from these old findings, set many years back. Everyone is told to stop at traffic lights when the lights change to red, but a natural reflex for the colour person is to race through! I find I need to stay on full alert when I am driving, otherwise I will drive through every red light, as my natural and automatic response to red traffic lights is to rev up!

Findings from an in-depth study I undertook for a cosmetic company proved beyond doubt that red lipstick is the most

seductive and sexy colour choice for lipstick. During the study women licked their lips more when wearing red lipstick, citing it was hard for them not to lick their lips when wearing red lipstick. They pouted more, nibbled their lips causing a slight swelling, and flirted, acting more flirtatious when wearing red lipstick than the other colour lipsticks. Red lipstick reinforced their flirtatiousness as they flicked their hair, smiled, tilted their heads and laughed. In the room the majority of women were encouraged to wear red lipstick with a handful guided to choose from another selection of alternative colours. All were told that the lipsticks were available for their use and, also, they could take them home. None of the women were aware of being studied for the purposes of lipstick colour choice.

The mixed group of men and women were advised they were being observed for their colour choice in clothes, with the make-up and lipstick made available for their use. The lighting was dimmed at one point for 15 minutes – red is also known as the colour of the night. Interestingly, the women wearing the red lipstick vamped it up with more exaggerated flirting and hair flicking once the lights were dimmed and did noticeably change. None of the red lipstick wearers wore their hair up. Running their fingers through their hair was more obvious in the red lipstick group. The observation of the men highlighted that they were more open with their body language when talking with the red lipstick wearers and they stayed longer chatting to them than with any of the other colours.

The conclusion, red is absolutely the sexiest colour of all time for lipstick. Equally with hair colour, reds stand proud holding the number one spot. Blondes have for so long reigned supreme in the popularity stakes of hair colour, so it is refreshing to see reds have over taken and stand confidently in first place. For the past 18 months reds have been jostling blondes for top spot, now they proudly own it. With red hair colour sales booming, red lipstick sales up, the next delight for women are their shoes, and

we have seen an increase in red shoe sales marked by the renewed popularity of red. The red dress has consistently held its place in the 'must have' colour dress stakes, running neck and neck with the little black dress. Fashion of late is displaying an array of jewel colours and within the display of colours red stands tall.

Within a few seconds on meeting, others will base their opinion of you on colour first, body language and posture second, then eye and facial expression. We are programmed to identify the human face more than fixtures and fittings. We cite people before anything else, therefore logic demands we pay careful consideration to employees' outfit choice, important for any business and, especially so, if customer facing.

Wearing red to business meetings will ensure you are seen, heard and not talked over. Red will enhance your presence. It is all-powerful, dramatic and demands attention. At meetings when seated, the top half is on show. Support your presence by carrying a red handbag and wearing red shoes. Louboutin heels will ensure every step is seen. If your personality type shies away from wearing an all-red outfit, wear large pieces of red jewellery, necklace, earrings with a red ring to support (as hands will be on show), block red top or stripes with red the main colour or highlighted on cuffs. For guys, a red watch, a red tie, block red or striped shirt with red as the stand-out colour, maybe with red cuffs to achieve the same impact. You will be noticed wearing red, so don't consider wearing the colour if you want to blend into the background. Choose natural fibres as red fires and heats the body, raising temperature, rather than at a pivotal part in the meeting, when about to show your ace card, you boil and melt into a wet sweaty mess... not a good look... Be prepared as cool natural fibres are best to allow breathability.

Red is bold and makes an instant impact. In the environment, less is more when used in any setting as the main décor colour. The first hit of red comes with such force it can sometimes be

difficult to sustain such a punch. The downside is that it can be a five-minute wonder in terms of business usage if not used with careful consideration and continuity. Small hits of red in the business environment are stunning, and help keep the motivation up. Too much and in the wrong areas can stir up the negative attributes of clashing egos, impatience, with themselves, their colleagues and the work at hand. Unable to keep momentum, they rush through tasks, not reading the small print carefully, with an inability to see tasks through to completion. Red is the life force colour, and representing life, blood, birth and death. It is globally recognised as an auspicious colour (when used appropriately) and well with colour knowledge... Red represents good luck, good position, good harmony, good wealth and is also used in ceremonies and for many celebrations in numerous countries and cultures.

Red gets the blood flowing, it is vibrant, juicy, intense and passionate. When we get angry we observe a red mist enveloping us. Blood pressure readings taken at point of anger surge show heart rate increases and blood pressure elevates rapidly. We can't see straight in anger and frustration. Red affects heart rate, palpitations, increases inflammation, and intensifies emotions by boosting a power surge.

Ancient Chinese, Indians and Egyptians believed in the healing properties of colour, believing red stimulates the physical and mental energies. Time and study have proven their colour theories to be correct. In China red is the most popular colour choice, for its strong, positive and prominent properties. Red depicts 'good luck' to the Chinese, who always use it in celebrations. Chinese brides like to wear red or to carry red flowers and decorate their reception venue with red. Red is prominent in Feng Shui and used in the home. The belief is that it gives a positive energy and motivates.

The colour red increases our breathing rate and activates the pituitary gland. Red never disappoints, it will always deliver the

most passionate response, yet not always favourably. I like to refer to red as the provocative colour. The list of positive and negative attributes is the longest for red than the other colours. In earlier colour studies it is documented the older generation prefer the lighter shades of blue, green and violet, when in fact latest studies have found they need the properties of red and orange to boost the life force within, to activate inner warmth and to energise the system. In homes where the elderly spend much time sitting add the two colours by way of touches carefully placed in the room to catch the resident's eye as they are sitting. Review the carpeting and soft furnishings. I am not advocating a red carpet, I am suggesting red within the pattern of the carpet, as most elderly people's homes I visit choose patterned carpet for convenience and longevity; spillages are less noticeable.

One thing is certain, colour affects our psychological responses and the way others respond to us, our self-esteem, confidence, mood, mental agility, our physical self and well-being. Red has long held the top coveted spot for sports car colour. We now see the most popular car colour overall is white, for the first time in history, with white car paint now accounting for 28% of paint sales to the motoring industry. In previous years red was the colour for sports cars, with green a close contender. In the consumer market blue, metallic grey, silver and black have traditionally led the field, almost neck and neck. Can there a deeper meaning and significance to white's new rise in popularity? In the East, white has been favoured far longer than it has in the West and now we are seeing a surge in popularity of white globally.

When a large motoring company sought my professional services, I predicted the future trend to be white. I was met with some uncertainty when another 'expert' came out to the press to predict blue. Happily, I was proven right and more importantly the company who hired my services stayed with me and promoted my prediction. Many months after the news broke,

sales figures confirmed white to be the best-selling car colour and the most popular car colour in the West for the first time. It was great news. Not only does colour influence the car value, but it also makes a statement about the driver's personality. Consumers should think carefully when choosing their car; not only the model, but the colour too. Colour has a significant impact on the resale price and also on how it affects you whilst driving as colour will support calm drivers. Today the paint supplier to the automotive trade sells more than a quarter of its total paint sales in white. In the East white has always been the first choice, the West is catching up fast.

We react to colours differently; our reactions are quicker to some colours than others. For example, red is the colour of power. It's a sassy erotic number, full of courage and passion and substance – the ultimate sexy power colour. It's the first colour to be seen, it is the first colour that you notice, an in your face colour, a stand out from the crowd colour. Red has got 'It', whatever 'It' is. Red discovered and flaunts 'It'. Red is the first colour to be seen in any setting, giving an understanding of how the red dress competes favourably with the sexy black number. Brands using an all-red colour scheme are out there and mean business. A smiley one for you. When left to their own devices the majority of men will book a flight through Virgin Atlantic favouring them over other airline providers. Look at the advertising campaign girls; their campaigns display glamorous women dressed top to toe in vibrant red uniforms looking sassy and beautiful, and if you are still wondering why it is the male airline of choice, seek out the Virgin Atlantic advertising campaign and view the images of the female cabin crew in their uniforms.

We make a subconscious judgment about people, business, environments, services, products, space, buildings, etc., with an initial assessment based on colour alone. We most certainly react quicker to red than to any other colour, yet don't be fooled, red isn't for every setting. Even red has its limitations; red used

unwisely is the most ghastly and unforgiving. To visualise and to perceive more clearly colour effects, draw a triangle. Divide it into seven segments, placing red at the bottom with violet at the top showing the triangular scale of the seven colours of the visible spectrum: red, orange, yellow, green, sky blue, indigo, violet. The red at the bottom of the triangle shows red as having the longest wavelength, with the slowest frequency, best described as a steady beat of the drum.

Red energy can be compared to the voices of Heather Small (of M People fame) and Barry White, sexy and deep. Moving up the triangle we hear Adele and George Michael, on to Elton John, Ed Sheeran and Sarah Brightman. At the top is violet, the shortest wavelength and fastest frequency best described as the violins of the spectrum.

A red case history from the past fascinates and is a most interesting read. It is the true story of Kasperbauer. A small boy growing up on a farm in the USA wanted to know why pigweed plants are easier to pull up when growing close together than grown alone. When crowded together they had fewer roots. Through trial and error the young boy experimented, enquired and puzzled, spending much time over the years; going into manhood he studied at agricultural college where at the same time he put into practice his theories. He went on to discover that the use of coloured plastic sheets spread under growing plants improve their flavour, ward off pests and produce more anti-cancer chemicals.

The colours red, orange and yellow are known as the magnetic colours and rise from hot to warm. They are the activating colours, energising and arousing, needed to ground earth and root, whereas the colours sky blue, indigo and violet are known as the electrical colours being calming, sedating, purifying, releasing and clearing. Green is neither warm nor cool. It sits between the two and is the harmoniser, the balancer and regulator, the calming one. Not so with red.

Red commands our every action. It is the colour of our physical self, our survival instincts and our connection to the earth. Red activates, creates movement and arrests attention. It expresses passion, danger, anger, joy and celebration. Creating warmth and excitement, red stimulates our senses. It has the longest wavelength and slowest frequency. Having the closest vibration to infrared it creates a sensation of fiery heat and warmth. Red boosts our circulation, raises blood pressure and gets our heart pumping faster. It raises our libido, increases determination and gives us the will to move forward. It pushes us to break free from the past and demands that we live in the here and now.

Action, self-awareness and passionate about all things, red can be counted on to evoke a passionate response but not always a favourable one. Red is thrusting and courageous. Giving the energy to take action to complete the task, red is the reminder of what needs to be done. Blush with red, rush in with red, go in where others fear to tread with red. Nurturing base instincts it's the life blood of life. Red leads the way and takes control as destiny calls.

Orange

Audi and BMW have not had such great success with orange yet Apple, BSM, easyJet, Mini and Coutts have. To most, the reasons for this are baffling, yet to me, a professional colour expert, the reasons why and differences are as clear as crystal.

Thomas Cook Group, and their logo. I have always thought their heart symbol was misplaced and not in my opinion well coloured or designed. From the moment they were rebranded and I viewed the outcome, I did not like their heart symbol. Not a clear true heart, rather an odd shaped heart with what appears to be a tear within it. It appears strange and out of place and when I look at the shape, it never sat well to my discerning eye, and also appears torn in half. That was the first thing that took

takes a subtler approach, yet don't be fooled. It is more than able to pack a punch as one of the most beneficial colours to use for a myriad of reasons. The Humpty Dumpty colour of the spectrum, in the nursery rhyme Humpty Dumpty fell off the wall and put all the pieces together again. Orange has the ability to bring it all back together because orange is individual and unique. Orange is not a sheep! By developing its own unique style and trend it is the realist of the spectrum, what you see is what you get. No hidden agenda: orange has great potential and abilities, and will shine when used in the right setting and is the perfect shade of colour for usage. Orange has the capability to revitalise. It holds within it some of the qualities of red, yellow to a lesser degree (to lessen the load of red's temperamental attributes) yet heightens yellow's butterfly input, with such a combination that it has its own exclusive and unique contradictory and dual personality associations. The key to understanding the abilities of orange is to remember Humpty Dumpty. Orange hits the spot as far as emotions are concerned and will always be remembered. "Happy talking, talking... happy talk... think about things we like to do..." lyrics to a song from *South Pacific* that describe perfectly the attributes of orange. Many years ago I recorded in my first book titled *Colours of the Soul* the heartening true life story of the ability of orange to affect deeply a disturbed child. It is one of many true colour healing experiences recounted in the book. Here is a potted version that I would like to share with you to share the absolute perfection and abilities of my glorious colour.

I spent time working with blind children. One child refused to give up the orange silk she was working with: she was struggling with emotional problems rather stoically by herself, rather than share and be supported by nurturing carers and professionals. I knew nothing of this nor her background, yet during the workshop and a colour practical session, and to the surprise of all present (myself included), she felt able, with orange to support, to release the pent-up emotions she had for so long held within.

Throughout the colour session she refused to let go of the orange colour. As the session drew to a close, she finally opened up and shared with her guardian. It was an emotional moment for all concerned, and therein lies an example of the connection between orange and Humpty Dumpty, another case of orange putting all the pieces back together again. Children and adults with eating disorders, behavioural and learning problems all benefit from particular and differing shades of orange to bring about constructive change and help them nurture the courage needed to change and highlight their awareness to their inner potential.

Orange encourages togetherness, is adaptable and sharing. Orange lifts our spirits, freeing our emotions. It encourages us to feel happy and liberated. Orange casts a spotlight on our creative impulses, nurturing them and providing us with the energy to put them into action. It works powerfully on the emotional self, releasing feelings which may be deeply buried or hidden. Orange encourages self-confidence and enthusiasm to live our lives with joyful independence. It has a milder effect than red on the circulatory system and reproductive system, and it can act as an antidote to loneliness and depression. By its very nature orange will increase tolerance and release fear and aid tiredness. We feel good bathed in orange. In business orange has made its mark.

'Orange' the brand, one of the global brand icons created more than 20 years ago and first launched in 1994, quickly secured a place at the top of the league to become one of the world's most successful brands. Wolff Olins said, when they were employed by Orange to create a corporate identity, "We gave the network the name of a colour, not a techno name," and WCRS came up with the catchphrase we all know, love and remember... "The future's bright... the future's orange." The simplicity of the logo using the colour in combination with a catchphrase worked beautifully for Orange. Easy to remember and easy to associate, with simplicity being the key, they grasped and ran with a great idea and colour combination to their credit and long-running success. Orange is

the perfect choice for their product and time of launch. Colour emits subliminal messages continuously. Ask people today, twenty years later, and they will remember the unusual and distinct name of Orange the brand, the plain logo coloured orange and the tag line.

Orange has a loyal following; in colour terms it evokes feelings of sociability, sharing and encouraging togetherness with a unique, extra special identity and happiness vibe going on. It is perfect for telecommunications, retail and customer facing, and (as displayed by Hermés Paris) as a choice of beautiful bright orange for their gift boxes: "Beautiful gifts come in an orange box." EasyJet hold true to using orange for their corporate colour scheme with rising success and United Parcel Service of North America, branded as UPS, confidently use orange in their logo and branding. Choose right, and orange works. Choose the wrong shade and it leaves a lot to be desired. Sorry, Mary, but your team's choice of orange in store for dressing rooms does not work in my opinion, too harsh. A softer shade will make a stronger impact and extract a more favourable reaction from customers. Interestingly, the in-store dressing rooms have now closed.

Apple recently released an orange cover and discovered to their delight, and shortly after release, the popularity of the orange cover. They deduced from high sales that the orange cover is one of their greatest colour editions. For global business orange works.

Martin Lindstrom in his published book *Brand Sense* argues that one great thing about colour is that it contributes to the smash-ability of a brand. He suggests successful brands can be smashed like a glass bottle of Coca-Cola and consumers will still recognise the brand from its pieces. Coming from the colour perspective I agree with him.

Analysts and marketers see a trademark disaster looming on the horizon as more companies strive to trademark ownership of

their colour. They believe it prevents competitors using the same or similar colour for their product. Cadbury's are one of the latest causalities who tried recently to trademark their iconic purple and failed. Whispers abound orange coloured corporates considering the same route. We wait and see whether they will be successful where Cadbury's and others have failed. Like it or loathe it and regardless of personal taste, orange continues to make a mark – an indelible mark. Wherever it is used, orange is remembered and the multiple applications where orange is used are successful and create change.

Orange has the last laugh. Orange will always be remembered, regardless of liking the colour or not, and invoke deep feelings in the audience. The perfume 'Happy' entered the market as the first all-orange packaging for a perfume. It did create a stir, did its job, stood out on the shelf to be seen from afar. To date there are still fewer orange coloured businesses than any of the other colour choices available, yet gradually over recent years we see a number emerging to market. More than ever seen in the past they remind us of the positive aspects of orange; the joyful, carefree and togetherness aspect of caring orange shine brighter in austere times and tough markets. When the going gets tough, orange holds its own.

Sainsbury's has yet to discover how changing an iconic and easily recognised brand colour can have lasting effects, positive or negative, and I fear the latter. A respect for brave decisions in business is a given. Reinventing the wheel is foolish. Brand overhaul and colour change on the high street is a huge investment, and time will reveal whether prudent or ill advised. An overhaul of the website may be wise as orange does not work so well when it is overpowering. A journalist wrote an article on her experience of online shopping at four of the major supermarkets. Her comment after visiting Sainsbury's website is revealing, "… after 20 minutes and getting a headache (it's all that orange). The colour may look fun on plastic bags but embla-

zoned around all the pages it's decidedly off-putting."

Colour does affect our reactions, whether we want it to or not. The effect is subtle but very real nevertheless. It can help customers feel connected and a part of something. One of the easiest ways to sway a decision, attract an emotive response or alienate is through colour. Companies spend considerable money on changes. It can either go spectacularly well or dramatically wrong.

Yellow

Yellow has stood the test of time and we are seeing a new demand for yellow in the fashion industry. Yellow has had an unfair press because so many feel they cannot wear yellow. Yet the truth is, everyone can wear every colour if they choose the right shade for their skin type. In the wrong shade of skin type yellow will drain, and make skin appear sallow and grey in some cases. Take the lead by holding the garment up to your face in natural light. The easiest and best way to be sure the shade works for you is to take the garment to a window in the store where you can see instantly whether it is for you as flaws will be highlighted quickly. Yellow is a high recognition colour, used as a primary colour when communicating and identifying. Yellow helps designs stand out and appeal to a wider audience. Using a chosen colour consistently will maintain recognition, loyalty and trust. Many companies have chosen yellow as their main colour: Yellow Pages, CAT, Ferrari, DHL with red, Shell with red, Cats Protection with blue.

Shell is one of the world's most valuable companies and in 2013 Shell revenue was equal to 85% of the Netherlands' GDP. Founded in 1907 the original logo looked like a puffed Frisbee. The current logo, created years back, stands untouched and true today. In the 90s the company's environmental record was dented. Protestors criticized the handling of the proposed disposal of a platform in the North Sea. Despite government

support Shell was forced to reverse their decision: public pressure won the day. It is alleged that the controversy in the Niger Delta (where Shell owned pipelines that were old and corroding) resulted in oil spills killing off vegetation and fish. Amnesty International and Friends of the Earth Netherlands protested. Shell addressed the above problems and went on to become the sparkling success they are today. Yellow does not flinch or sidetrack from problems, it will address them head on and strive to resolve. In the main yellow companies stand firm and will not bow to adversity. Yellow Pages can join the small list of yellow companies highlighted in this section.

Cats Protection work tirelessly on behalf of all cats everywhere. With a band of dedicated volunteers who foster cats in their own home, they take in and care for any cat that needs their help. Their aim is to rehome cats to responsible new owners. They are dedicated to finding secure long-term happy homes for all cats who pass through the Cats Protection offices. They also assist people on low incomes with financial assistance to look after and to get their cats neutered. They are not funded: all running costs are raised through fundraising, donations and legacies. An example of the very best yellow company, walking their talk.

Yellow can be a motivating force for good, stimulating strategic planning. It affects mental abilities, gives hope, motivates and upstages. In the right circumstances we can relate to yellow on the shelf as a 'grab it quick' colour. In the USA the highest number of pencils sold are yellow in colour with Europe not far behind. Yellow will give a company a voice and a strong presence that builds over time when they work with the positive attributes of yellow. However, allow the negative traits of yellow a place and growth is doomed. Yellow companies need to be transparent in all dealings – a sure-fire way to work with the positive attributes. Yellow as a presentation colour is a no-go area, as yellow is extremely difficult to be seen by an audience on

a white background and may also appear fuzzy on a darker background. Used as an online colour for websites, like orange, less is more. The limey yellows, the citrus colours should be used sparingly on a website, if at all. Yellow is a confident, optimistic and creative colour and can be strong when used wisely. Highlighting where the old has to go and the new be brought in, I have always said nothing can hide in yellow's glare. IKEA has had great success with their yellow and blue branding. In the main, yellow can be picked out quickly as it catches the eye.

Many claims are made of yellow, some negative, such as: people argue more in yellow rooms, actors struggle to remember lines and opera singers throw tantrums, things go missing and minor accidents are blamed on yellow. Yet there is not a finer sight than the daffodils heralding spring, reminding us that the hues of each colour are of more importance than a generalised opinion of block colour. The colour yellow is said to be the most eye-catching colour. Yellow makes the eyes work harder than other colours and can be an irritant to the eye. Yet paradoxically, if a finer muted shade is chosen it can be very pleasing to the eye and will not cause eye strain. It is worth noting that the studies carried out chose a limited range of yellow hues, so cannot be conclusive.

In every culture yellow is associated with the sun and history tells us that cultures the world over hold the sun in the highest regard and have done so since records began and beyond, as ancient murals confirm. The recognition of the power and need of the sun's rays has always been recognised. They send a bright and positive message heralding the beginning of ongoing success. Yellow when placed correctly will portray all of these positive traits and more, and when not placed with considered care, yellow swiftly reminds us of the sun's capability to burn and to destroy. All good intentions are lost.

the 'green' bandwagon with their green labels. Seeing green may confuse, and it be assumed that it is a green product. It may be, I have no idea, as I have not researched this. If the marketing department of companies believe that by using green for packaging the consumer will regard it as a green product, that is a mistake. Consumers are becoming ever savvy. Staying with what works, rather than reinventing the wheel and making changes for change's sake, is wise in many cases. We know that colour and design are king, working with the two most important aspects, ensuring they are right for type and fit for purpose is more important than any trend. Otherwise we shall see many more new products drop by the roadside. Fashion and trends are fickle partners; colour and design are stable and secure.

Marks and Spencer have had two makeovers in the recent past, and both in my opinion leave a lot to be desired. I believe the second makeover was brought about purely because the first was so wrong. Black uniforms are not for their sector and I am still at a loss as to why they elected to lose their original safe, robust colour green. I find it tragic for Marks, a British shopping institution, replacing the best possible colour for their particular retail sector with a non-descript new logo and colour scheme selection. Next they added insult to injury by placing staff in all-black uniforms. For a section of the design and creative industries and in the right setting, black is a great colour. For Marks black is a 'no-go' and proved to be the case. In the second 'new' makeover they opted to discard the all-black uniforms and rearrange the shop floor layout. Sales still fell. New colours for the staff uniforms have been introduced, but I fear a little too late. It will take a few years of bad results and further shake-ups and changes, further colour and possibly shop floor changes, for them to steady themselves in terms of profitability and sales. Marks are in an enviable position compared to most retailers as their food side of the business is very strong and therefore excellent profits from food sales prop them up in the short term, but possibly may

London office block to comment and correct the interior and I was slightly taken aback at what I found. Every natural earth colour had been used in an attempt to create an earthy environment for the workers, however, the wrong colours had been chosen for the space. Green was in abundance in the wrong places, and green used in that placement and in that particular shade encourages people to escape! In the meeting I respectfully asked to relay my findings first, to share the effects I believed the staff were experiencing from the current décor. Within an hour my findings were confirmed by staff sickness, turnover and behaviour figures. The clients confirmed my findings and were relieved that I could rectify with the correct colour palette.

One of the latest trends is to bring the outside in. This can be interpreted as choosing green for décor. In the right circumstances, great, not so if the wrong shade of green is chosen. Take corporate interiors for example. Green encourages people to walk around the floor at every given opportunity, to go outside for a break more often and will encourage late returns from lunch, rather than heads down working achieving targets. Specific shades of green promote strong feelings of escapism. Where do we all crave to flee when we are feeling below par, under pressure and ache to get away for a break? Most usually the number one choice is to the green of the countryside, hence the popularity of city parks and open spaces for workers to relieve stress and feel they can breathe. Inner city green spaces have often been referred to as the lungs of the city. My team and I carried out a survey in London, and the results confirmed the need for workers to spend time outside in nature and the green. With careful questioning the survey results confirmed the number one reason workers chose to go to the park at lunchtime was so they could breathe! They each felt they were so stressed and uptight that it had affected their breathing. However, when at the park and surrounded by nature's green they felt their bodies relax. Many spoke about being able to breathe better,

some adding that they sighed the moment they saw the green open spaces prior to relaxing. Specific green shades incite feelings of escapism in all of us to a greater or lesser degree dependent on our inner feelings and levels of despair driven by our coping mechanisms.

Including the Victorians' experience with green, we can see the many contradictions and complexities of colour. Colour affects human behaviour, health and well-being as each colour initiates an emotional, physical and mental response. Every level of our being is affected by colour. Applying the carefully considered principles of colour to interiors can have far-reaching long-term benefits.

Green as with all spectral colours holds within it 'dependent on shade and hue' many meanings. Amongst them are the basic well known characteristics such as regulating, harmonising, and balancing of a positive and peaceful colour. It is restful to the eyes, calming to the heart. Green activates the bringing forth of new ideas and prosperity. Yet, if you considered giving a gift of a green hat to a Chinese chap you would cause offence as it is a clear signal that his wife had been unfaithful.

Colouring a call centre in a particular shade of green will not promote the business. Rather it may bring about a decline and depressive tendencies in staff, higher than usual staff turnover, lack of motivation (by the finding of any excuse not to work) and to leave their desks, spend time in the loo, at the copier, vending machine and chatting to colleagues. In Malaysia green is unlucky and foretells illness and disease. Green is viewed with suspicion and bad luck. Yet in Ireland green holds a special place in the hearts of the people, the luck of the Irish is linked with green, the little green men, the four-leaf clover. It's their favourite colour and the colour of the traditional dancing dress and it is in the design of the flag.

Writings report from Egypt that there is a particular deep green, almost emerald, that represents positive fertility, and the

lighter lime green they saw as unlucky. In the West for a number of years apple green has been associated with fresh new ideas, yet that meaning has been found to be flawed, following a number of mistakes in the use of apple green. The desired vibrant 'new feel' sunk. In the West we associate green with balance, safety and monetary gain and it is seen in medical settings and surgery. Most first aid kits are green, surgeons operate in green gowns and hospitals in Europe use green widely on the wards alongside shades of blue.

The earth, sea and sky colour palette is superb when each shade is carefully chosen and for the right environment when supported by warmer colours. The hospital environment is not the exclusive use for such a palette, and after viewing some of the hospitals in question, sadly the shades of colour used are not right, and some not choosing the correct colour palette at all for the building. Colour is a minefield, a complex yet delightful area to work; colour works beautifully when colour is fit for purpose.

Sky Blue

The Smiths Group have been listed on the London Stock Exchange for more than a century. The ultimate communicating group, Smiths evolved from clocks and watches through automotive and aerospace development into a world leader in advanced technologies. It has successfully reinvented itself in line with market opportunities. Their products touch the lives of millions of people.

Kingfisher Group is a typical sky blue company. Major ongoing expansion by one of Europe's biggest retail conglomerates continues. Successful and determined, the brand communicates their values well. Kingfisher is included in two of the main socially responsible investment indexes – the FTSE 4 Good and the Dow Jones Sustainability Index.

Blue the most popular colour globally is most associated with calm, peace, restfulness and sleep. Blue can envelop us with safe

feelings and we can sometimes drift off under blue's influence, and conversely be kept wide-awake, as found by insomniacs who react both positively and negatively to blue's energy. However, we are told through advertising that blue is the colour for rest and sleep. In some cases, yes, in others no. The hue will dictate the outcome. Revealing, a deep knowledge and understanding of colour is vital when delivering colour consultancy. Blue has the capacity to swirl us into complete chaos, incapable of making a decision or in taking action, unable to decide on what direction to take. Lack of action can result in missed deadlines, yet many alternative shades of deeper blue uplift, inspire and support. So easily forgotten and not often taught, blue can descend us into a melancholy state when used inappropriately and can powerfully disenchant shoppers. One of the most formidable colours when used incorrectly.

The colour is associated with winter blues and Monday blues. Monday is the day when most heart attacks happen. 'Blue collar workers', 'blue jokes', 'out of the blue', 'blue with cold', 'blue elephant', 'true blue', 'blue ribbon' and 'blue blood'. It's a real mishmash, and that sums up blue. On a personal note, 'moody blue', if anyone is to be a moody git, blue wins the prize. Only a blue can do mood swings spectacularly well, and second to blue is violet. When you do your karmagraph see where blue is on your chart. The chapter, Colour Numerology – The Karmagraph, will reveal all the details. Loyal and true is a blue personality type, and oh so sensitive.

Painting a skirting board in dark blue will ensure that no litter is thrown on to the floor in that room. Painted on the ceiling it will depress everyone, and on one wall in a light room will define that space as the no-go area for all. On two walls it will cause division of the people who share that room: interesting but true. Melancholy and moody, desperate and worried, blue is the bipolar colour of the spectrum: on one hand it is light, positive and energised; on the other, downhearted creating feelings of

'nobody cares'.

Nationwide, during one of their makeovers, used a combination of blue with the most ghastly blackish purple. Staff using the small meeting rooms felt stifled and uncomfortable, suffering headaches and pressure on the top of their heads. The rooms were windowless with one main wall facing them painted in purple. Possibly a saving grace was not having windows as some may have jumped! Halifax went down a similar route to Abbey National. Abbey made the fatal error of colouring each branch a different colour, confusing the customer and losing much of their loyal customer base. The Halifax makeover is different to Abbey's as they have kept their distinct blue branding externally, each branch identical on the outside. Inside the branch a number of changes took place, such as different coloured chairs, uniform and layout. The colourful décor, chairs and uniforms have been discarded for a more appropriate corporate look, and I believe another makeover is in the wings. Ford, GE, Hewlett-Packard, Facebook and Twitter are a small selection of popular and successful blue companies.

Indigo

RNLI is the charity that saves lives at sea. Staffed mainly by dedicated volunteers, they provide a 24-hour on-call lifeboat search and rescue service around the UK and Ireland. The charity is committed to saving lives. They uphold the ideals of indigo, working for the greater good of all. Lifeboats of the RNLI – bright clear indigo branding highlighted with red, perfect for their name and encompasses all that they do and offer. Whereas indigo with specific dark grey and black hues does not take prisoners quietly, their decisive intent makes clear from the outset what their aims are. It can be ruthless and focused purely on the end goal, regardless of the human cost.

The London Stock Exchange is indigo and grey (not the specific grey as explained above). LSE have chosen the right grey

for their product, money making and exchange. Theirs is a very serious money institution with one clear goal in mind – to increase the amount in the coffers. They have succeeded and continue to succeed.

Friends Provident Group founded in 1832 as a mutual friendly society for the Quakers, was demutualised in 2001 to become a public listed company and ceased all links to the Quakers at that point. Friends Provident was the first financial organisation in the UK to offer an ethical investment fund called the Stewardship Fund, aligning itself with and displaying the best of indigo attributes, high ideals and service. Their products benefit millions of people.

In the sixties we saw an explosion of free love, hippies, conservation, nature lovers and peace rallies. It is the era best known for the rise in popularity of indigo denims. Levi's, one of the major indigo companies, cashed in on the denim phase, and true to form, the indigo company has seen out many fashion crazes and fads to hold a secure place in the hearts of both men and women from that era up to the youngsters of today. Everyone at some time in their life has worn denim.

Indigo is a 'stayer', goes where angels fear to tread, takes calculated risks and usually comes up smiling. If after failing once, maybe twice, they will return with full throttle to surprise even their most ardent fan base. Indigo is the dark warrior, brimming with ideas and forward-thinking idealistic plans to benefit everyone. Indigo is a deep thinker, sharing thoughts with a trusted few. Indigo companies are less represented than other colours, yet more successful in terms of comparing percentages.

I looked at the effect a coloured computer has on workers. Different colours impact positively and give support to differing work-related ailments, such as the winter blues. The study investigated the possibility of colour alleviating workplace ailments through the use of coloured computers compared to the beige, mushroom coloured computers in use, and ways to best use

colour to achieve results, as part of an energetic and motivating workplace environment. The study concluded that specific colours for computers is the way forward and contributed to the sudden and meteoric rise of the vast range of coloured computers available today. At the time study results that would stand up to scrutiny were needed to persuade manufacturers to veer away from beige. Why change the colour when they were selling millions worldwide? I argued the need to strike a balance between keeping up with technology while keeping workers content and happy, and offering a solution that can help them work at optimum level.

For the majority, the working day involves sitting in front of a computer, therefore the colour of a computer can have positive effects on users. It is important that employers are aware that the colour of computers can have therapeutic effect on their staff. Computers are directly in our line of vision and therefore affect us on a subconscious level as we concentrate on the screen. The colour will affect the user. Once the computer is fired up, a vast array of colours are constantly impacting, and moving, whereas the screen colour is affecting the user constantly in the background, like the hum of a bee. It is continuous, therefore will have more impact than colours coming and going across the screen. The subconscious is being gently affected by the hum. The environment will also have an effect on mood and performance as discussed, highlighting the need for a professional colour survey to reveal a colour scheme for a harmonious workplace. The ceiling, wall and lighting colour is just the beginning.

Purple

The Purple Heart associates the colour with bravery, and in the branding of luxury goods we have seen all the hues of purple used at some time over the years. A paradoxical colour, one of upliftment and melancholy, sedation and addiction. The careful use of violet/purple must be respected. A purple dye was made

from a rare Mediterranean snail, hence cloth dyed in purple was expensive, rare to find and could only be afforded by very wealthy families, royalty and the church.

Historically purple is seen as a royal colour and can be traced back to the Emperor of Rome: Julius Caesar and Augustus decreed that only the Emperor may wear purple. When Nero became Emperor, the wearing of purple and even the sale of purple was punishable by death. By the time Alexander Severus, Emperor of Rome from 222 to 235AD, all the workers who made imperial purple worked for the Emperor. Years later magistrates were allowed to wear togas decorated with purple ribbons. Unfortunately, purple can exude feelings of pomposity, superiority and conceitedness. Purple/violet are masters of their own ego, when chosen appropriately.

Cadbury's iconic purple is recognised, known and loved worldwide. They did try to secure the colour as their own but were unsuccessful in their bid. A precedent was therefore not set for other companies to follow. I doubt that they have to fear securing the colour as their own. In the consumer's mind purple is Cadbury's. Rival manufacturers have tried to copy the colour in the hope people will be too busy to check the brand as they pluck goods from the shelf, with some coming too close for comfort by falling just short of identical branding.

Disney Paris chose purple when they first opened; purple was chosen as the main colour for advertising the opening and ongoing marketing, with no consultation or consideration other than the top gun in the company at the time chose the colour purple because it was his favourite colour. Many thousands were spent on marketing, advertising and printing to no avail; major losses were realised. Purple is absolutely the wrong colour for them. Sadly, major losses proved the point. Once realised, they quickly sought advice, and moved on to a change of colour palette and to success. Their reputation was dented for a few years as they strove to stabilise and overcome a very costly

mistake. We all remember the first years as Disney worked valiantly to attract customers to their European set. AstraZeneca is another purple company, operating in health care, with the NHS as its primary customer. Fourteen per cent of their NHS budget is spent on diabetes. With an expectation of cancer rates in the UK to rise by 50% in the next ten to fifteen years, the question must be asked, why?

Purple is either adored or shunned and one of the most paradoxical colours of the spectrum. Orange comes a close second, another 'love me' or 'hate me' colour. The range of attributes/associations for purple is wide, from sophistication to melancholy. Sloppy to perfection and nostalgic to clearing the decks and starting from scratch. It can appear a luxurious colour in the right hue, or cheap and tacky. In the right setting and shade, a happy uplifting colour that oozes charm and restfulness, bringing with it a lightness of spirit and upliftment of mood. When not chosen with care, purple is the heaviest and most depressing of colours. Paradox is the key word with purple.

A purple haze best describes the depressive side to purple, alcoholics, overeaters, comfort eaters, drug addicts; in fact anyone with an addiction should not use purple in décor or wear purple. I was surprised at the time when purple walls were used as a main feature wall in each meeting room in Nationwide branches throughout the UK. Airless, small windowless rooms with the main wall to look at in purple... please.

White

Can be difficult to use in large interiors, yet some companies have used white to their best advantage. It works beautifully. Others have tried and failed, proving once more that one colour does not suit all. There is a correct colour palette for every home product and business: the key is finding what works for you. When we enter a space we first see the people, then the human face, then living plants. Rarely do we notice the colours of the décor, nor the

flooring, yet the whole time we spend in that space the colours are impacting and affecting us from the moment we walk in, until we leave.

Pink

I must finish this chapter with a few words on pink. For too long pink has been associated with being light, fluffy, loving and kind etc. Pink is all that and more. Known as a loving and caring colour when operating on the positive, what is not so well known nor written about, however, is the darker side of pink. A pink personality in the negative is the bitch of the spectrum. Pink can bring out the crafty, manipulative side of people and especially in an all-pink environment. Too much pink can support lack of motivation. A great colour for letting go of emotions – especially those associated with hormonal issues – it also helps with relationship issues such as codependency.

Chapter 4

Business

The only man I know who behaves sensibly is my tailor. He takes my measurements anew each time he sees me. The rest go on with their old measurements and expect me to fit them.
George Bernard Shaw

Future trend in business as the economic situation becomes ever more fragile and vulnerable is social responsibility and creativity. Business principles based on values committed to social responsibility by encouraging employees to get involved in community activities and to think creatively about their business insights and goals. Key words: philanthropic care, empathy, fair and honest in dealings and pricings, transparency, integrity and giving back to their community. Huge changes are on the horizon for us all.

Colour Associations

Colour is an integral part of life. By using the phrase 'human being' we are acknowledging that we are made of colour. The word hue means colour. You can't avoid colour in life, it is everywhere. The more we embrace it and allow it to fill our lives, the more we will come to understand how it affects us and helps us. It is there to give and to sustain life, bring balance and well-being. It is incredibly powerful and transformational, especially regarding memory links.

Why do we care about the concept of colour association? How can this awareness help us in business? Colour association can be historical, national, cultural, personal and linguistic, but one thing that we can't deny is that it is also visual, I have done some colour work with blind people (see my first best-selling colour book, *Colours of the Soul*). Colour has impact and, for that reason,

the way we use it can create either the right blend for the intended use or not. One of the known ways colour is associated with a country is through its national flag. The most popular colour in a flag is red. Almost eighty per cent of national flags contain red and the least used colour is purple. The most popular tricolours are red, white and blue.

Colour associations for each culture are interesting to note and important for business. We may be familiar with our own culture symbolism for a given colour and know how people will interpret it here, but if that colour held a different meaning in another country or culture, there is high risk of giving offence. To know the deeper meaning of colour is an effective way to show that you have learnt something about their heritage. It is a way to show courtesy and respect. It is a means to bridge the difference between people and cultures, to show willingness and to meet them halfway. One clear example of this was on the Queen's State Visit to Ireland where she wore green (a highly significant colour worn as a sign of respect and intention for the future).

With more and more business conducted beyond national and continental boundaries, this understanding can make the difference between you and a competitor who doesn't appreciate the importance of cultural diversity.

An example is red:

- Western – Energy, passion, warning, danger, excitement
- Eastern – Good fortune, fire, prosperity, worn by brides
- China – Ceremonial, vitality, happiness, good fortune
- India – Power, opulence, fear, fire, fertility
- Thailand – Fire, Sunday day of rest, procreation
- Japan – Danger, frustration, life, blood, anger, death
- Cherokee – Honour, triumph, success, virility
- South Africa – Mourning, life blood, death
- Russia – Communism, marriage ceremonies, beauty, Bolsheviks

- Nigeria – Worn by Chiefs, ceremonial colour of the highest order
- Aborigines – The land and earth colour, from the red dust, ceremonial colour
- Christian – Love, passion, sacrifice, blood, death, birth
- Hebrew – Sacrifice, sin, death, blood

And here we were just thinking colours were colours...

Linguistic Colour Associations

Red – Red herring, red rag to a bull, red sky at night, in the red, shown the red card, see red, red tape, see the red light, paint the town red, roll out the red carpet, scarlet woman, red-blooded man, red as a tomato, left red-faced, catch the red-eye.

Yellow – Yellow bellied, yellow streak, yellow journalism (using strong language or extreme verbiage to sway opinion).

Brown – Browned off, brown nose (to suck up).

Green – Be green, green with envy, green-eyed monster, on the green, get the green light, green around the gills, grass is always greener, green belt, green fingered.

Blue – Blue-blooded, feeling blue, appear/happen out of the blue, blue-eyed boy, bolt from the blue, blue moon, blue in the face, blue pencil something (censor), men/boys in blue, blue brigade, blue collar worker, Monday blues.

Pink – Tickled pink, pink and fluffy, girlie pink.

Purple – Purple prose (writing that is more formal than it need be).

Black – Something is/isn't black and white, black out, black sheep, in the black, blacken/darken a doorstep, black hearted, black market, blacklisted, black and blue, black look, black dog (depression).

White – White as a sheet, white elephant, white as a ghost, white lie, white collar worker, white as snow, white knuckle, white wash, pearly whites.

Grey – Grey area, grey matter, looking grey, grey cloud hanging over.

Silver – Born with a silver spoon, every cloud has a silver lining, silver tongued, silver screen, silver platter.

Psychology of Complementary Colours – Keywords
- Red – Sky Blue
 - Active – passive, hot – cool, loud – quiet, physical – spiritual
- Orange – Indigo
 - Warm – discreet, modest – noticeable, innocence – peace
- Yellow – Violet
 - Realistic – showy, real – ideal, hope – magical
- Green – Magenta
 - Natural – noble, earthy – extraordinary, precise – sensitive

This small sample shows the importance of being colour savvy in international trade, and I haven't even scratched the surface!

Days of the Week for Business – Monday to Sunday
Each day has its own particular colour. The ancients believed and practised that each day of the week is a particular colour day. They celebrated this fact by wearing something of the colour of the day. Today we associate the days of the week with the same colours as the ancients, with the information being passed down through the ages through first via word of mouth and then via the written word. Her Majesty the Queen wore green on a Friday recently and can be seen wearing the appropriate colours of the day on many of her visits to counties around the country. Coincidence?

Bringing the practice forward with some tweaks to meet modern day demands, I have listed a few suggestions that fit with the colour energy of the day.

Monday – Violet – Consider what it is you want to achieve in the forthcoming week – plan your strategy. It is a day to connect with inspirational ideas and projects, clear away outgrown thoughts and patterns that no longer suit. Usher in the energy of inspiration and integrity.

Tuesday – Red – Now put thoughts and plans in action. A day to get moving and put into action projects that you feel most passionately about. Today will strengthen your resolve and increase your levels of confidence. Spend a minute focusing on the centre of a red circle, take three deep and slow breaths in through your nose to usher in the energy of confidence and passion.

Wednesday – Yellow – Oversee everything in place and being actioned. Everyone clear on what is expected of them to best fulfil the plan. A day to concentrate on ideas, blow away any feelings of melancholy, raise your self-esteem and to look on the bright side of life ushering in the energy of knowledge and empowerment.

Thursday – Sky Blue – The end of the week is nigh. Re-communicate your strategy to all concerned early morning. Ensure that everyone is supported and confident that they will complete their task on time; if not offer support today. It's a day to express and to communicate your creative self. Slow down and return to a peaceful state of being. Spend a minute focusing on the centre of a sky blue circle and take three breaths and usher in the energy of calm and creative communication.

Friday – Green – Day to check and go over finer details, any corrections are to finalised and carried out on a green day. A day to come back to your centre, show compassion to others, begin new projects and bring in new growth into every area of your life. Spend a minute focusing on the centre of a green circle to usher in the energy of change and rejuvenation.

Saturday – Indigo – Relax, enjoy hobbies, activities and get outside to discover the natural world. A day to tune into your

inner self, inner knowing and intuition. Tap into your happiness centre. What makes you happy and feel fulfilled? What lights your fire? Makes your world rock? Go find it, buddy.

Sunday – Orange – Sociable, family, gatherings, to rest, recharge batteries and enjoy friends and loved ones' company: To eat, drink and be merry. It's a day to recognise the joy of life and spend time releasing your creative potential, release emotions, and relax and re-energise in readiness for the working week ahead. The day of sociability, vitality, creativity and being with loved ones.

Corporate Blues

With stress being a major part of today's working environment, we need leaders and heads of industry to test out colourful environments. The result and impact is measurable. Stress levels will reduce dramatically and productivity will increase as the workforce is happier. Coupled with introducing regular creative training sessions that are both fun and productive, to benefit everyone, to help people rise to everyday challenges and strategic changes in a healthy and productive way. I understand the issues faced by people and organisations in this very fast-paced and competitive world.

Workplace stress is on the increase, triggered by anxiety, depression and addictions. These issues are cited as the top reasons for stress at work. Large demands from companies on city professionals is causing overload with stress-related illnesses peaking at never before seen levels, attributed to overwork and long hours.

The decisions made at the top affect us all; stress is an area to resolve and in the shortest possible time. The financial institutions are being hit the hardest; legal, second, then accountancy, with workers doing regular night working sessions in their battle to get on top of the workload. There are signs of strain at senior management, with many battling some form of mental health

issue. The attitude of employers needs to change, to help address and prevent the increase of mental health problems and stress in the workplace.

With some illnesses taking people out of work from between 2–4 months, nobody wins, therefore a resolution to solve the problem is imperative and must come from the top. Immediate colour measures are available that can be implemented to ease the stresses felt by so many. Occasionally support is needed to rise above negative feelings, which need to be nipped in the bud and turned around. I recommend the following: these suggestions may help with corporate blues, which we all experience more often than is spoken about. Here are some of my colour suggestions that can be carried out discreetly at work and in your own time.

Mental Fatigue

Our mind can become tired and confused when we are under pressure. Regain your focus by wearing indigo/navy blue. Indigo/navy reduces blood pressure, keeps you calm, reduces sweating and calms the higher mind. It nourishes on a mental level, giving you clarity of thought, makes things appear clear once more. Find something in indigo/navy that you can place on your desk to look at during the day: it will help focus your mind. Sip still water from an indigo glass bottle throughout the day as a regular internal top-up.

Uninspired

Get up and move: Take an early lunch. Go for a brisk walk or jog if you can. Violet is the colour of inspiration and creativity. When you feel unmotivated and apathetic your energy is stagnating in your centres and needs you to move to make the shift. Find something in violet to look at throughout the working day, which will help to recharge you. Eat an aubergine-based meal. Suck violet drops. Have a drink of Ribena or Vimto.

Anger Management

To avoid confrontation, literally think pink. This non-confrontation colour, which helps the muscles to relax, encouraging feelings of forgiveness and calm, can help to disperse anger and negativity, road rage and office rage. It helps to reduce blood pressure and takes the heat out of a situation. When you feel so angry you could burst, take yourself away from the situation and take a few moments to regain composure. Find a quiet spot to sit quietly and imagine yourself in a pink bubble. Walk in greenery. Find a park in which to stroll for fifteen minutes. Buy a bag of marshmallows, line up the pink ones to focus on, eat some if you so wish or a pomegranate for a healthier option. Drink a pink drink, a strawberry smoothie with almond milk or a milkshake.

Confidence Crisis

If you feel in need of some self-belief wear something in my favourite shade, magenta. Magenta is uplifting, inspiring and fearless. It commands respect and releases you from past conditioning, making a fabulous colour to wear to boost your confidence. The Chakra Silk Collection that I designed (see Products) is a collection of 'new' coloured scarves (pashminas) intended to be worn daily in a choice of shades, the perfect everyday fashion accessory. Drape one across your body or around your neck and let it flow around yourself, so that you can benefit from the colour energy; also look at the colour during the day and breathe it in.

Monday Blues

You need orange. Another popular 'June-ism', one of my catchphrases: "Orange is the Humpty Dumpty colour of the spectrum." It is the colour that is known to put everything back together again emotionally. As a great emotional support, it is the colour of happiness, vitality and laughter, which research has shown is a tremendous mood booster. Give yourself the jolt you

need and kick-start upwards by thinking 'orange'. Drink a glass of orange juice, eat citrus fruits, keep an orange in your sight at all times, glance at it regularly and take deep orange breaths.

Sleepless Nights

Keep the bedroom uncluttered, especially bedside tables, allow no patterned wallpapers or carpets unless the room is very large. Keep lighting soft and dim in bedside lamps with bedheads away from the wall. This allows air to circulate and the electrical energy passing through the walls serving plug points to prevent adverse effect. The bedroom must be an oasis of calm, to encourage a good night's sleep. Keep fresh air circulating, maybe a window open ajar through the night. If there is a TV in the bedroom keep it at least eight feet away from the bed. The *Colours of the Soul* CD is excellent for insomnia and studies have proven the many health benefits from using the CD regularly. Snorers are another group to benefit from regular listening. I have my own theories for modern day insomnia; in my next book I go into this in detail.

Personal Attributes of Colour

Another overview of the colours for your information and this time on a personal level.

Red – Red expresses passion, danger, anger, joy and celebration. Red boosts our circulation, raises blood pressure and gets the heart pumping faster. The fiery heated red increases our sexual drive and sexual pleasure. It gives us determination and will to move forward. Red is the colour of our physical self and our base instinct, our grounding to the earth for everyday reality, giving us a sense of security. This is the colour of action, of warmth, vigour, strength, courage, vitality, spontaneity, and physical energy. Negative reds are domineering, angry, defensive and sexually deviant, controlling and manipulative.

Orange – Orange helps us to bring up, accept and release deep

long-standing hurts. It has a milder effect than red but it's still beneficial to the circulatory and reproductive systems. Its ability to relieve muscular pain makes it a good colour choice to erase period pain and other bodily cramps. It can aid the digestive system, bring relief for asthma sufferers and be a useful colour for combating depression, loneliness and lethargy. Orange is the colour of health, vitality, lifting of spirits, freeing our emotions and encouraging us to feel liberated and happy. Orange helps us to feel exuberant, sensual, playful and sporty. It increases our self-confidence and enthusiasm for life. It highlights our creative impulses and provides us with the energy to put them into action. Negative orange can be domineering, aggressive, negative, insensitive, self-centred, impatient, lazy, superficial, overindulgent, codependent and unkind.

Yellow – Yellow is the colour of the self and the ego, it increases our feelings of self-worth, self-confidence and benefits our social side. It is an energiser relieving exhaustion, boosting digestion and speeding up the elimination of waste products and toxins from the body. Yellow can assist in the treatment of arthritis, diabetes, constipation, skin problems and nervous exhaustion. Yellow is associated with the left brain and stimu-lates our intellect giving us a rational, clear focused outlook. This strengthens our mind and ability to absorb knowledge making it a useful colour for study, revision and retaining. Negative yellows are opinionated, restless, critical, argumentative, evasive and envious.

Green – Green is the great harmoniser, the relaxer: It creates balance in our lives on all levels and brings us back to our natural balanced centre. Greens are generous, compassionate and kind, not only towards themselves but also for others in the world around them. Green regulates the blood pressure, relaxes the heart, calms the whole physical and emotional body and the nervous system. Negative green can be jealous, bitter, envious, very mean and inflexible.

Sky Blue – Sky blue relates to the throat area and thyroid gland therefore encouraging communication helping with public speaking and easing of sore throat. Sky blue is serene, sincere, faithful, fluent, introspective and contemplative. It induces feelings of peace and trust and has a cooling and calming effect on our senses. Sky blue acts as an anti-inflammatory antiseptic. It relieves stings, itchiness and rashes. It cools, calms and reduces fevers and aids the respiratory system. The gateway between physical and spiritual, helps us to realise our soul's purpose and express our creative ideas. Negative sky blue can be withdrawn, closed, cold, manipulative, unfaithful, untrustworthy and non-communicative.

Indigo – Indigo has a calming, peaceful effect on the body, helping with insomnia, night sweats, and hot flushes and rashes. Its cooling calming effect can bring relief to eczema, breathing, boils, ulcers, chicken pox and shingles. Indigo is an intuitive inspired link to the higher mind, which expands our consciousness encouraging us to view higher spiritual dimensions and gain valuable insight into our everyday lives. Indigo is a good aid for meditation. It purifies the mind as well as the body, helping us release fears and calming of the mind. Negative indigo can be deluded, arrogant, fearful, isolated and over idealistic.

Violet – Violet is spiritual, humble, noble and dignified. The colour is transcendent of mind over matter, the higher self over the lower. It is the colour of divine inspiration. Violet links to our divine will and spiritual quest. It encourages us to aspire to our highest ideals and unifies body and mind with spirit, restoring peace (which often escapes us in this busy world). Violet purifies the blood; benefits skin problems, nervous headaches, eye and ear disorders and sore gums. It restores calmness to the body and mind easing headaches and migraines. Negative violet can be a perfectionist, self-destructive, fanatical, depressive, serious, doubting and alienated.

As part of my work I create bespoke interactive colour practicals for each business type to support and create an improved winning team that is inspired, yet focused. Together they see a vision that they never saw before, as a succinct united creative team and a powerhouse of ideas. It is a craft to inspire a team to think more creatively about their business and the possibilities that can be achieved through colour and exercises. The aim is to bridge the gap between creativity and commerce achieved by the clever use of colour techniques. We know business growth and expansion is vital in global markets. Colour helps achieve that. The challenge for business today is not to change it, but to transform it.

As adults we think we are not creative, yet most children think they are. Young children believe that they are very creative. Gradually, as they go through the education system (up to and including eleven to thirteen year olds), that belief-set is replaced with adult thinking, now filling them with self-doubt about their creative abilities. We need to encourage people to colour outside the lines, to recognise and support engagement in more creativity for everyone, especially in business. Original ideas spring from the imagination when we are creative. Interestingly, strong left brain intellectuals/academics say it is too hard, and they just don't know how to be creative, yet it is a hugely important aspect of the human mind.

We don't understand enough of what it is and how it happens, yet it does happen and is the most powerful and positive aspect of ourselves that needs a release and outlet in our personal life and career and will transform and benefit every business. To be creative is essential. Everyone has creative ability and I believe and have found over the years working with colour, in my own unique and creative way, that colour is the key to personal and business achievement. An understanding of the impact of colour unlocks creativity in us all. A natural ability lies dormant in most

adults. Once released, clear creative thinking is the result, an ability to see many solutions to problems. We need to do things differently and to think differently. With creativity and colour at the core of change. Studies reveal children from two to nine are most creative, then a decline sets in between nine and eleven as the academic side of education takes precedence.

Creativity is at the centre of innovation and to be creative is essential in business, to generate original ideas and concepts that have value. It must be remembered that original thinkers break new ground. We become more creative by working with colour in specific ways. I shall share some of my exclusive techniques with you. The natural world is beautiful and inspiring. The divine can be found in nature and much of the inspiration for my work comes from the natural world that surrounds us all.

Isaac Newton, when asked how he could see so far into the Cosmos, replied he could only do so because he stood on the shoulders of giants. At this time in our history when we seem to know so much, the sad realisation is that we know so little. We need to be open to the wisdom of those who have journeyed long before us. People do not usually think creatively about their business in the workplace setting. They need to be taken out, be released and guided through a carefully considered creative process that will release their creativity and in turn their potential.

Colour is the most powerful form of communication.
June McLeod

We know that image language develops before verbal language, therefore the practicals have been invented with this and many more facets in mind. When working with groups and analysing the choice of colours each participant has chosen a particular piece of practical work. I am made fully aware of the individual's strengths and weaknesses at that time. No one can bluff their way

through. They say a little knowledge is dangerous and never more so than with colour. With some degree of colour understanding, a participant may try to choose what they feel to be the right colours to try to fool the 'reader'. Fortunately, expertise overrides. I take the whole picture into account plus signs I read from the individual themselves. Colour and placement reveal all. No one can hide from themselves, colour shines the spotlight every time and reveals all.

The analysis encourages barriers to come down whilst preparing participants to think about new ways of doing things, to work together as a cohesive team and produce winning business growth opportunities. It is a constant building process from the start that buds during the session. Interactive, creative, colourful and fun. The deeper we search, the simpler and more balanced we discover the world to be, and the more we discover, the more we reconcile with ancient wisdom. Do you want your business to be a shade brighter, to obtain results, to increase profits? Do you want motivated and loyal staff? The correct colours will bring in balance and harmony, will motivate, innovate, inspire and accelerate success. When we first view a person, product or environment it takes just a few seconds to make a subconscious judgment and that assessment is based on colour alone.

The study of the effect that colour has on human behaviour, particularly the natural instinctive feelings that each colour evokes, is ongoing. Colour psychology reveals how each colour creates a collective emotional, mental and physical response in people as a whole. Red for example will create feelings of warmth, movement, ambition, determination and also frustration, anger, lust and passion, bringing to mind sayings that have been passed down through the ages, such a 'it was like holding up a red rag to a bull'.

Cultures from around the world may differ in their use of colour symbolism and psychology. For example: in South Asian

culture it is common for a bride to marry wearing red whereas in Western culture a bride traditionally wears white, the colour of death in some cultures. In colour association and meaning we read red as a colour of attention seeking, passion and flamboyance. To suggest some of our accepted Western meanings to the Eastern mindset can be insulting and highlights a scant knowledge of local custom, colour and a lack of respect for different cultures and religions.

With such a vast and diverse subject, one thing can be promised, colour will take you on one of your greatest learning journeys. We are surrounded by unique exciting colours and colour combinations that nature provides on earth, in the skies and under the oceans. By thinking out of the box, by colouring out of the lines, by teaching and encouraging the student to think more broadly and differently we can create original and informed colour thinkers.

I have never wished to confine colour by placing colours into specific seasons; rather I place colours into colour bands, for example looking at reds as a whole (all shades, hues and tones). I do, however, take inspiration from the vast and wonderful array of colour combinations provided by the natural world. These encourage me to experiment and use colour in different ways and combinations. My work can provoke debate whilst encouraging thinking out of the box. Colour is my passion and life's work. I live and breathe colour and my aim is, and always has been, to deliver colour in ways that are new and exciting to move colour thinking forward. I encourage the student to continually question themselves and colour to ensure a more knowledgeable, rounded approach to colour.

Millions are spent daily creating and perfecting the marketing and launch of new products, new brands and new business. The most fundamental aspect to perfect the brief is colour, impacting global business and international trade. It is only of late that we have begun to accept and understand the vital role colour plays

in all areas of our lives. A colour expert needs to be brought in at conception and design stage. Some suggest in today's stressful climate with tough markets and time at a premium that we haven't got time to consider colour choices. I do not agree. I point out that colour is the reason we are hurriedly running around plucking goods off the shelf, or off the rail, enter a shop or walk past it. It will always be the number one reason why we make the business and retail choices that we do, and stands unsurpassed in its ability to communicate and sell. Surely the two one-hundredths of a second proven theory to register red goes a long way to persuading non-believers. It takes twenty-five one-hundredths of a second to register three words of this text, yet only two one-hundredths of a second to register red. I have always encouraged 'colour outside the lines' – it is a 'June-ism', one of my many catchphrases used in training sessions. Part of business is risk taking, yet traditional colour combos are set in place with not much risk taking involved. I actively encourage experimentation when it can cause no harm or add to problems.

Wherever I work I bring a fresh approach by encouraging the use of nature's palette. In the interior design field, bringing the outside in has long been accepted in residential interiors with a few businesses breaking the mould. But in the main, a staid and what is viewed as solid colour scheme is adhered to. Some even suggest in today's climate when time is at a premium that there is no time to consider or to take 'a chance' on a new colour scheme. I disagree. Everything must evolve and change, and the colour is the sole reason you are plucking goods off the shelf at lunchtime. Colour is the number one reason consumers make their choices.

Colour is an area that demands perfection, a master in its craft. A colour can only be as good as the knowledge and under-standing of the person advising on the colour scheme. One shade out will leave a whole project lacking and the business unfairly struggling to understand why colour isn't working for their company. In the hands of a professional colour equals success; in

the hands of an inexperienced colour professional it equates to disappointment and sadly will affect the positive promotion of colour use in business. Colour application can only be as perfect as the level of knowledge of the person employed to carry out the colour work. Every industry accepts to some extent that colour choice is important, yet there is the need for greater acceptance of correct colour choice in business to promote success.

The way colour is used has evolved internationally. Colour does not follow a 'one size fits all' mentality. The colour choice and meaning change, dependent on the business, the environment, the placement, culture and the country. The proven skills of an international colour professional are essential in business for global success in today's international market and never more so than today, as world trading becomes standard practice for survival in a tough and shrinking market. Colour provides the positive support to all that business offers or just as easily can alienate. The importance of colour is accepted with colour weaved into our language. We use colour meaning without thinking: yellow belly, red and angry, green with envy. In the UK we accept feeling blue but in Germany (to be blue) is to be inebriated. Colour is complicated and takes years of under-standing to fully appreciate its use. The web is full of colour contradictions. Sadly, a little knowledge is dangerous and is ever true in the colour arena.

Each colour is more than and has far more reaching conse-quences than catchphrases and buzz words. Take blue for instance. Blue will envelop you with safe feelings, you can sometimes drift off under blue's influence. Conversely, some shades of blue will keep you wide awake. Insomniacs react strongly in both negative and positive ways to certain shades of blue. The unknowns of blue are disconcerting. Blue has the capacity to swirl you into complete indecision, going around and around, incapable of making any decision or taking any action, wearing you out by creating a sense of absolute apathy and

tiredness and not meeting the deadline.

Blue the most revered colour in the spectrum, yet so very little is mentioned of the many facets of blue, and not all positive and uplifting. Blue is quite contrary, as certain shades of blue uplift, or create a mood of melancholy, rest the mind and body, or keep you wide awake. It brings about feelings of bodily discomfort or calm and at-one-ness. Architects' use of blue glass in office buildings is an area of interest and the shade of blue used in some for the sake of the workers inside the building requires a rethink. Blue is a powerful colour and when used without colour awareness and inappropriately in a shopping precinct will discourage shoppers. It is one of the most effective colours to run a business down, regardless of effort on the owner's part. Blue, black, white and grey have been used as standard business colours with the odd splash of colour. Over the past few years you see a fuller range of colour emerging, supported by advertising, fashion and the green movement.

The colour green raises suspicion in some countries although in Ireland it is known as the colour of luck, 'the luck of the Irish'. Being one of their favourite colours, green is linked to the little people, four-leaf clover and national guard's dress. Some nations link green to illness, disease and bad luck. In England, green was considered unlucky in the home for many years, yet it can be the colour of growth, monetary gain, good luck and stability. Deep green can send a strong fertility vibe, and light green is not to be trusted but an alternative lighter shade of green is seen as fresh and supports new ideas.

Confusing, yes. Wondrously fascinating, absolutely. Green is associated with medical surgery, safety, monetary gain and balance to name a few. It's also associated with losses, illness, disease and poverty. It is a minefield that should be approached with caution, as mistakes can be difficult to rectify. Dark green in the West is depicted as offering the olive branch, wanting forgiveness. In Greece, green has evil connotations of

hopelessness and despair. In Japan, sinister figures are often clothed in blue. Colour raises cultural awareness, as colour associations are a vital part when working with people from different countries.

In springtime, the greens become lush and beautiful, a symbol for growth, fertility and abundance; radiating a feeling of fullness. Green is a good colour for dieting, as it gives a feeling of fullness and satisfaction. Forget the blue plates, use green and eat up your greens.

In Celtic myths, the Green Man is the symbol of fertility and used extensively in pagan ceremonies. Early Christians banned the Green Man ceremonies. Nature's splendid backdrop in the main is green, the most restful colour to the eye, coupled with proven healing qualities. The first choice when unwell, feeling off colour and stressed, is to escape to the green of the countryside for rest and recuperation. Second choice is to water. Green soothes pain and in certain green environments people have fewer aches and pains. But take caution as in other green environments workers take every opportunity to leave their seats to wander around the floor talking to colleagues, spending more time in the restrooms than usual and taking more absence. A fine line rests between shades of colour. When London Blackfriars Bridge was painted green, the suicide rate dropped dramatically. Interestingly the Egyptians symbolised one of their gods, Osiris, as the God of death and vegetation. Examples of the negative and positive aspects of green: a darker shade of green links to monetary gain and the financial world. A lot of countries use green on their banknotes and currency.

Colour can be used to your advantage, allowing you to communicate effectively and persuasively by guiding the response of your audience and by leaving an unforgettable impression. There are many colour clashes on the high street and many find that shopping has become a stressful experience with bright bold colour combos clashing; the bright colour palette in

the working environment, installed with the best intent, completely wrong for the business is long remembered for the wrong reasons. We all know and feel something is not right in the environment even if we can't put our finger on exactly what's not right. Conversely, the more demure colour experience can dampen feelings of retail therapy excitement that we need when shopping, by leeching any initial enthusiasm that we began the day with. Demure colours can also lessen motivation in a work environment if the combinations are too earthy.

The high street needs to up its game and fast. Up and down the country there are high streets that are deserted, the only missing element is tumbleweed blowing down the main thoroughfare. Leaving the high street to effectively close encourages waste, litter and vandalism. With most towns having a good end and a bad end, why not close the bad end and invest in bringing the good end up to a high standard, by offering shoppers a lifestyle experience. People will then be willing to return to local high streets to spend. Bring in street theatre, live music, art, interactive stuff a vital component for today's high tech savvy youth. The bad end can be redeveloped into creative work spaces at easily affordable rentals for designers, crafters and creatives.

The high cost of shop and office space proves to be an ongoing barrier for small business. The units will be secure and vibrant places to make and sell their wares: a hub for the local creative and design community. What we see on most local high streets today is an abundance of charity shops and coffee shops with a few alternatives and staples sprinkled in-between. Things could be so different, vibrant and exciting with some thought and imagination. No wonder online sales are rising, albeit slower than expected, but rising all the same. The local high street can be boring with little on offer. We are a nation of shopkeepers in Britain; we have always enjoyed shopping, it is a very sociable thing to do, with friends or by oneself. Internet shopping offers

ease of use but cannot compare to the many positive sociable facets of high street shopping. Recent surveys show we are returning to our parents' ways of food shopping, buying smaller amounts at each shop and less of it. Many are seeking out the smaller retailers for foods such as the local green grocer, butcher and baker, yet the small individual staple shops are disappearing at a rapid pace as most cannot keep up with high rents and business rates. Another sign of the times is the opening of more pawnbrokers and betting shops on the high street than we have ever seen. In the case of pawnbrokers, today there are more than 2,000 in Britain compared to approximately 450 a few years ago.

When the banking crisis happened in 2007/8, seemingly overnight saw household names close and leave the high street: Woolworths, Jessops, MFI, Blockbuster, to name a few, along with many smaller retailers. The losses and closures seemed to rage like a bush fire through towns all over Britain. The retail sector was temporarily shaken to its core, a throw everything up in the air scenario happening in real time and real life, to see where it lands – a pivotal time in retail history. Once the initial shock was overcome we saw new types of shops opening. The old-fashioned sweet shop experienced a surge in popularity with retro and vintage become popular once more, taking on a new lease of life. This positively extended in everything from fashion, to gadgets to furniture, to cars and caravans with street food trendy and popular. Charity and betting shops tripled in number taking over vacant premises. Manufacturers and retailers had to adapt and evolve to survive.

At the moment there is not a level playing field between high street retailers and online retailers. Cost implications affect both yet the highest costs are borne by the high street retailer. A recent study confirmed that customers are more likely to seek out goods they can touch, feel and try on in the high street, then source the cheapest comparable product online; many have had their fingers burnt, however, as the quality from some 'shops' online is

questionable. Landlords and councils play their part. The need to reduce rents and business rates is clear. Retailers are disillusioned and cannot see how the high street can compete; with more than 400 million potential shoppers online around the world, an online presence needs to be supported coupled with a high street presence. A rethink could include considering pop-ups in place of stores in some towns. Pop-ups are easy to set up, cost effective and can be taken around the country supported by an online presence, with a difference.

ASOS pioneered social shopping. When they started many in retail believed it would not work, without significant marketing investment and without placing adverts. ASOS used the power of social media networking to establish their brand, share ideas and attract customer feedback. They very quickly had in place a high tech support system to their site, when customers telephone, text or email the reply is instantaneous, helping to further cement the customers' perception and feeling. These techniques are important to ASOS, and cleverly give the customer the impression of one to one attention. We all want to feel special and never more so than when we are spending money. Drawing on the time proven method of great customer service skills taken from the high street converted into their online shopping model is paramount to their success coupled with excellent products at the right price. Customers recommended ASOS to their friends and seemingly overnight ASOS became an overnight success.

High streets have learnt to evolve and adapt over the years, but now there needs to be a radical rethink on the way forward. Things have changed: the IT revolution is juggernauting fast. To keep up, the high street needs to be innovative. There is a proven need for both high street and online shopping. I hope the high street can survive. The possibilities are endless! By embracing the change, massive opportunities are there to be grasped and acted upon, and colour is an integral part of the change. The high street can be a success again, by bringing communities together rather

than isolating people.

Colour holds a coveted place in the changes. Happy colours in the retro and vintage ranges are used to entice shoppers and raise spirits as a cheerful memorable day out shopping on the high street. We experience colour flooding the market to brighten our day as a counterbalance to the stress of the austerity measures. Throughout history colour has played its part to uplift and to regenerate our feelings. When the going gets tough... colour comes into its own. Future shopping trends are changing, things can never stay the same; colour, however, remains potent and stable. With different colours contributing to different moods we can conclude that a carefully thought out interior design and colour scheme to complement offer a supporting environment and nice place to be, resulting in people wanting to return to a place in which they feel most comfortable just as the children in the McDonald's survey want 'a happy place with happy colours'. It can be interpreted as a colour scheme fit for purpose.

Of late when in doubt use white; white interiors are again fashionable, but an all-white environment can be disturbing, creating a depressing atmosphere unless specific pick-me-up colours are used in subtle touches, pictures, murals and soft furnishing all supported by lashings of natural light. Creating a harmonious energy space that supports a healthy business and nurtures people starts with a considered colour scheme, following through to the colours of the business by refreshing the logo and branding, reviewing colours used for packaging, then the product, service, and finally the colour for marketing and advertising.

In recent years we have begun to accept and to understand the vital gift colour shares with us, and the transformational power it holds. What a drab, boring and depressing world it would be without colour, living in monochrome. Conversely, using colour with minimal understanding of the vital properties and energies each shade holds is kaleidoscopic suicide. Colour throughout

history and economical ups and downs has played its part magnificently. Following major wars, the brighter colours have emerged to raise the spirits of the nation. During the recent banking crisis, and with austerity measures in place, fashion led the way to uplift the mood by displaying an array of the brightest jewelled colours on the catwalk, which in turn inspired the high street. Burberry gave a glorious show of the brightest metallic colours in pink, magenta, violet and more.

Throughout the ages colour has made its mark, and history plots and records its progress. Examples and discoveries for further investigation passed down through the ages sharing theories and findings, passing on the mantel for the next generation to further their work for the benefit and good of all.

Science is a fairly new study in comparison to the thousands of years colour has been documented and used, therefore I go back before I attempt to go forward, as Confucius once said, "To divine the future first we must study the past." Colour choices need to be spot on and fit for purpose. It is complicated agreed, and with such a huge variety and range of colours to choose from, hundreds and thousands of shades and hues, the task is enormous and can be daunting, especially as each colour impacts in its own particular and unique way. Every colour has dual personality meanings and associations and the responsibility for success rests with the person or team who choose the colour. With their own unique set of variants and meanings, each colour has far-reaching implications for the growth and endurance of the business. Colour associations can be historical, national, cultural, personal and linguistic, but one thing we can't deny is that it is also visual.

Colour has impact, and for that reason the way it is used creates either the right energy for the intended use or not. With more business being done beyond national and continental boundaries, understanding the fundamentals of colour associations can make the difference between you and a competitor who

doesn't know or care. Colour in business is vital, yet it is also complicated and can be confusing to an untrained colour eye. In advertising the misuse of colour regarding contrast is very prominent on the Internet and other aspects of media, where very light colours such as pink or yellow background have white text, almost indiscernible and practically illegible.

When companies declare their colour choice is not living up to expectations, I am called upon as a troubleshooter. The feeling around the table is united, they cannot understand why colour has not worked for the business. Without exception my findings show the wrong palette of colour is the culprit, leaving me feeling embarrassed on behalf of the colour 'expert' who chose the original scheme. Once the correct colours are in place the difference is noticeable and felt immediately. Following through with a six-monthly check makes for a great read, as the report highlights the positive impact the colours instantly had and confirms the effect is ongoing, ensuring a steady and influential colour process is undertaken. What ultimately drives me to accept the challenge is my love and passion for colour. Colour works, I have no doubt, and when applied correctly, colour is transformational changing lives with far-reaching positive implications.

Colour is a lifelong learning curve; once study is complete, very much like passing your driving test, you are safe to go out on to the road, where the true learning begins. Through trial and error and many years of hands-on practical experience in the business arena I have achieved the highest credentials to advise corporations. Colour is an in-depth and diverse subject, with far-reaching effects, therefore it demands excellence and accuracy. To meet the needs of global business, colour choice requires an exact and carefully defined process. Fit for purpose colour drives sales, brand awareness, profitability and success naturally follows; beautifully and seamlessly it fulfils all business needs and requirements.

Under Fives Children's Nursery

I wanted to create the perfect environment to complement the innovative care and development programme. I knew June was top of her field and came highly recommended but I was not prepared for the outstanding impact her work had. The atmosphere, the energy, and the visual image were all transformed. The children's behaviour bore an instant calmness, the staff were more relaxed and the parents' reaction on entering was simply, "Wow!"

It has definitely increased both the perception of my business and its performance and has been one of the most influential business decisions I have made.

A. Spencer, Angels at Play

Once I had completed the colouring of the under-fives nurseries rather, than a report, I instigated an in-depth colour study to show the wider world that my colour choices for the nurseries were absolutely perfect and exact. I asked educational psychologist G. Sbuttoni to collaborate with me on the study: the findings proved that the colours I had chosen throughout were spot on, bringing about the following positive and improved results.

An environment that encourages creative and inventive thought in children:

- Improved emotional development in children
- Children shared and cooperated more
- Decreased noise levels
- Children found it easier to organise their own thoughts – leading to higher intellectual development in the long term
- Tension and aggression were reduced
- Babies slept more peacefully and easily
- Staff were happier and more content
- Calmness increased and relaxation was easier

Another proven success for colour.

Kitchen Research Findings

When I was approached by a leading kitchen manufacturer, the brief came at an exciting time. Colour in the kitchen was a hot 'new' media trend. It is accepted that the colours we choose within interiors affect our mood and well-being on a daily basis. They affect how we feel, think and act. Colour involves a response that is based on what we see, sense and feel. This response to colour can sometimes go unnoticed but certainly has far-reaching effects on our physical, emotional and mental health. Yet little study had been carried out to date on the effect of colour on us when working in the kitchen, and was an area I wanted to look into.

We are able to see around 7,000,000 colours that are absorbed through our eyes and skin. Previous studies I have carried out reveal that blind children are able to sense certain colours correctly through touch alone as each colour has a specific vibrational energy. Colour reaches us all on a very deep and instinctive level, and when combined with specialist knowledge of colour and its therapeutic effects, a balanced nurturing environment can be created.

The kitchen is the heart of the home; creating a space that moves beyond the purely functional is a desirable asset to any household. Light, space and colour go hand in hand; the effect of each kitchen range needs to be considered in relation to the space and light that each room allows. The colour and design of the kitchen range is dependent upon the thorough survey taken of the results from my property placement of light, space and layout prior to the consideration of design and finally colouring. Having worked with numerous clients on their kitchens and the latest brief highlighting the kitchen space, I felt the time to be right to organise a study to find the most favourable colour for the kitchen area.

Undertaken over two days and with a number of volunteers participating, I set up seven identical kitchen areas, coloured in the six spectral colours and white – red through to violet and white. The colours were not primary, they were softened with white and I deliberately chose the paler shades with enough depth to soften the harsh primary colours so as to influence the volunteers. Otherwise I felt the volunteers would be overwhelmed and possibly not be able to carry out the experiment in the time allotted. The six identical workable layouts set up as functioning kitchens were equipped with identical recipe sheets and utensils. Volunteers were asked to wear the white T-shirts and trousers supplied, and to remove all jewellery.

I didn't want any clashes with the kitchen possibly creating an unfair influence and to ensure a pre-result from the study. Lighting was exact, temperature exact. In every way the exact conditions were identical. Being an initial study I began with the six basic colours and white. Over time I want to revisit the kitchen area to look at the effect of more colour ways and materials. Pale pink is one of my no-nos for the kitchen for a myriad of reasons. Smells linger longer in pink kitchens indicating the rise of bacteria, although surprisingly not in red. Red refreshes and clears the atmosphere in subtle and correct placement. Yet overwhelming red will have an adverse effect on other levels. With such a strong colour you cannot expect anything other than a dramatic effect. Placed correctly, red is one of the most striking and likeable colours of the spectrum. It's a memorable colour placed well, and in the right setting, creates more 'wows' than most. You can therefore imagine the surprise of the helpers when the results of the study did not highlight red as the clear winner. The volunteers were given recipe sheets and ingredients with a start and finish time. The straightforward menu was set out in clear step-by-step foolproof instructions.

Observations during the process highlighted that in the red kitchen the volunteers speed-read through the written guidelines

and recipe instructions. The simple straightforward menu may have lulled people into a false sense of security. If this was the case then there would be an expectation of all the colours speed-reading, yet this did not happen. The red kitchen returned more often to the recipe instructions than the other colours. We expected to find 'reds' slower overall due to the time spent returning to the instructions, yet reds managed to sail into second place for timekeeping. Orange was the accident prone area with a cut finger and a crockery casualty. Orange did not copy red by returning to recipe instructions; however, they did lack the understanding to follow parts of the recipe by losing their place and leaving out two ingredients. They also found timekeeping difficult. Yellow attacked the experience with military precision by laying out all the ingredients in a specific order before they started to mix, followed through by keeping exactly (30 seconds out!) to the set timetable. The determination to succeed was evident. In their enthusiasm yellows opened the oven far more than necessary, regularly checking the food, resulting in sponge dipping in the middle and dumplings being undercooked.

The greens were the slowest off the mark, leaving the helpers to ponder whether they would ever get started. Greens checked and rechecked ingredients, oven temperatures and utensils and spent a considerable time on reading the instructions carefully. Their diligence paid off as greens came in on time, no accidents and the food was cooked thoroughly and well.

Sky Blue – Popularly known as the calm and serene colour – has ridden on the back of incorrect coverage for too long. Particular shades of blue are calm and relaxing. It is a shame not more is shared on the negative aspects of different shades of blue, especially when blue is chosen as a colour of choice for important areas where stress-free environments are conducive to safety in crowded spaces such as airports, public spaces and sports arenas.

Visibly stressed blues valiantly completed the tasks but not without problems. Talking throughout rather than spending

more time concentrating on the jobs at hand, the observers did not feel blue would complete the task. Outbursts of frustration came forth with alarming regularity from the blue kitchen and two announcements of "I can't do this!" They were the least impressive for timekeeping, yet food was well cooked and presented nicely and surprisingly with no accidents.

Violet – A quiet rush; the only words to describe the activity in the violet kitchen. Like the swan, all appeared calm on an initial view but further observation revealed the paradox – a calm but highly stressed environment. A plate was broken early on in the study, not through use, but by moving from one side of the worktop to another. Calmly the broken pieces were brushed up and discarded without a word spoken. A small cut when chopping ingredients. Attempts to keep to the timetable were thwarted by rushing through instructions, working to their own timetable and order of cooking food resulting in thirty minutes lost overall.

White – Not surprisingly was calm, serene and coped well throughout. No accidents or dramas, the final of the baking came in twenty minutes late as the volunteer became visibly drained and tired towards the end of the session and began to dawdle. This may be a combination of the draining effects of too much white or when questioned a very late dance and drinking session the night before. Guess we will never know!

Final results showed and revealed the white and light green kitchen triumphed. But it must be remembered that they came out on top in this particular space and with particular colourings and materials. Please note: the outcome of the study is not recommending white and light green kitchens as the ones to go for in every home. We were looking at a number of things, including the environment, space, direction and the materials of the particular kitchen. Have your home surveyed by a colour professional who will draw up plans and give colour advice that is exclusive to your home. I want to demonstrate the marked differ-

ences between the colours and people who work in particular coloured environments because colour affects everyone.

A tailored, fully fitted kitchen designed around client needs and coloured in the correct shade for the home and family will give many years of functional use and importantly will be a happy hub of the home that is safe, harmonious, that supports and nurtures the family dynamics.

Pushchair and Nursery Equipment

The baby and nursery equipment market grew substantially between 2003 and 2008 to reach 650 million pounds by 2008 in the UK with consumers taking inspiration from celebrities. Fashion was found to be more of a focus, consequently, mums are prepared to pay a premium price for products that they feel deliver the best image for themselves and their babies. The 'must have' celebrity accessory is the designer pushchair. The trend began in earnest with the Beckhams. When Brooklyn was first seen in his Britax, sales soared, and from that point there was no looking back.

Jamie and Jools Oliver along with Ben Affleck and Jennifer Garner opted for the Bugaboo Bee. When Gwyneth Paltrow was photographed for the first time pushing Apple in a Bugaboo Frog, hits to the Bugaboo site rose dramatically. Customers were ordering 20 weeks in advance, afraid the shops would run out. Kate Moss chose the Combi, Heidi Klum, Jennifer Lopez and Jessica Alba chose Silver Cross.

Maclaren, phil&teds Sport Buggy and Mamas and Papas are a small selection of the great pushchairs and buggies out there with celebrity endorsements and a loyal customer base.

Celebrities are inundated with free samples of products as companies send out products to celebrities in the hunt for the endorsement. The top end of the market thrives, and as the market expands and grows, sales consistently rise.

Good innovative design coupled with the correct colour range

are vital ingredients for success. My client wanted to bring to market a new pushchair, and following a comprehensive trends forecast report, the customer age range to be targeted was decided. I was busy over many months that summer, compiling reports, setting up studies and researching. My team worked well together and for me, no quibbles, heads down, I was thankful for the long light summer evenings as we worked through the evening till darkness on most days. After much deliberation, consideration and use of skill, the design confirmed, the colours chosen, the product launched. Sales exceeded expectations, and the pushchair is one of the most popular and fastest-growing brands.

Make-up

Make-up can change the way one feels and looks. Applying the right colours will uplift your mood, animate your personality, make you feel good and coordinate an outfit. You can absorb colour frequencies through perfumes, aromatherapy oils and the colours of the make-up and skin care that you use.

Flowers and plants are full of solar energy because they absorb and store sunlight. You can therefore benefit from cosmetics using flowers, herbs and essences because they too hold a colour frequency based on the colour of the part of the plant that is used to make the essence. The majority of the large cosmetic houses do use natural products in their ranges, yet fail to advertise the fact. Some 'natural' companies market the natural, yet sometimes fail to disclose the weaker sides of their operations and manufacturing. Companies spend many millions to ensure that their products are safe and pass stringent testing and hygiene regulations for your comfort and enjoyment.

What do the colours suggest?

- Pink – encourages feelings of tenderness and loving
- Peach – promotes an inner appreciation

- Coral/gold – combines the special qualities of gold and mystique of coral
- Orange/apricot – confident and happy
- Blue/lilac – recognise your uniqueness
- Red – passionate and desirable
- Smokey brown/taupe – earthy and passionate

A glimpse of the research findings at the time told us:

- 75% of women wear make-up everyday
- Women felt more confident wearing make-up
- 48% of women wore make-up at home
- 29% of women went to bed with make-up on
- The majority preferred the natural look

The most popular make-up, in order of preference:

1 Lipstick
2 Mascara
3 Third place goes to, surprisingly, lip gloss

The Most Popular Hair Colour

Red is the new blonde. I set up a study on what I foresaw, the coming shift in hair colour preference. At the time blonde was top, yet I felt changes were imminent and set out to prove my theory. My findings are taken from my own extensive knowledge, expertise and research base. A lifestyle study was set up to research forthcoming hair colour changes, if any, and here is a taster. The lifestyle trends highlighted: young professionals/ young families evacuating the city to relocate. House prices drove the evacuation with London house prices rising faster than anywhere else in the country. Everything eco/green became trendy. Hairstyles: the natural look reigned, with tong and straightener sales dropping.

Blondes, for an age, have come top of every hair colour popularity chart. Women preferred to be blonde and men preferred blondes. The blonde popularity was based on findings for men's preferences and popular icons such as Marilyn Monroe, Brigitte Bardot, Charlize Theron, Kate Moss, Gwyneth Paltrow and Jennifer Aniston to name a few. They played to a sexualised stereotype flamed by the film industry and media. Blondes have held the top spot for many years supported by tag lines 'blondes have more fun'. The populace bought into the blonde preference big time. It may also have something to do with the fact that blonde, blue eyed people are the lowest number of hair colouring group worldwide. A natural rarity.

Today with the help of hair dyes/bleaches many millions are now blonde. Marilyn Monroe became the epitome of the blondes 'not taken seriously', with her giggly, breathless voice and sexualised stance, no one can forget her *Happy Birthday, Mr President* rendition, and she remains a siren fifty years after her death.

Hair Colouring

The effect colour can have on our self-esteem, mood and emotion is purely expressed through make-up, hairstyle and hair colour. With changes seen over time in make-up and hairstyles, hair colour popularity has remained fairly stable until recently. In the main blondes have rated top in every hair colour study. When I was asked to carry out the hair colour study, I must admit to not feeling terribly excited by the prospect, yet, as I became more involved in organising and setting up the study, and as the results came in, my raised enthusiasm was palpable. For the first time in years there was a definite shift from blonde to redhead. It was the start of the recession in the UK. I know from historical records, during times of restraint and austerity colour comes to the fore in areas not seen before. Had I been looking for a possibility of colour change, fashion is the first area to look at or

possibly the accessories market.

Blondes have topped the polls for so long, yet here it was, the results overwhelming; red the next colour trend for hair colour, knocking blondes off the top spot. Exciting times! We were on the threshold of major change. There was no time to spare, if the company was to be the first out there blazing the trail for redheads everywhere – a pioneering move. Suddenly and within a short timescale following release, every hair colour company quickly ran to catch up. Today we see redheads at the fore of most advertising campaigns for hair colour products. Reds are staying the course and holding their place at the top. Of late brown combined with blonde is trying to edge reds off the top spot – allegedly a marketing ploy; I doubt if reds will want to move off the top spot just yet.

It has long been recognised that colour affects how you feel and impacts on your personality. How you wear colour can tell those in the know so much about your personality, what is happening in your emotional life, your career, your health. In fact it is a blueprint of your life at that moment in time. Hair colour, make-up and fashion displays to the world all of the above plus highlights your friendship groups, how friends are chosen, the way you nurture, and how much time you spend developing friendships. Colours display your abilities and confidence, and don't be fooled, loud clashing colours are not usually the expression of a confident person. With colour, the inside is on display to the world; someone like me can source so much from what colours people wear. Traditionally women's hair is referred to as her crowning glory, and with very good reason. A woman's femininity and sexuality is expressed through the hair. Long, thick, flowing shiny locks are chosen by women in their sexual prime, and has long been men's first preference. Most peri and post-menopausal women opt to wear their hair shorter, possibly a subconscious statement: 'my reproducing days are over'. According to research the main problem people face in ageing is

thinning hair, and the one defining action that declares sexual interest and attraction to another is the flicking of hair or playing with hair while talking face to face. With thinning hair that behaviour is made more difficult. Here is a light-hearted look at hair colour and personality types.

Looking at the five hair colours – black, brown, blonde, red, grey:

- Black – The deep thinkers, the black hair types are nicknamed the 'seeders', they think long and hard, mulling it over and making sure "it" be clearly formulated in their own minds before they talk about it with another.
- Brown – Security issues are of prime importance to the browns. They will never resent working hard to ensure materially that they are secure. A healthy bank balance with savings is like nectar to a brown. They will rarely overspend, if they do then you will know that gentle heart has been affected, maybe a broken romance? Or worse, a betrayal. Loyal and true, partners, loved ones and close friends take pride of place in their lives.
- Blonde – For many years the most popular hair colour. Blondes present to the outer world happy-go-lucky personalities with a great sense of humour who certainly won't harbour grudges. Blondes love to be at the centre of the action, the centre of where it's all at. Rarely a wallflower.
- Red – Now the number one hair colour – go reds! The lively ones, great company and matching the blonde for popularity any day. They have a deep inner spark, 'the seekers', wanting to see more than their daily world who love to travel and explore.
- Grey – You know what it's all about. You've been there, got the T-shirt and still have a few surprises up your sleeve. To help create that extra excitement you may choose to colour

rinse your hair with pink, violet or blue. It is never too late to break the mould.

Hair Colour Personalities

- Black – the listeners. Easy to talk to, giving you the time to share what's on your mind: not heavy on the advice either. Just great listeners and will give you all the time you need to talk and offload.
- Brown – the nurturer of the group, calm and serene. They know instinctively what you need and will supply that 'nourishment' whether it be a quiet night in for the two of you or a night out on the razzle.
- Blonde – your adrenalin is flowing, you need a blast of action so bring in a blonde for a whirlwind of energy and fun. Who could possibly be down with a blonde on top form around? 'Life is a blast' is their motto.
- Red – they know where, when, why… they have an uncanny ability to spot the 'new' before it's been spotted. You've lost your creative spark? Want something different? Grab red and hit the town. Red will show you the sights you never thought of, let alone knew existed!
- Grey – can't quite see a way forward? Made that mistake before? Oh gosh, just need some solid no-nonsense advice. Call in the greys, for a free no-holds-barred reality check.

Computer Colour – Keywords

- Mint Green – to take a new approach, encourages fresh ideas
- Turquoise – to boost confidence in the task and unleash communication skills
- Burgundy Red – supports organisational skills with new enthusiasm
- White – focuses the mind and encourages clarity of thought

- Black – best for colour definition, observing detail with commitment to completing task
- Violet – stimulates creative imagination and quick thinking
- Blue – composure while multitasking and creating
- Orange – helps to boost mood especially in badly-lit offices where natural daylight is at a premium, confidence to carry out complicated tasks
- Green – to view from a wider perspective, another colour for creatives, stimulates new ideas, encourages perseverance and motivation

Bedding

I decided to look deeper into the impact of bedding colour on sleep patterns. Does the colour of sheets and pillow slips impact on sleep? And if so, how much? And what are the effects?

Traditionally, indigo and deep blue were the colours to use in the bedroom. I wanted to test this, as I felt that it was old news, and having successfully colour branded a number of bedding manufacturers' goods in a delicious array of both neutrals and coloured designs, I felt that it was high time to possibly change the thinking around deep blue being the colour to entice sleep. So in the same room with an identical bed, setting and furniture and with two bedside lamps, the experiment began, using volunteers. Each night a different set of sheets were slept in. The duvet was plain and white, the sheets pure cotton. We rotated the volunteers to achieve a fair representation and results. The colours used for the experiment were: white, taupe, pink, green, spice, grey, black and navy. The sheets were used on the bed and an over sheet to maximise colour exposure. I suggested white to be the overall winner prior to the experiment commencing, and I was right. The all-white bedding came top as the clear winner. One volunteer tested navy, spice and white. He dreamt and experienced a disturbed sleep in spice, woke up once during the night in navy, yet slept through in white. White consistently came

tops throughout, bar one volunteer who slept like a log in all of the colours!

Branding

I found I could say things with colours that I couldn't say in any other way – things that I had no words for.
Georgia O'Keeffe

A strong brand will aid survival in every climate from recession through to strong market trading, giving you the confidence to ride the storm, to be noticed and to secure funding. A recession is not an excuse to give up. Every trick needs to be pulled out of the hat to survive and the colour scheme of your brand should be top priority. For all chocolate lovers out there, Green and Black's, created by a husband and wife team in a recession, grew to become a strong market contender and when they sold to Cadbury's in 2005 for £38 plus million, 85% of the deal was intangible: most of their value came from the intangible asset, the brand. The brand should be at the heart of every business. While competitors are refinancing and checking figures, why not strengthen your brand? Cutting costs is the traditional reaction, yet research over time shows significant results (achieved through a strong brand) are the best asset a business can own, develop and secure. Colour stands proud and at the helm of strong branding. The most memorable part of your business is the colour.

What is branding? In the Oxford dictionary the following definition is offered: "to impress unforgettably, identifying trademark, label, goods etc." Elsewhere we read, "The goal of a brand is to make a company unique and recognisable and to protect a desired image." To create a brand for a business is to create an image and to promote that image. The rest is up to the business to promote, gain trust and to upkeep brand mainte-nance. Why brand a business? For loyalty, familiarity, memora-

bility and greater company value. Look at the longevity of the brand of our Royal Family and how it has endured giving great value. A brand is created through the name, symbol, font and strapline. Once these are agreed, the most important part of the whole process is to bring it all together in the choice of colour.

Brand protection is ongoing via trademarks and copyright. A strong brand can be created during a recession with confidence and clarity guiding the focus with a sprinkling of innovation and difference, by trusting the vision and holding the focus. Disney was started in a recession and some of the world's largest companies all started in a recession. Don't be deterred by what's happening around you. The timing is only ever right when you feel it is right. Rather, focus on creation of your brand, implementation and maintenance. A strong brand will aid and support survival in the most austere of times. Rather, put your energies into securing the accurate colour for your sector.

Martin Lindstrom in his published book *Brand Sense* argues that one great thing about colour is that it contributes to the 'smash-ability' of a brand. He suggests successful brands can be smashed like a glass bottle of Coca-Cola and consumers will still recognise the brand from its pieces. Coming from the colour perspective I agree with him.

Jay Conrad Levinson wrote one of the best books on the subject of marketing. He pioneered going viral, a man ahead of his time, encouraging the masses to get yourself out there, years ahead of it becoming popular and the norm. Read all about it and much, much more in his best-selling book *Guerrilla Marketing*.

Lucas Conley wrote in his book *Obsessive Branding Disorder* the need for professionalism and a strong knowledge base: "… in the name of the brand, any idea can be defended as valid and any crackpot can assume the status of a guru." Seems colour is not the only arena for the self-styled expert! It is refreshing to read Lucas Conley relay the importance of knowledge and accuracy, knowing one's subject thoroughly, rather than blind an audience

with impressive rhetoric, supported by fragile and limited knowledge. With so much hype and less substance we are part of a downward spiral in many areas of business: colour, branding, marketing and advertising. Unfortunately, the rot has started to set in. Let's change things quickly. In advertising many have lost their way. There was a time when good adverts were talked about for months even years after launch, today it is a rarity. Advertising, marketing, branding and colour must hold our attention and spark our imagination to be remembered. There are exceptions; Sainsbury's delivered a fantastic advert, based at the time of the First World War, featuring soldiers laying down arms to come together on Christmas Day to play football, a brilliant piece that is remembered by many. Creativity is the key to releasing inspired thought, and using colour throughout as the main focus, we find new ways to release the creative spark, to enable a flood of new ideas and concepts. Without recognising the role of colour creative play, led by a professional to create the space to doodle, colour, and release, many new ways of moving forward stay locked in the mind as thoughts passing through. Creativity in the workplace catches those thoughts, asking the relevant questions: Are they useful? Is there mileage in the idea? Where can it be used? Once expressed and out in the open and on to the drawing pad, suddenly they are given new life, with fresh eyes and a renewed enthusiasm of possibility, carefully considered.

Not so many years ago schools of colour were teaching the outdated theory blue and green should never be placed together; my thoughts then as now, if it's good enough for the natural world then it's good enough for me. We have evolved and moved forward fast: now we need to surge forward with new thinking around new ways to use colour and creativity. I have never been lacking in inspiration nor disillusioned by the natural world. Coupled with getting outside as often as possible to become part of the natural world (at the very least spending time in open

green spaces), in summer by laying on the grass and admiring the cloud formations, you can admire the interplay between cloud formations, feel the sun on the body, wind in the hair. Observe sailboats creating ripples on the lakes and smell the salt in the coastal air. Take a quick hit of vibrant yellow as you drive past the rapeseed fields. All these experiences ignite the creative awareness and stimulate the senses.

My (what-happens-if) mentality when experimenting with colour has unveiled many new discoveries over the years, some usable, some not. But hey, character building none the less, and surely the basis of all learning – to test, to try out, to accept or to discard, to move on or to progress. But what I am a stickler for is absolute perfection when working with corporate clients. I have never tested new concepts on my clients. I set up colour studies in a safe environment to do that, measure the study carefully then use the results to further my work. Branding is seen as key in the business world, yet it is colour that must be revered and prioritised. Traditionally, design has held the coveted hot spot. Without colour, design cannot sustain itself.

Colour demands perfection. Just one shade out disturbs the whole integrity leaving the project wanting and impact reduced. Colour cannot be fooled, neither can it be surpassed. Blue, black, white and grey are traditionally the serious corporate colour choices for website colours. It is pleasing to see a gradual change away from the limited palette of four colours and an opening to a wider more colourful choice. Throughout history, the way colour is used has evolved internationally. Today the vast ranges of colour allow us to achieve far superior results. Colour does not follow a one-colour-fits-all mentality. Colour method and meaning changes dependent on the business, the environment, the culture and the country. Proficient proven colour skills are essential in business for global success in today's shrinking global market.

Business success depends upon its brand, service and product

excellence being recognised and hailed globally. Colour being the major ingredient works for every business. In the cases where colour is perceived not to have worked, it has been proven that the responsibility rests in human hands. Colour is the most powerful communication and sales tool known, which can attract success or just as easily alienate the target market. It is well to remember when working with colour it has a dual personality. It holds within it positive attributes and negative attributes. For balance and a fuller expression of meaning both need to be recognised and utilised.

With instant and powerful impact. Correct colour choice is imperative and will perfect business advantage. Companies need to consider placing colour at the top of the agenda, as colour plays the most vital and important role in global trade. Yet the task of choice is enormous and can be daunting with thousands of tones, hues and shades to choose from. The colour needs to be spot on, and fit for purpose. To be thoroughly effective it requires exact selection to guarantee results, complicated, yet possible and with knowledge and right guidance, achievable.

To first accept that each colour impacts in its own particular way, and every colour has dual personality, meaning and association, is a good starting point. With their own unique set of variants and meanings, each colour has far-reaching implications adding to the endurance and growth potential of the business. Colour associations can be historical, national, cultural, personal and linguistic, but one thing we can't deny is that it is visual. Colour has impact, and for that reason, the way it is used creates either the right energy for the intended use or not.

With more business being done beyond national and continental boundaries, understanding the fundamentals of colour associations can make the difference between you and a competitor who doesn't know or care. Feeling blue in the main is accepted as feeling below par or feeling down, yet in Germany a quite different meaning is the norm; it means being inebriated in

the German understanding. Learning the rudiments of colour gives global business some grasp and understanding of international colour meanings as we are immersed in international trading, and to be colour savvy is to survive.

In the right hands colour cannot be surpassed, branding is seen as key in the business world. Management fads come and go, yet branding has stood the test of time and is growing in popularity and use. Traditionally design held the coveted hot spot, unfortunately designers and managers upheld the limited belief that without design, colour cannot sustain itself. Colour is more than able to hold its own in any setting. Good design is essential, but design is not the brand and without best colour choice the design is lost before it has started, a brand lacking colour impact is forgettable and a brand without continuity is lost.

Abbey National made this error years back when their team agreed to a makeover, colouring branches across the country in different colours. Customers were confused: in one town the branch was orange, in another green and another blue and another red. Confusing and lacking thought of the consequences, customers voted with their feet. Colour is by its very nature perfect and, unfortunately, success relies upon the team choosing the perfect colour scheme; colour works, there is no doubt. The choice of the colour palette is where the problem lies, the human link in the chain can be weak or strong.

The most remembered part of design and branding is the colour; the colour palette is vital. Just as it takes more than a carrot and a piece of coal to make a snowman, it takes a strong combination of colour and design to create a lasting brand. Every colour has dual personality, meanings and associations, the responsibility for success rests with the person or team who choose the colour scheme for the project. Colour is the pivotal, visual element, aesthetically pleasing, unsurpassed and the most profound and important non-verbal communication tool

available. The colour choice for business heavily influences customer choice of one product over another and therefore determines the popularity of the brand and selects the best-seller, long before customers have rationally processed what instigated their decision. They reach out to make their choice, often not consciously considering their actions fully, as we know a high percentage of shoppers' choice is based on colour alone.

Websites

Does the colour choice matter? Should the background colour of a one-man band be different to a global multinational? There can be only one answer to both these questions, yes. Colour is the key. It is accepted that different colours have different meanings internationally, therefore the choice of colour and the placement of the colour is important and requires careful consideration.

The components of colour, design, typography, layout, image and language all play their parts and are vital to success, and none more important than colour. Each country is defined by personal and unique cultural and customary behaviours, communicative styles and values. To grab attention, make a statement and keep audiences on the site. Websites are an effective form of recognition. To build brand loyalty the website and branding must be memorable, and colour fits the bill beautifully. Apple have stayed with white as their global background colour, regardless of international perception and meanings; it's a canny move, as everyone worldwide reads from text on white paper and writes on white paper, therefore the most comfortable colourful way for reading is black text on a white background.

Psychology confirms the first stage is feeling comfortable; when we feel comfortable we stay/linger longer. Within seconds audiences decide whether to stay or move on. A hard hit of clashing primary colours or a background colour that makes reading the text difficult is not conducive to feelings of comfort. The key is to get people talking about you, your site and what is

on offer. Good news travels fast.

Physics

The science of colour and light is being heralded as new and exciting, yet research confirms it is well documented and goes back to ancient times.

Aristotle 384–322BC – from his study of how light travels arrived at the theory, which remains close to current thinking. Light travels in waves. There was much scientific debate about the wave versus particle over the following 2,000 years until physicists Max Planck (1858–1947) and Albert Einstein (1879–1955) laid the foundations for the currently accepted quantum theory. The current theory is that light energy moves in discrete packages or quanta, known as photons, and this movement is a waveform and a wave with a long wavelength and has a low frequency. Red has the longest wavelength and slowest frequency, whereas violet has the shortest wavelength and fastest frequency. The healing effects from wavelengths, which we perceive as colours, are greater than from white light. Red stimulates and boosts healthy cell renewal, whilst blue calms and reduces inflammation. There are 7 accepted colours in the spectrum today, but the number of colours in the spectrum must be open to question and depend upon on how the overlapping colours appear.

Electromagnetic waves have three components: wavelength, frequency and amplitude. Amplitude is the height which measures its intensity. The wavelength is the distance between successive waves, and the frequency is the number of times the wave oscillates in one second. The general rule is the longer the wavelength the lower the frequency. A wave with a short wavelength has a high frequency. Since earliest days, many from diverse backgrounds have attempted to understand and have investigated colour. Extensive research and studies have been carried out by many high rankers in philosophy, physics and

science. Unfortunately for too many years their sole interest was looking at the physics of colour rather than to grasp and understand a more whole and fuller view to include the importance of psychological and emotional significance, even spiritual. Some expanded upon others' work who had gone before, and colour became pigeonholed and imprisoned in physics.

Today there are two schools of colour thought: the left brain colour camp supports and upholds physics by complicated scientific and mathematical explanations of colour. These can be unyielding in the acceptance of the ability of colour to transcend all matter, but in life there are some things that cannot be tried and tested: they just 'are', as colour is more than calculations alone. The right brain colour camp is accepting of the powerful transformational effect of colour on the whole being, mind, body and spirit. Always questioning, trying new ways and never accepting with blind faith. Colour shall reign victorious when the best of both camps is merged. The scientific world can still view colour as having no structure and see it as subjective, missing the fundamental truth. Colour cannot be slotted neatly into a universal colour system as it has many different meanings worldwide.

Colour Systems

Today we find many different and 'new' colour systems emerging in the West, and in my opinion, needing a colour meaning overhaul. It is in the West where we have seen colour interpretation/association changes. Chinese and ancient cultures were averse to change and their colour meanings have stood the test of time. They trusted their ancestors' wisdom coupled with thousands of years' usage. Unfortunately, in the West, I believe, commercial competitiveness, greed and monetary gain has driven the changes made to colour association and meaning, rather than proven ancient colour knowledge and know-how. To appear innovative and new, to support colour predictions, I

believe some companies have wreaked havoc and damaged how colour is perceived. They have changed colour meanings and it may be the very reason why in many cases colour has not worked as effectively as it should have, and why colour has led a backroom existence for many years. It is only in the past years that we have seen colour rise, straddle and be presented by these companies with 'new' colour meaning and association. Regardless of changes made on its behalf, and without permission, colour remains a formidable force, screaming to be heard and determined to take its rightful place. Colour will not be silenced into submission. With the best will in the world, and try as some might, colour failures will happen when an incorrect colour palette is chosen, and that, my dear friends, is the crux of the matter, and nothing I nor you do can ever change that.

Ancient Colour Systems

The Chinese base sound principles on the ancient Yin-Yang system, the I Ching and Feng Shui, together with many more ancient tried and tested methods. They stay with their traditional meanings of colour and direction bringing together a winning formula, although not without fault. No colour system can be perfect because the human element is vital to all systems, and therein lies the weakest link. However, I respect the determination to uphold sacred traditional values and proven ancient ways, which we so readily discard for the 'new'. Scientific views on colour have not been given the authoritative placement in the East that we so readily uphold in the West. The ancients and Chinese have a great respect for the ancestors' interpretation of colour as proven by unchanged colour systems that remain the same today as in ancient temples. The code of law according to Sung tradition was birthed to the world in the form of a diagram held in the mouth of a dragon horse. The colours on this ancient diagram stand today – unchanged: with the earth in the centre and, holding the centre solid, is yellow. The other four colours

point in the four directions as hailed by many ancient cultures worldwide. Most easily recognised and known is the Native American 'four- direction system'.

- Fire – South direction – Red
- Wood – East direction – Green
- Metal – West direction – White
- Water – North direction – Black

This demonstrates the four directions, colours and the seasons. Fire represents summer, Wood spring, Metal autumn and Water winter. The colours used in ancient Feng Shui have traditionally stayed the same, apart from a few new rising systems. When we look closely the majority of the 'new' systems have either been created in the West or by Westerners. There are many meanings and the study is lifelong. I shall show one for each direction in my example, and should your imagination be fired, there are a raft of excellent traditional Feng Shui books on the market for further information. For the purposes of my example I want to cite instances of the Chinese traditional colour meanings left unsullied for generations and throughout history.

Direction	Colour	Interpretation
South	Red	Fire
Southwest	Pink	Together
West	White	Enjoyment
North	Black	Strength
Northeast	Blue	Enquiring
East	Green	Growth
Southeast	Purple	Rising
Northwest	Violet	Peak
Centre	Yellow	Movement

Chinese tradition and ancient cultures in the main respected

tradition and kept the colour meanings the same; whereas in the West I believe colour meanings have been distorted and driven by business competition, rivalry and commerce. Colour creates formidable impressions and drives every area of our lives and never more so than in the important areas of well-being and business. Colour is the pivotal visual element, aesthetically pleasing, unsurpassed and the most profound and important non-verbal communication tool available. The colour choice for business heavily influences customer choice of one product over another, and therefore determines the popularity of the brand and the best-seller, long before customers have rationally processed what instigated their decision. Customer choice is decided upon by colour. To be successful in global business companies should be looking more closely at 'how' colour can work for them to ensure business success, as colour plays a most vital and important role in business and global trade.

Uniform – Dress Code

It is worth remembering when wearing colours that it is the visible colour that is being reflected outwards for all to see and the complementary colour is affecting the physical body of the wearer. Always consider the duality of colour when choosing a uniform or clothes to wear. The duality of colour can sometimes be overlooked and forgotten.

If you think about it quickly but without analysing it, you naturally react more formally to someone in a navy suit than to someone in a yellow one. Colour can and does affect our reactions to people whether we want it to or not. The effect is subtle, but very real nevertheless. In the form of uniform, it can help people feel connected and a part of something. It is a way of extending the brand image to customers. You have a sense of equality but also lack a chance to express your individuality. The first time we come across real use of clothing is in our school uniform. It may have been itchy, but you and your parents didn't

have to spend precious time deciding what you wore that day! So what about work uniforms? Are they a good thing? One of the easiest ways to sway a decision is by the colours you wear. Wearing certain colours will influence the way others relate to you, and I don't mean glancing at colour online, popping on a pink top thinking you've cracked it!

Colour is far more complicated and needs a seasoned professional with many years' practical corporate experience behind them to oversee significant colour changes. You can send a positive or negative message by the shade of colour you wear or use in business. People are more influenced by the colour you wear than by any other aspect of your appearance. Companies spend considerable money on changes, which can either go really well or dramatically wrong. The health considerations of colour need to be taken into the equation. Staff will be wearing the same colour for five days of the week, therefore it is an important factor for consideration and discussion.

Red – Commands attention and our every action. It is the colour of our physical self, our survival instincts and our connection to the earth. Red activates, creates movement and arrests attention. It expresses passion, danger, anger, joy and celebration. Creating warmth and excitement, red stimulates our senses, it has the longest wavelength and slowest frequency. Having the closest vibration to infrared it creates a sensation of fiery heat and warmth. Red boosts our circulation, raises blood pressure and gets our heart pumping faster. It raises our libido, increases determination and gives us the will to move forward. It pushes us to break free from the past and demands that we live in the here and now.

Orange – Lifts our spirit, freeing our emotions. It encourages us to feel liberated and happy. It casts a spotlight on our creative impulses, nurturing them and providing us with the energy to put them into action. It works powerfully on the emotional self, releasing feelings which may be deeply buried or hidden. Orange

gives us the self-confidence and enthusiasm to live our lives with joyful independence. It has a milder effect than red on the circulatory and reproductive systems, and is a good colour to use for menstrual problems or painful periods as it relieves muscular pain. It can give relief to sufferers of asthma and is an antidote to depression and loneliness. It enables us to release fear, tiredness and increase tolerance.

Yellow – Vibrant rays of sunshine stimulate the intellect, radiating outwards. It is the colour of the self and the ego. It stimulates our sense of self-worth and empowerment, waking us up to our feelings about others and ourselves. Yellow ignites self-confidence helping us to realise our place within the world. It helps bring mental clarity and focus, strengthening our mind and ability to absorb knowledge. An energiser, it aids exhaustion, relieves arthritis, helps relieve water retention, acts as a stimulant and is even helpful to use when giving up smoking as it removes toxins from the body.

Green – Balances, creates harmony and brings us back to our natural centre. It connects us to feelings of love and compassion for one another and for the world we live in. It regulates and harmonises blood pressure, the nervous system, soothes and relaxes the heart and calms the whole physical and emotional body. Green encourages growth, self-love, eases stress and strengthens our inner resolve. Fresh lime and vibrant apple green stimulates us to earth and brings about new ideas.

Sky Blue – Creates a feeling of peace, serenity and trust, and has a cooling and calming effect on our senses. It encourages us to communicate our needs, realise our soul's purpose and express our creative self. Sky blue helps relieve insomnia, lower blood pressure, calms the nerves, eases the mind and soothes the entire being. It has an anti-inflammatory and antiseptic effect on the body; it relieves stings, itchiness and rashes. It calms, cools, reduces fevers, feeds the respiratory system and links to the throat and thyroid gland.

Violet/Purple – Links us to our divine will and our spiritual quest in which we desire to experience all that the universe has to offer. Violet inspires us to seek answers to philosophical questions and develop our ability to freely discuss our changing beliefs. It encourages us to aspire to our highest ideals, replacing creative blocks with inspiration. Violet purifies the blood, relieves skin problems, nervous headaches, eye and ear problems and sore gums. It restores calm to the body and mind, easing headaches and migraines.

Grey – Moody and unapproachable or in the thick of things stirring it up. A point not widely circulated or known about grey is that the shade is paramount to ensuring positivity when worn. Grey can be a glorious colour to use as part of a corporate dress code: the defining factor lies in the shade chosen.

Brown – Another colour that requires caution. UPS have got it right: cream with brown works for their business. It's smart, approachable and oozes responsibility with a professional air. Brown can work for the financial sector too, yet is rarely seen in that sector. Blue takes prominence in that area: a case of follow the leader with blue, I'm afraid. For some reason years back everyone believed only blue would do; I hope we see refreshing and more appropriate change in the near future.

Black – Great for the artistic, creative sectors, but not as a generalised across-the-board colour for all. Each will have their own way of working and delivering their service, therefore requiring their own identity.

Magenta – Is the colour of respect, demanding and giving in equal measure. The colour stimulates a balancing of emotions. Releasing from past conditioning, the colour of earthly wisdom combined with spiritual knowledge. An organised and protective colour that respects tradition while seeking the new.

Chapter 5

Corporate Personalities

Colour can sway behaviour, emotion, perception and judgment.
June McLeod

Red – Motivated Action

Reds crave attention. With a spirit of adventure, they adore a challenge, with a 'gung-ho' and 'can-do' attitude. They are more than able to take on tasks that others may feel defeated by. With a pioneering spirit for adventure, and the support of a loyal team, they can see things through to completion. Left to their own devices reds can flag at the last hurdle, therefore, it is at the last hurdle with the finishing line in sight that colleagues need to rally and offer their support, as reds need the reassurance and support of others at the end of a brief. More than able to delegate throughout yet hold on tightly to the reins, taking ownership and responsibility of the brief as a given. Reds do have the vision to pull every part of any brief they are allocated together beautifully and seamlessly with gusto and sustained effort and energy that floors most. The brief in red's hands is safe up until the last push (having used every ounce of energy getting the vision to become reality); it is at the finale that reds need to know, even if they are not used, trusted others are there on the sidelines, willing and able to step up to the plate at a moment's notice. Reds move with lightning speed, following what appears to be a dormant time. In reality it is a time of careful consideration, mulling over fine details, cementing the vision in the mind and thinking through the 'what ifs?'… once embedded. Then, lightning strikes as all hell breaks loose: they are off like a Formula 1 racing driver at breakneck speed, depleting energy faster than you can whistle.

At top performance level, blink and you'll miss them. Reds are

born leaders with a lust for adventure, curiosity and trying out new things. They are passionate about many things, but must be careful not to use energy to excess. Reds can burn out more easily than other colours. Impulsive, energetic, reds tend to dive into things feet first, which can sometimes lead them getting into hot water. They want to work on their own initiative. They adore movement and change in a working environment, and to be seen and recognised for their efforts at work, with huge amounts of energy for projects and interests they feel passionately about. Their strong will can sometimes be used negatively to control and manipulate others. Be careful. Channel energies for the good of the whole. Initial bursts of passion and energy can lead to burnout, so focus needs to be on seeing projects through to completion.

Orange – Versatile Planning

Oranges have a good sense of humour and can be independent with a positive outlook: they love to live life to the full. Oranges are optimistic, seeing the best in everyone and each project. "Always look on the bright side of life... da da... da da da da... always look on the bright side of life..." sees orange tripping along whistling to the tune. They are usually morning people, up bright as larks then fading by late afternoon. A midday catnap will work wonders for orange's energy levels, giving a boost of much needed energy to sustain the happiness gene.

The laughing clown hiding self-imposed insecurities, with nearest and dearest being the only people privy to the differing layers of doubt and insecurities that rumble away internally and are rarely seen or recognised. In the working environment oranges have a great ability to hide their innermost felt emotions of unease and insecurity, yet they release and share the happiness gene. Every team needs an orange player to ensure spirits are lifted and the energy sustained. When the tough gets going, orange appears on the sidelines to enthuse, to cheer you on, to

support to get you over that finishing line. "Come on, you can do it," shouts orange, the life coach of the spectrum, seeing all sides to situations. There are just two colours with this drive, orange and indigo. Blessed with identical abilities, no other colour can touch them for enterprise and sustained genuine effort for themselves and their team. They are capable, versatile and able. They love to travel and meet new people, have new experiences, and are creative thinkers, spontaneous, paradoxical. More than able to work alone and on their own initiative. Yet they feel happier in groups or as part of a team. With a natural outgoing personality that deplores drama, with effervescent and contagious humour, fun and laughter are key for orange. "Always look on the bright side of life... de dah de dah de dah de dah de dah." 'Living life to the full' is of utmost importance, they grasp the 'live for today' theory. They shine on social occasions with their love of meeting new people, and appetite to travel.

Often short journeys and channel hops for a night or two stopover on the spur of the moment is typically orange. Knowing that they can get away from it all at a moment's notice uplifts and refreshes; they need to be able to get away from pressure to regroup and to rethink their strategies and position. Just like greens, they need to let off steam by escaping. Getting away does wonders. No one wants to be around orange or green when they explode. Other colours can be dramatic when they lose it and orange and green mean business. On a happier note, orange will bring a light and playful atmosphere to any occasion with a good clean sense of humour backed with a positive outlook. They work on releasing self-imposed barriers that may be holding you back, recognise your insecurities and let them go. Talking about your deeper emotions or writing them down can be a good form of therapy and release for you.

Yellow – Analytical Networker
With a strong mind they love to absorb information, the mimic of

the spectrum, the social butterfly. Networking was termed for yellow, with a self-justifiable attitude… 'I can do that better'… their self-belief is untouchable and cannot be challenged by any other colour. Yellows are admired by others, they overturn reds' 'can-do' attitude by spotting a gap and filling it almost immediately. Yellows do not spend time mulling over and contemplating as much as reds can before they take fast action. Yellows are on the case, sustaining momentum throughout, by highlighting the flaw, the gap in the market. They research with gusto, moving quickly on to create, design or source the 'filler' job done. They then flutter off like the butterflies they are to the next project. Yellows don't hold on to past experiences; they are not generally tenacious. As long as they receive the level of praise they feel they deserve, they are happy to fulfil a brief and move on. The key with getting yellows to eat out of your hands is the level of praise as and when they feel it is appropriate. Timing is everything to yellows. Many a missed trick is due to poor timing. Innovative with many inspiring ideas is a plus that is inherent in yellow and needs nurturing. Thinking about things too deeply, over thinking is a flaw that can easily be overcome by working on connecting to your inner voice, using an analytic mind; practise following your feelings and intuition more.

Not everything can be or needs to be analysed and tested. With a talent for organisation and spotting gaps that require filling flaws that others may miss, yellow are unsurpassed in their abilities. Your many interests and activities at work and for leisure can fuel your butterfly tendencies to flit from one to another, in some cases from one person to another. Aesthetics are important to you, you always make a positive impact at social occasions, but often only reveal some parts of yourself to others, the perfect example of a chameleon. Some will know one part of a yellow and others another. If everyone who knew a yellow at work, home and leisure were brought together, they would all describe someone different. Remember yellows are mimics. They

blend in beautifully, up until the point of boredom, then flitter off to another group to present as someone else and enjoy the new-found experience. They can be whatever is expected or wanted of them. For this reason, yellow... know thyself. Talented orators and writers, communicate well relaying what needs to be said in a succinct and tight format. Getting the message across and heard is a gift that comes naturally to yellow. The ramblers of the spectrum, let's say it all, are the sky blues: 'Why use one word when 500 will do?' Yellows have an illuminating quality that can light up a room. Presentation is very important to them with a good sense of the quirky and funny side of life. They are broad-minded souls blessed with a clear, logical mind. As long as they rein in their sarcastic and judgmental attitudes that spring up, and keep them as thoughts that can be internally processed (without voicing their strong opinions), then all will be well.

Green – Strategic Financier

Industrious, hardworking, trustworthy and dependable. The accolades can go on for green. Trustworthy, good listeners treating others how they would wish to be treated themselves with a quiet given respect of others and others' opinions. Green creates a nurturing and supportive environment whether at home or at work. At home they are the spectral homemakers. Females express green in the home by being mother earth types, homemakers and creators. Males are the same, both sexes love to take every opportunity to display their cooking skills, to cook for themselves and friends, and when shopping for ingredients only the best will do. All of these skills are transferred to the office, and greens go out of their way to create a harmonious workspace for themselves and their colleagues. Warm and open-hearted they have a special care and love for their environment. At home they work with the open door policy, everyone is welcome, by offering good company, great laugh, good food... a winning combo. With a love of beautiful things and good food, greens are

happiest when they are sharing their good fortune at home or at work. A real team player with a strong sense of fairness in the workplace, on that there is no doubt and is what makes green stand out from the rest.

Indigo shares the same deep principles as green; all victories are to be shared in green's eyes and no one person takes credit, seeing and hailing the abilities and input of the people behind every aspect of the project. Green sees easily that a result comes from a team effort and recognises all who played their part, whereas other colours given the job of presenting the findings can easily grasp full credit for the findings. They conveniently forget all those who worked hard behind the scenes to bring the project to fruition and public airing the results. Green inputs and works hard whilst acknowledging everyone's part in every project. On a day to day process and along the way, greens will need an escape strategy; as momentum and pressure builds, the intensity is felt with every fibre of green's being. They have to acknowledge the need to regularly take time out and away for overnighters and weekends, booked on the spur of the moment to keep the explosive tendencies at bay. A green exploding is not a pretty sight nor one to forget. At best, a joy to be within 10 yards of absorbing the harmonious level-headedness greens are famous for. Yet... on the rare occasion greens explode all hell will break loose, and I challenge anyone to choose to be within spitting distance of a green at the time. I am convinced the *Hulk* programme was created following a green explosion. However, let's come back to the reality of green in everyday life; when a green takes regular time out, keeps mind, body and soul working in harmony, it is then hard to beat a green for fairness. A natural peacemaker, a mediator and more than able to see all sides of a situation. They have a unique talent and ability to nurture, and encourage others in their personal growth and in reaching their potential. Greens are dependable: will always be there. Jealousy can rear its ugly head in every colour personality, but greens do

not have the monopoly on ego and jealousy. Greens will feel deeper and hold on to hurts and betrayals longer than any of the other colours.

Sky Blue – Project Communicator

Peace-loving characters but certainly not sit-on-the-fence types. Sky blues will happily voice their opinion and trust that they are heard. In authoritative positions they dislike repeating directions, rarely suffer fools happily, yet they possess the patience of Job when they feel it is genuine and appropriate by repeating over again when necessary. They don't like to let anyone down; being blessed with a generous spirit and a giving nature they need to remember to allow themselves to receive. Others feel good in their company as they have, amongst many more attributes, an uplifting and serene energy emanating from them. They can be sensitive souls. The need to express themselves, to be heard and respected is of utmost importance. Sky blues need to speak up and out more and express the deep intuitive nature that naturally bubbles away until noticed. Once aligned with and using their intuitive, gut feeling abilities, this extra gift can be used to advantage in the workplace and relationships on any level. If it feels right, move on it, action. Should a niggle keep chipping away, by creating a funny feeling in your stomach? Hark well, listen, be cautious. Inventive, talkative and very communicative. Sky blues are good at nurturing team spirit and having a good sense when someone isn't bonding with the team, and the reasons why or whenever trouble is brewing, when there is trouble at mill, within the team or project, blue will know before other colours (and this includes indigo who have an even stronger nose than sky blue). Sky blue will sniff out trouble at 50 paces, a rare gift. Indigo can sniff out problems at 100 paces, an even rarer gift.

Either colour will be excellent to have on-board a project. They are the most likely of the colour personality types to enjoy

working from home, able to work on their own initiative and fulfil the criteria and to complete a brief. By working at home they enjoy the sense of freedom so important to sky blues. The need to feel they can fly freely is vital, and to work to a timetable that suits them (usually early risers with best energy levels in the morning), they soon grasp that sooner they are heads down after rising, more is achieved.

Lists, lists and more lists, for some unknown reason blues, both sky blue and indigo, love lists, to tick off, to store, to file. They are hoarders in the organisational sense who don't throw that list away as it may 'come in handy' syndrome is blue's philosophy and can rise up in blues at any time. There is no one as bitchy as a negative pink, by jeeps... Keep that under wraps at all costs. The only colour that comes close to being as bitchy as pink is sky blue. Unique in their ability to shoot down another by sarcastic wit, is devastating for the target when overheard on the floor by others. When a sky blue fires bitchy ammo, best to dive for cover and get out of their way. Leave the room, keep your head down and focus on anything other than being on the receiving end. On the positive side, the firing will be short, quick and direct. More often than not sky blue leaves the scene. A quick fire then exit leaves a more indelible impression than perusing the damage. Sky blues know they can't be touched for sarcastic wit, yellow comes a close second. Rarely is the 'gift' applied; when it is, pull up the drawbridge. Natural debaters erring close to arguing and, like a terrier with a bone, won't let a matter drop. Opinionated? ... Never... claim sky blue, absolutely... claim the other colour personalities. In their defence they are natural orators, can communicate on any level, just like indigos. More than able to get their point across. Exciting debaters they are a must have attendee for every important meeting and discussion. With sky blue onside the deal is kept on track and keenly guided through to final negotiations, then sealed.

Indigo – Inspired Management

Blessed with a sharp wit and a deep unique understanding of the unspoken. They are a master at picking up correctly on non-verbal communication. Indigos can feel when the status quo has shifted, even slightly, and know unless action is taken that they can become unbalanced; therefore they strive to resolve a problem, way before other colours even sense something is amiss. Their abilities come into their own when attending important meetings and likewise at presentations to assess audience reactions. Indigos can outwit and outplay. Underhand tactics are not triumphant against indigo (who play their cards close to their chest). The other colour ways mimic indigo and want to be them; unfortunately for the other colour ways, there is only one indigo. Always copied, never bettered.

Superb organisers, their orderly minds quickly grasp the situation then actions. They are shining stars as event organisers, at conferences, charitable events and corporate meets. Indigo is at the centre of all and more: striving, overseeing and completing. Indigos are confident speakers with a creative witty way with words. They are well known for laughing their way through the difficulties that may arise, but never sarcastic or judgmental. Always humorous and a natural open-minded leader, they are excellent at encouraging and inspiring individuals or groups by building and uniting a strong team spirit. Jealousy abounds, amongst indigo, not emanating from them, but aimed at them. They deal with adversity in creative and exacting ways that do not harm their adversaries other than highlight to and within them embarrassment for the tardy way in which indigo can be treated at their hands. This gives rise to a guilty conscience in others, punishment enough. And all without explosions, sarcasm and drama. Any hurts or negative effects in indigo are rarely seen or heard bar a few very close and trusted colleagues. The public face is always positive and smiling while the inner self is cracked and creaking with the pain – a spiritual soul with great under-

standing of justice. Indigo has the capability to rise to any challenge to soar above the competition. Defeat is not a word that figures in indigo's vocabulary. It's the Phoenix rising from the ashes... written for indigo. They have an ability to listen and understand where the other is placed and how they are truly feeling. Abilities of counsellor shine through. Boundaries may need to be set as indigos will support endlessly where they feel there is genuine need, sometimes to the detriment of themselves and their own energy levels. A great sense of humour and an ability to communicate on any level, they are a star in the colour personality selection. A must for any business, indigos will make their mark and usually leave a legacy behind. Once met never forgotten; their creative talent for bringing to the table innovative practical usage is indigo's forte. What comes easily and naturally to an indigo takes much effort from other colour personalities to even arrive at the starting block. Others struggle to work at arriving at the starting block while indigo is racing down the track way ahead of the competition.

Indigos feel deeply and sincerely and are hurt often, yet have the ability to never allow hurt feelings to show on the surface. When interacting and engaging with indigo no hint of deep feelings other than sociability and positive rhetoric are experienced. The piercing ability of indigo to get the nitty-gritty out of the most complex situation is a gift indeed. When interacting indigo will pick up on another's innermost feelings because nothing is hidden from indigo. Seriousness is a fault at times, brought on by digging deeper than most into every angle to unearth the consequences of every players' actions. This is a heavy load indeed, and can go some way to justify the serious mood rarely displayed for public viewing. When evident and experienced it can be very heavy and daunting, and is always felt in the surrounding atmosphere. A grasp of the reasons behind the heavy atmosphere needs to be understood to appreciate indigos and to know it is them not us nor anything others have done.

management is necessary daily for purple, and never more so when they are full on and getting their teeth into the project, when time literally flies out of the window for purples. Inspired thinkers coupled with a cautious, careful element to their personality, unlike indigo and sky blue who will dare to take action.

Purples will restrain from taking action until absolutely cemented in their thought processes that every angle is thought through. More importantly, that leading executives approve, and this is where the difference lies between purple, sky blue and indigo. Once conclusion has been reached and after careful, considerable analysis, sky blue and indigo will make their move regardless of wider opinion. Their research reveals and supports results for the betterment of the business. Purples will follow through with the identical analysis and research arriving at same conclusions yet never feel truly comfortable taking the required action until senior management are made fully aware and agree to the actions needed. Once given the nod purples are unstoppable: every detail is carried through with exact precision.

An instinctive personality, hopefully the right brain is given some credence rather than all left analytical brain thinking. The intuitive side is strong within purple and they need to stay with their first line of thinking on any subject. Purples cannot be sheep otherwise they do an injustice to themselves and their colleagues, yet purple is the easiest colour personality to mould and, sorry to say, manipulate. Once out in the open and taken on board, purple have every resource necessary to knock this part of their personality on the head once and for all. To be aware of this glaring trait brings an awareness to mend and to fix the weakest link in the armour to ensure that no one invades and manipulates purple's good nature for their own ends (to aid and abet their own rise within a corporation). Bringing many positive and unique changes to people's lives, purple reigns supreme by motivating and teaching people by example... 'don't do what I say, do what I do' is purple's mantra. Prone to melancholy and over precision

of detail, brought about by a sense their achievements are never quite good enough. They can go over and over a completed brief; to other people an excellent and thorough piece of work. Everything has to be perfect in purple's eyes. To them, if it is not quite right… many a bin has been fed excellent work that purples redo and go over to their detriment, causing them a melancholy state of mind over their wrongly perceived incompetence. Unfortunately, their level of perfection is more than good enough and surpasses other levels. Impatient with themselves first and foremost, and frustrated they find their energies slowing. To redress the imbalance, find ways to relax and unwind. The purple mind is very active; they need to take time out to rest.

Magenta – Ambitious Entrepreneur

Naturally at ease in a business setting, magentas give and demand respect, for themselves and the current project. Unless they feel passionately about a brief or project, expect magentas to bail out. Faced with no choice but to proceed, their passion will fade faster than any team member, their disinterest palpable. The opposite is true when fired with interest and passion for a task. There is no stopping a magenta, flying against the face of diversity and against all odds. Magenta meets timelines and deadlines and pulls the rabbit out of the hat every single time. Magenta treads where angels fear to go to ultimately achieving the goal. The message is loud and clear when dealing with a magenta: delegate very carefully, to your benefit or detriment. Enthused, fired up and passionate, magenta wins the race, but disinterest and boredom bring about chaos. Your choice! Discuss thoroughly and carefully every detail. Observe magenta's reactions, level of interest and input, then and only then delegate. Magentas are natural business people, who are practical and down-to-earth and able to bring a spiritual element to the work that they do. They are capable of making their ambitious dreams a reality. Magentas respect and admire decisive management. A

strong handshake is noted more by magenta than other colours because the moment they are in receipt of a weak handshake, body language experts see them recoil (albeit a slight reaction and possibly missed by the untrained eye), yet there all the same.

Magentas enjoy organising themselves with time management lists, timetables, pie charts and are enthused when organising others. A management trait of magenta is visible to all, as magentas walk their talk, with a deep seated belief in 'what goes around comes around'; as above, so below is a mantra for magentas. They are fair and work hard to be fair and to see all sides in every circumstance. Favouritism is a turn-off for magenta and they fight hard to alleviate favouritism and treat everyone from the cleaner through to the CEO with respect. Respect and fairness play a large part in successful negotiations with magenta. A combination of red and purple create magenta, therefore a combo of both colour personality traits. People will display varying degrees of traits dependent upon the individual, the chart will highlight the attributes from the birthdate. Warm, respectful and welcoming. A combination of both ends of the spectrum gives magenta completeness, by combining all aspects giving a rounded effect, addressing all and satisfying all.

Gold – Insightful Performer

Gold is blessed with an alarmingly accurate insight to a situation. Where there is a non-performing sector bring in gold. With a wide range of zenith proven abilities their sound guidance and advice is priceless. Golds tend to be the quieter types, not in the background as such but with a more relaxed style. They are certainly not up front, in your face, like other colours but a more steady solid presence. They are confident in their all-round knowledge and ability that has been hard won by experience. Their tactical skills are unsurpassed and their steady determined focus on end goal can bring about miracles where all appears lost. Rarely will gold be found amongst tomfoolery. Their energy

best spent solving problems, fixing and mending. Once achieved, gold seeks out the next 'job'. Never seeking accolades, recognition or applause, gold moves in one direction only, forwards, they trample down the weeds, uncovering the weak spots, repair and mend whilst putting in place systems that are innovative and workable. Gold picks up where others have lost interest.

An inspired mind, go-getter performer who listens, seeks truth, offers solutions to old problems, a must have on board. Gold likes movement as they can stagnate if kept placed on one task for too long or alternatively sat at a desk daily. Gold needs movement. They are the colour nomads; ensure their brief includes time out of the office meeting, researching and discovering. Otherwise their restless spirit can see them seeking another post elsewhere and the last thing you want to do is to lose gold. To have them eating out of your hand, enjoying fully their working environment, ensure that their tasks are varied. They move around and like to be left to their own devices to work on their own initiative. Golds will perform and complete the task and provide solutions that are not uncovered by others. In return they need space, freedom to move around the office with some time during each week spent out and about. Complex sometimes, contrary rarely, but never has a gold not completed. The gold mantra is... completion. Regardless of whether they stay or go, they will never leave tasks incomplete. A handover from a gold is usually a joy and one of the easiest handovers to pick up from: complete and in order.

Chapter 6

Environment

The beauty of the trees,
the softness of the air,
the fragrance of the grass... speak to me

The summit of the mountain,
the thunder of the sky,
the rhythm of the sea... speak to me
and my heart soars.
Chief Dan George

The further we search, the simpler and more balanced we discover
the world to be, the more we discover, the more we reconcile with
ancient wisdom.
June McLeod

Colours in our environment affect us on a daily basis, acting as conscious and subconscious triggers that influence how we think, feel and react to the world around us. We are able to see approximately seven million colours and some combinations can create a clash of the senses, whereas other colour combinations create an atmosphere of harmony and balance. The right choice of colours can create a haven for relaxation or an upbeat environment that can increase productivity, stimulate the mind and raise energy levels. A place to escape, gather thoughts, create and ponder is essential. In the past workers went to the loo or had a cuppa to get a well-earned break, a breather, to put distance between themselves and their work. Sometimes just ten minutes away from the desk is ample time to relieve any feeling of mounting pressure. Today forward thinking companies provide

play and relaxation areas for staff, recognising the importance of keeping a happy workforce whilst encouraging loyalty balanced with more production. In the right setting and combination, colour is a great motivator and has positive benefits. The work environment must provide a stimulating and motivating environment for workers. The correctly chosen hues, fit for purpose, can have a calming effect where needed to refresh workers. In today's fast-paced working environment colour plays a vital role.

The colours we surround ourselves with have a profound effect on our mood, well-being, personality and emotional stability. The correct colour combinations can inspire us to achieve our goals and progress in life by increasing our determination to succeed, steer us towards our goals in a positive, 'go get it' frame of mind. Many things are made possible with the right colour. It is the most powerful tool at our disposal, yet the least understood. I believe our connection and discovery of the natural world is positive and vital on so many levels, including well-being, stress reduction and mental health.

We are gradually losing our natural rhythms by disconnecting with nature. We have lost our natural rhythms. We need to regain our connection to mother earth and find our way back. The more sensitive we become the more we need to get closer to nature to keep balanced, rooted, and in touch with the real world that surrounds us all. Everyone has their own vibrational frequency: it is said 7.58 hertz is the norm. The colour around us is constantly changing in shade, volume and density, according to our mood and health. More people are feeling the stresses of modern day life, insomnia is escalating and the more sensitive need to reconnect to the earth to feel rooted and balanced is palpable. We each have our own frequency, multiple studies confirm each muscle, bone and organ of the body vibrates to its own frequency. This in turn produces the electromagnetic field that surrounds us. Colour has a higher frequency than sound

therefore colours are more effective therapeutically than sound. By analogy, the homeopathic principle that higher (more dilute) potencies have higher vibrations equates to greater effectiveness than remedies with lower frequencies.

The long-standing trend to bring the outside in is helpful in some ways. Interior design goes some way to addressing and recognising the inherent attraction within us to the natural world, yet the natural colour scheme is not always appropriate for every property or building. It is best to remember the golden rule, survey each environment on its own individual merit before colouring. The limited connection many have with the natural world is detrimental to health and inner balance. Other than lunchtime breaks, much time is spent travelling and working indoors, adding up to many hours weekly spent indoors and out of natural light. Hence the importance of getting outside at lunchtime.

Home Décor

When decorating her home, Ruby Wax once joked, having to choose between so many shades of white paint catapulted her into rehab! With a wide choice of every possible shade, and with many more 'colours' emerging monthly, the choice of colour for the home can be a minefield. The most straightforward is to choose a neutral for ceiling and walls, a foolproof way to choose colour for the home. We know colour influences our mood but by introducing the right amount of colour through ornaments, soft furnishings, rugs and lighting, every room can be lifted and brought together beautifully to harmonise with the family – a scheme to suit all tastes. Living in the space for a few weeks before you start decorating or dressing a room allows you time to get to know how you feel in the energy of the space. Mistakes are easily rectified and are not a drain on the purse. Bring the colours most abundant in nature inside. Green is the colour of prosperity, growth and regeneration. Known as the balancer and

harmoniser, a relaxing colour in the right shade and positioning. It is not by chance green unites the spectrum.

A Glance at Home Colours

Red – Dynamic, energising and physically stimulating red can be associated with luxury and grandeur. Red can be oppressive, you will not want to stay in an intensely red room for long.

Orange – Extroverted, playful and cheerful, it's a pure rich hue which will always look opulent. Wonderful for social occasions and parties, as it encourages sociability, happiness, movement and dancing.

Yellow – Is mentally uplifting, optimistic and bright. It's a stimulating colour of both positive and negative emotions. Yellow will boost the ego! Soft creamy yellows will bring a cheer to almost any room.

Green – Encourages feelings of stability and security and is the easiest colour on the eye – being the colour of nature. Our eye muscles don't need to adjust to green as it is a colour which can bring calm, harmony and contentment, soothing all the senses.

Blue – Associated with the vastness of the sky and the seas – a calming colour and the most popular of the spectrum. It instils calm in a stressful world and is supremely restful and soothing. When decorating a room in blue, there is a vast choice from light to dark. Choose the shade that you are attracted to, while taking on board that the lighter shades should be mixed with white and the darker shades mixed with black.

Violet – A regal, spiritual colour promoting mental reflection and high ideals, coupled with a cleansing and clearing energy, especially when the deeper blue white shades are chosen. Violet calms the spirit at the most deepest level, soothing body and mind.

Pink – A refreshing open-hearted colour that encourages nurturing of self and others. It teams well with creams, whites and soft greens. It can be used in any room of the house bar the

kitchen. Pink in the kitchen brings chaos of a different kind when planning i.e. preparing and cooking a meal.

White – Traditionally 'holds' all the colours of the spectrum within it. Its purity can be associated with light, peace and serenity. It creates a clean, calm environment, whereas an all-white décor, with no colour splashes from ornaments, soft furnishings and rugs, offers a space to lose oneself. Unfortunately, this can mean taking oneself away from the wider world and becoming a recluse. White encourages a withdrawal from life and activities, deep thinking and going within and facing demons. It's great for the short term but not wise for permanent living space.

Black – Regarded as a physically protective colour, it can represent elegance and cool sophistication. Black highlights other colours, showing them off to their best.

Brown – A darkened pigment of orange that connects us to the earth, it is a practical nurturing colour, associated with growth, comfort and security.

Grey – A neutral colour, however, certain shades of dark grey can be oppressive and create a heavy atmosphere, although soft dove grey creates a light, open welcoming space.

Sunshine Brilliance – Our Best Buddy
Without daily and regular top-ups of natural light we flag, deplete and sag.

Eat more, sleep more and become a drag.
June McLeod

Whether we are aware of it or not, natural light affects our physical, emotional and mental self. Today we are rediscovering the immense importance of sunlight in our everyday lives as once again it is being recognised and understood for its health-giving properties. Our ancestors knew much of the goodness of natural light emanating from the sun, and today a new generation is

open and eager to relearn. It's a natural health-giving source to benefit every part of our being. The health benefits of natural light are circulating wide and far. Our bodies are dependent on light and operate as a prism. When the sun shines on our body the 'white' light creates the rainbow colours which fragment equally into seven main chakras or energy centres of the body – our battery packs. When our batteries are low, we feel 'off colour'; yet, when we are fully charged, we feel vibrant and energetic once more. Natural light is vital for good health, therefore the homes and workplaces filled with natural light are the places most likely to be conducive to good health and well-being.

Warmer Climes

Many of the warmer climes display their love of sunshine with vibrant colour in multicoloured vibrant textiles and an array of colourful spices. People are awash with a myriad of different colours from colourful clothing, shoes, jewellery and make-up taken from a vast array of bright colour palettes as used in their homes to decorate and dress. In warmer climes we see colour combinations that are not usually seen in cooler climates. What is it exactly that brings out the varied comparison and difference? Does natural light play a part? Brighter colours work more easily and become more restful to the eye and relaxing to the spirit. People on the whole are happier when the sun shines. When we experience the sunshine effect here in the UK, strangers smile at each other. We feel uplifted and better about ourselves, and there is a feeling of hope and optimism in the air.

The warmer climes awash with light and sunshine are a blaze of brightly coloured palettes and mixes that revitalise and uplift. Is it the culture, the light or the heat that is responsible for the glorious riot of colour? Artists the world over speak of how important the light is to their work and of the differing types of light. We know we are more comfortable wearing colourful

clothing in the summer months than in the winter as brighter colours look so much better in sunshine, most likely because colour in sunlight is more appealing to the eye, coupled with tanned skin tones. It has long been known, since the 1800s, of the importance of natural light and colour in a healing environment which has a significant effect on patients' recovery. Blue creates a feeling of cleanliness and healing, it has been shown to calm patients' reactions in accident and emergency wards. Indigo on skirting boards prevents rubbish being thrown on to the floor and lingering.

Natural daylight is key when considering a healing environment as it contains all the colours of the spectrum and is absorbed through the eyes and skin. Patients' recovery time has shortened as a result of them being able to look out into nature:

> I have seen in fevers, the most acute suffering produced from the patient not being able to see out of the window and the knots in the wood being the only view. I shall never forget the rapture of fever patients over a bunch of bright coloured flowers.
>
> Florence Nightingale, 1860

Today paint sales rise sharply during spring through into summer as manufacturers know we need little encouragement at these times to redecorate our homes. The spring/summer light is brighter. It is different, as we come out of the darkness of winter we rejoice in the lighter brighter days, yet at the same time the light highlights our need to redecorate. Nature bursts forth with the first colours of spring. The temperature rises and it is then we begin to re-evaluate our home décor. The brighter days filled with natural light highlight the need to spring clean and to decorate. It shows up in the areas where a fresh lick of paint is needed. In the darker months subdued lighting camouflages many a sin. Winter is the most natural time for us all to hibernate.

How cosy to draw the curtains and snuggle in the warmth of our nest but when the sun shines it is the natural rhythm's alarm, our internal clock – wake up wake up, she cries. There is no place to hide, coupled with a renewed energy the brighter days bring. We spring clean, clear and paint anew with relish. We are more inspired by nature at this time in the seasons than at any other as nature awakens from her winter slumber and bursts forth with spring colours to jolt our senses. The sunlight triggers an active response outside and within us. We spring clean the home, our workplaces, throw out the old, bring in the new. We clean, clear and decorate with a renewed energy. Even the car has no escape from scrub time – the busiest times in the year for car washes are spring and summer. We revisit our dreams and review our goals with renewed optimism. HR departments are busiest, new jobs are created, people move jobs, seek new jobs, move house, travel and reassess their relationships and lives.

Coastal homes the world over are more likely to be painted in bright colours externally than inland homes as the light on the coast is different. It varies in intensity, is markedly different by the coast, the one significant reason why artists and creatives congregate. The light not only helps feed creativity in the most positive way; it also feeds them physically with renewed energy and enthusiasm. It is true that we wear more colourful clothing and jewellery, and use more colour in our homes and everyday lives when the sun is shining. Sunshine seems to spark off a reel of positive events that result in a more colourful, happier way of being. Gardeners nurture and fill their gardens and pots with colourful blooms and everyone tries their hand at planting and growing, whether in the garden, pots or herbs on the windowsill, and we all want to try our hand at growing something. We feel more assured about our abilities. It lifts our spirit and our mood, and we are happier and smiling a lot more regardless of everyday stresses and strains. Additionally, more able to catch and cope with the curve balls life throws. With a more positive outlook and

carefree approach, things don't look so bad and life is manageable. When we are permeated with sunshine and blue clear skies, life is pleasant regardless; things seem easier than when it is grey, damp and cold outside.

Sunshine elevates our minds to have positive thoughts. It soothes our emotions and minds, lifts our thoughts, warms our body, brings joy to our heart and brings about restful sleep giving hope and a spark to our spirit. Why? Because natural sunlight boosts our energy centres, recharges our batteries, feeds our endocrine system strengthening our immune system and being on every level from the cellular level to the skeletal. It is good for our hair, eyes, blood, skin, heart, bones, nails and teeth – in fact every part of us. Fungal toes need time in sunshine and fresh air. Dermatitis, eczema, psoriasis and acne all improve with sunshine, and most complaints improve to some degree in sunshine and fresh air, some markedly so. Convalescing too should not be forgotten. Have you noticed how flaky and dry your skin becomes during the winter when it is covered up and how exposure to fresh air and sunlight eradicates that seemingly overnight? The importance of natural light in the working environment and the home can never be overestimated. Try living indoors never going out into natural light for a week and note the decrease in your mood. Observe your agitation increase, along with the short fuse! After 48 hours you find yourself gravitating to the fridge for more to eat at each sitting and more in between. Food intake increases, sweet cravings increase, after 72 hours headaches, body aches, tiredness, listlessness and fatigue set in... by the end of the week you will appear pale with a washed-out complexion, feeling tired most of the time with restless and broken nights' sleep.

We all need the natural goodness of natural light. Newton proved natural light contained all the colours of the visible spectrum in an experiment showing natural light being passed through a prism. Proving at the most basic level of colour

knowledge that when we are bathed in natural light, we are bathed in colour, and by being bathed in colour we experience mood enhancement, feelings of well-being, happiness and satisfaction of our lot. Natural light sends impulses via the eye to the hypothalamus and pineal gland of the endocrine system to activate the various systems. In badly-lit environments people can feel drowsy, tired and lose their get up and go, which is detrimental to business especially if the staff are customer facing. In an environment flooded with natural light coupled with correct colour choice, staff morale increases naturally. Customers enjoy the experience and have been found to linger for longer, impulse buy, are more satisfied with the purchase and more likely to return. A 'win-win', with more monies spent, increased sales, turnover and profitability.

The future may not be orange; it is however green. Populaces are becoming more eco-friendly and sustainably aware. With a fast rise in eco homes and energy efficient homes, and demand for cheaper heating and cooking, back to basics with wood burning stoves, wood fired heating and cooking ovens are finding an ever-increasing market. The home environment is changing; with new properties getting smaller, the furniture manufacturers are making furniture smaller to adapt. Unfortunately, with smaller living spaces do not come a bounty of natural light, a missed opportunity, as the windows and openings are being made smaller to match the reduced square footage. There are some glorious examples of office buildings that are flooded with natural light for the benefit of all who work in them, proving architects are aware and can deliver. The smallest home should be light filled for the benefit of the occupier.

Chapter 7

Creativity

Creativity sparks innovation and will deliver value and performance across your entire organisation.
June McLeod

At one point June placed us in an imaginary rock band, I was a guitarist, strutting my stuff to George Michael playing. I have never had so much fun and laughed so much whilst learning. Come on up off your butts, she cries, no one does it quite like June and I loved every minute. June encourages people to think out of the box, the best, I love the content, her method and exciting delivery, so different to anything else I have attended.
Janice Fitzgerald

I encourage thinking out of the box, to colour outside the lines. We are always putting things in boxes, even ourselves, although nature doesn't box things. Why do we love to straighten things out? In the majority of homes worldwide there are straight lines, yet in nature there are spirals, curves and circles. Academics find it hard to be creative due to high levels of left brain activity causing an imbalance between the two, yet creativity is a hugely important aspect of the human mind. We need a wider under-standing of what it is and how it happens and to promote the great benefits it brings to everyone and to business. My content and delivery method is renowned, combining fun and creativity with inspirational learning – supported by the best interactive hands-on practicals that are exclusive to my training. Laughter and fun are paramount to learning. My learning package showcases my abilities and passion for colour, to bring the very best out of people. I love what I do and it shows! I have trained

many thousands of students and trainers over the years, under my own name, and under my previous 'Colours of the Soul' banner; the colour course I developed and wrote was certificated. I am thrilled my students are using the materials, tools and method that they were taught at the time, to deliver colour to groups and small to medium sized businesses.

It is a personal pleasure to work with the large blue chip companies and large corporations, reaching many and impacting much by working and developing their colour ranges. To see the advantages and difference colour has made to their business, it is refreshing. To know that they are achieving maximum results inspired by colour is very satisfying. Big business taking the golden opportunity to increase margins and stand out in the marketplace with the colour choices that I have chosen. The bottom line for all business is profit and loss. Each of us has the power within to do more than we can imagine, but without a key to unlock our inherent gifts, we remain blissfully unaware of all that we can be. I believe that colour is the key. The more you work with colour and seek to understand its profound impact and transformational qualities, the greater the benefit.

Image and colour language comes before verbal language, so I start at the beginning to help to release the potential within each person. Research has shown that in an environment overseen by an expert with the appropriate skill set, people are inspired, can find their voice and find new ways of dealing with work-related issues. They can become more proficient in their job, more creative at problem solving with improved levels of self-confidence and self-esteem. Business needs creativity. Business needs the interactive bespoke colour training programme, a beneficial 'must have' for every business type. I have worked tirelessly to perfect my method for more than thirty plus years.

Informative, such fun and delivered with ease, from start to finish there is a careful, considered, planned and thought-through process that has taken years to format and perfect.

Building throughout the session, I take people through a rapid learning process and understanding of colour, to reveal all that is possible. I believe hands-on and innovative colour practicals solidify learning and give a deeper understanding of the subject, encourage teamwork and foster self-development, rather than standing at a flip chart lecturing. I prefer to guide and encourage people to discover colour whilst revealing how colour can first and foremost impact on them.

Colour will transform their own lives and their loved ones. Before showcasing colour's amazing ability and impact on their lives in the world at large, attendees are taken outside to work whenever possible, weather permitting. I prefer to work outside, to be surrounded by and to observe nature's colours. The whole process is relaxed, yet creative. Learning is unfolding from the moment the session begins. As the session closes down, a further selection of art, music and colour practicals are introduced to encourage people to view their situation differently, to find new solutions to old problems. The transferable skills learnt during the session can be taken back to the office for the benefit of the team and the business.

The colour sessions will feed people's creativity and help them excel at whatever they are already good at. Suitable for all types of business, the programmes are thought provoking and will increase productivity in business through effective teamwork and communication. The business benefits from people's renewed enthusiasm and focus and motivation to rise to everyday challenges, and strategic changes in a healthy and productive way.

Impact and feedback results of my colour training to date:

- Encourages creative thinking
- Discovering new ways of problem solving
- Improves problem solving
- Self-discovery and open to potential

- More drive
- Recognising importance of their role in the business
- Releases creative potential
- Learning new tools and ways to express creativity
- Encourages confidence and therefore reduces stress
- Improves work performance

All this, and more, taken back to the business for the business to benefit. I have proven in my work that colour and creativity are fundamental to business innovation and success. My method combined with my exclusive colour practicals provide interactive and hands-on experience of problem solving techniques in a new and exciting way.

> June expresses and expounds in beautifully plain language the hard to grasp technical colour stuff that blocks most minds, coupled with her innovative method and fun delivery to cement the information; it is clear, understood and retained. So unequivocally gifted with the ability to articulate profound colour knowledge and ancient wisdom her level of understanding is unsurpassed. An incredible person.
> Andrew Samson

I combine interactive play and dance with various colour techniques, combined with ancient knowledge. The music choices are taken from a selection of pop, rock, jazz and classical music dependent upon the exercise. I insist that the group breaks regularly in between creativity and colouring to leave seats and move to music or to interact with a hands-on colour exercise. When I invite the group to get up off their seats and move to Abba's *Dancing Queen*, a firm favourite of mine, I am not sure I can classify it as dance, so let's stay with good fun and movement! No sore butts in my class.

If at first the idea is not absurd, then there is no hope for it.
Albert Einstein

Over the years many of my innovative and creative methods have been viewed with both disdain and much scepticism, and in some quarters even horror! I carried on regardless, experimenting and working with my beloved colour in new and very different ways. I took the harder path veering from the traditional colour path; I knew in my heart of hearts colour was far more and could offer mankind far more than was accepted at the time. Today I am thrilled to see many of my methods and practicals and innovative colour practices being shared worldwide.

Aristotle was closely associated with mystery centres, where an invitation for young pubescent boys and girls was to participate in a ritual dedicating themselves to higher forces and the opening of their inner world. Much importance was placed upon what the inner worlds revealed. The path to wisdom begins with the opening and development of the inner self and on the forms revealed during quiet meditative times. Ancient tribes of every culture know this to be true. The creative imagination plays an important part during the process. Goethe in his *Faust* mentions the inner gods of form, confirming the importance of nurturing the inner self. In 1840 he stated, "Since colour occupied such an important place, we shall not be surprised to find that the effects are at all times decided and significant and that they are immediately associated with the emotions of the mind." The inner, creative self and the imagination are vital aspects of the whole, to be considered and activated to secure feelings of wholeness and well-being. The balance between left brain and right brain is a delicate balancing act that we need to address. Intellectuals find creativity so difficult due to their left brain being well developed. Yet, over imagination, creativity and inner world work develops the right brain, to the detriment of the left.

The art is finding the balance between the two, for a clear outlook and understanding that results in a more positive view of self and life. Instinctive understanding of the emotions of colour is revealed when we use phrases such as red with anger and green with jealousy. Much research has confirmed that when we see a colour we engage in the sensation of colour perception. By working with sensory perception and intuition we can extend our awareness of colour to levels beyond its visual and physical impact. We need to develop our ability to feel colour, to resonate with and synchronise with its vibration, then it will influence our personality, character and well-being, bringing a level of fulfilment and wholeness we may not have experienced before. Through colour meditation, dance, exercising and visualisation, colours can become a natural and integral part of our thinking, breathing and moving, to wonderfully enhance ourselves and our lives. The *Colours of the Soul* CD is a superb way to incorporate and reinforce colour into your everyday life. Play it in the car and during the day to benefit from the coloured music and information.

Since earliest times, many from diverse backgrounds and cultures have attempted to pigeonhole colour – an impossible task. Following years of study, I now take my inspiration from the natural world, where according to colour wheels and the science of colour, many unthinkable colour combinations, which should not work, do work, and beautifully so. They also have proven to be the perfect combination and fit for purpose when I have used them in my work.

Extensive research and studies have been carried out over the year by notable alumni from the scientific and psychological arenas, lecturing on the physics of colour and the psychological impact. Unfortunately, few study the powerful transformational and self-development effects of colour.

Today, we have two colour camps, one studying the physics of colour, supported by complicated mathematical formulas, and

the other camp, rediscovering colour's ability to transcend and transform. Accepting colour is more than physics and science. With numerous works recorded and handed down by word of mouth since records began, we know that colour was revered, used and accepted for its powerful transformational and spiritual impact on man.

The scientific world sees colour as subjective and concludes that its viewpoint is supported by the non-existence of a universal colour code. Some see the lack of a definitive code as a lack of structure. In many ways this belittles colour's ability to transcend and to be the powerful tool it is, by some sidestepping using colour as a prominent force. By missing the absolute truth that colour cannot be slotted into a neat universal system for man's financial gain (as each hue has its own unique meaning). We are still learning about the effects of colour.

I have stood at the front of classes in many countries over the world during my thirty plus years teaching colour, repeating, on opening:

> I will share with you the knowledge I have gained to date, as I experiment and work with colour, learning new information daily. By trialling and experimenting, if I put this hue with this combination of colour, what happens if...

There are many colour systems in use all over the world today all trying to slot colour into neat systems of colour blocks, seasons, groups; this can have limited effect and results. Not a perfect system exists, it cannot, colour by its very expansive nature cannot be, must not be, confined. Nature at its very best changes and evolves; I am learning something new every day. Colour won't be tamed; just like water, colour will find its way.

Chapter 8

Mandalas – For Personal Development and Business Success

You have noticed that everything an Indian does is in a circle,
and that is because the power of the world always works in circles,
and everything tries to be round...

The sky is round,
and I have heard that the earth is round like a ball,
and so are all the stars.

The wind, in its greatest power whirls,
birds make their nest in circles,
for theirs is the same religion as ours...

Even the seasons form a great circle in their changing,
and always come back again to where they were.
The life of a man is a circle from childhood to childhood,
and so it is in everything where power moves.
Black Elk, Oglala Sioux Holy Man, 1863–1950

Many years back when I first took my inspiration from the natural world, I found the circle to be the perfect shape for all colour work. Historically many different shapes were being used at the time in the colour arena. I went against the grain and stood fast. I combined the use of the circle shape with colour. It has now become the trademark of my teaching method; previous students of mine continue using the circle with colour today. Being the first in the colour world to work with and to promote using the circle, to colour in circles and to work with groups in a circle is based on much research and my findings. My suggestion to

everyone is to work with colour in circles of colour and place groups in a circle, my water exercise. See the colour practicals chapter for numerous colour exercises. The circle is the best shape for all colour work. The circle is a protective shape, unending and continuous, an ancient symbol of unity and wholeness – the shape given to infinity.

The five elements and circles are represented in the natural world for all to see. In nature we see spinning circular patterns in rivers, streams, whirlpools, oceans and the movements of the cloud systems. In the earth circles are formed from insects, worms and animals and in the air by tornados, hurricanes and cyclones, and in the fire we see the spinning of the flames. Dynamic energies meet together in nature to form spinning circular patterns and movement.

The word mandala in Sanskrit means circle and centre; the circle of life. We breathe in a circular motion, in and out in a continuous circle of respiration and circulation. The moon, the planets and stars are circular. Our seasons are cyclical and continuous in their movement. The rainbow is a circle, yet we only tend to see half. There are stone circles, crop circles, fairy rings, burial chambers and even mushrooms grow in circles. Every flower and tree has a circular mandala at its centre. Cocoons and spider webs, hailstones and the centre of snowflakes.

Wherever a drop of water lands the ripples it makes goes into a circle. Yin and yang, the tides and so much more in the natural world mirrors back to us the importance of the circular shape. Hence I have taught my method and invented my practicals using the circular shape throughout my thirty plus years of working with colour. No other shape does it for me so beautifully or more importantly, more powerfully than the circle when working with my beloved colour. Through nature I discovered very early on and many, many years back that the circle is the perfect and only shape to work with.

June inspires us to notice the tracks in the sand and to take note of what nature is saying to us, despite our minds being bombarded with 21st century overload and distortions. June's pioneering work reminds us of the importance of colour, to honour the earth we walk upon and be reminded to look for the many meanings within the shades and tones of nature. June reminds us to find the time to go within, switch off and open the heart. She stands as strong as an oak tree inspiring us to grow and stretch, re-root and shine as brightly as the day you were born. Love of colour, nature and the human condition is at the heart of everything she touches. June's writings and sharing of knowledge guides us back to our centre. She has developed her pioneering work, a unique understanding of nature's patterns, colours and codes which she has translated into a rich tapestry for everyone's benefit. This provides us all with an essential map of life.

E. Turner

The circle is a stress-less form that helps us to focus inwards. The mandala is a symbol of unity, oneness, wholeness and completeness. A mandala tells a story and helps release the creative spark that is vital for new ideas to spring forth. I believe you need to become more creative to be innovative. The first step I encourage is to 'feel' colour, and I do this through multiple ways, mostly students interact with the practicals I have invented and developed over the years. The process from start to finish is informative, inspirational and fun for the student, but more importantly, my educational and focused training package takes the student from a place of enquiry to a place of knowing. Secure in my knowledge training and expertise I have developed a proficient and widely competent educated colour person. Years of experience have gone into my package. It all appears so easy. Unfortunately, this has come back to bite me on the bottom, I have been made aware of some incredible statements passed to

individuals in groups under the guise of 'expert' colour knowledge. It is best to remember when interpreting a mandala that less is more.

Business Mandalas

The group mandalas I have facilitated in business are a unifying experience and excellent for new ideas to be transferred to the business. The real skill is in the interpretation of the mandala. It is a three-way experience between the facilitator, the mandala and the creator. My work is not a temporary measure to motivate and inspire; it produces personal breakthroughs to benefit the business long term, and bonds teams. The mandala is a powerful and transformational way of working with colour. For business I create a bespoke package to help unlock and sustain high growth potential and bond cohesive teams. A tailored vision using mandalas and creativity to release creative potential helps access new routes to market, business growth and expansion. My workshops are memorable and inspirational; they improve teamwork and have an overall positive influence to bring about positive change.

Mandala colouring is a wonderful way of working with colour, taking you back to childhood when you delighted in creating bold colourful pictures. This is something that many of us haven't done since younger creative days. As adults we think we are not creative, yet most children think they are. We need to recognise, engage and encourage more creativity in business. Original ideas spring from the imagination when we are creative. Interestingly, the left brain academics say it is too hard, yet it is a hugely important aspect of the human mind. Carl Jung believed that most of us have lost touch with important parts of ourselves, our creative self. The mandala is one way to get back in touch with our creative self.

We don't understand enough of what it is and how it happens, yet it does happen and is the most powerful and positive aspect

of yourselves that needs a release. An outlet in your personal life that will transform and benefit business. To be creative is essential. It is the original thinkers who break new ground. To be creative in business is essential. To this end let me introduce you to one of my favourite methods of working, the mandala.

I suggest you do not look at the colour meanings until after you have coloured in your mandala. In this way you are less likely to be influenced by the meanings and more able to concentrate on using the colours that 'speak' to you. In other words, rather than your logical conscious mind telling you what to do, you are relying on your creative unconscious mind to instinctively draw you to the colour you need at this time. Everyone is creative and enjoys being creative in the right setting and with the right tools and direction. Over the years I have created bespoke creative packages for companies; I have had top executives in groups working with mandalas and thoroughly enjoying the fun, comradery and satisfaction of the task.

A sacred space is discovered when working with mandalas, taking you on a unique and special journey of self-discovery and self-expression as you are connected with your creative self, your unconscious mind and intuition. The circular shape of the mandala is regarded as a symbol of wholeness, and by working with the mandala, this circular shape helps you to focus inwards and centre yourself, thus taking you to the very core of your own wholeness, allowing you to switch off from the pressures and noise of the hectic world outside.

The mandala has been used by many over the years for therapy, healing and meditation. There are any number of beautiful examples of mandalas dating far back in time. In particular those created by the Tibetan Buddhist Monks (who still produce the most incredible and colourful sand mandalas as part of their spiritual practice) today. The Tantric Hindus, and Native Americans still use these in creating sacred spaces for their healing rituals and prayers.

Initially a spiritual fad in the East, the mandala was introduced to the West and used by many, including Carl Jung, the Swiss psychologist, for psychological understanding of both himself and his patients. He saw the mandala representing a journey of self-discovery and self-expression, encompassing all levels of one's being: mental, emotional and spiritual. Mandalas can take many forms and you can see many around you in the natural world and the human body, such as the eye. In my *Mandalas* book, I share more information and I have created a number of mandalas for you to copy and use over again. These designs have one thing in common: they draw your eyes towards the centre of the design. As you work and colour, you absorb the beauty and qualities of the colours. They gently quieten your mind by focusing your attention inwards to the very core of the design (and your being). By working with mandalas and colouring in using your favourite pencils, pastel or paints, you are able to gently release these deep rooted pent-up motions, feelings, thoughts and experiences that are often too difficult to talk about.

Colouring mandalas helps you to express your innermost feelings, often feelings and emotions you may not be consciously aware of. However, your unconscious mind will work with you to bring these feelings to the surface so that they may be released in a gentle, positive process. This is especially useful for children and the elderly, and anyone who finds it difficult to express their feelings.

Children love colouring. Children are exuberant and creative and enjoy colouring in the mandalas, finding them highly beneficial. Mandalas used in the right setting with the process guided by someone with colour knowledge and understanding facilitates a process that is superb to calm nerves and an overactive mind, and to focus attention before tests and examinations.

The terminally ill benefit from the process of colouring

mandalas; this helps them to cope better with coming to terms with their illness and improving their outlook on life. As you become caught up in your hectic lives, very often you have little time for yourself – time to restore and rebalance. By working with and colouring in a mandala, you can achieve an inner peace that seemed so elusive before you began. By working regularly with colour and mandalas you will notice subtle changes whilst experiencing the benefits on all levels – emotionally, physically, mentally and spiritually.

I urge every company, small or large, to set aside creative time for staff on a regular basis. Invite someone like myself in to organise the sessions for you so that every member of staff on every level can benefit. You will request feedback from each session from the facilitator, setting out clear observations, recommendations and analysis.

When colouring in a mandala, you will be amazed at how absorbed, centred and balanced you become. A form of meditation is taking place coupled with a release of creativity; this will encourage new ideas and inspired thoughts to be released. The colours you work with will change at different times according to your physical, mental and emotional state. By understanding the meanings of colour you are able to, in part, interpret the colours you find yourself drawn to when colouring your mandala. I have given some meanings of colour in this section and there are also more meanings of colour throughout this book. To interpret the full meaning of a mandala takes many years of practice and experience. The professional eye is looking at the depth of colour used, the placement of colour, the symbols and pattern created, and where they are placed, whether more towards the centre, and direction – east, west, north or south. I am thrilled when I observe the brave hearts colouring outside the lines.

The mandala is a tool for your own exploration of colour and yourself, and as you analyse the meaning of the colours, these in

turn will help you to understand your inner self and your creative ability by the messages sent by your intuition and unconscious mind. Whatever your situation or circumstances, everyone will have fun colouring in a mandala, and benefit from the transformational and life-changing power of colour. The combination of colour and circle is unbeatable. My teaching is to work with the circle and colour in all situations, the most beneficial shape for colour. When working with colour, it is worth noting that colour has many meanings, both positive and negative. We all have a shadow side to our personalities and so do colours. The secret is to learn to accept these shadow aspects, to understand them and, as a result, to transmute them. Very often these shadow aspects, when understood, reveal aspects of ourselves that once tweaked are strengths not hindrances. The inexperienced facilitator can identify the darker muddy colours in mandalas as negative and the brighter lighter colours as more 'pure'. In the natural world every colour has its season because all colours are good and pure. The real craft is in identifying the true underlying meaning hidden within the colours and the completed mandala.

Colour Interpretations

Many interpretations of colour exist around the globe, ranging from symbolic and universal meanings to an individual's own personal experiences and associations of colour. The colour interpretations are scattered throughout the book and can be found in my other titles. They will provide you with some knowledge and understanding of colour, which you will be able to build upon with your own experiences, as you begin to incorporate and work with colour.

Red – Is the basic survival colour, supporting the will to live and physical health. Energetic, the colour of blood and of life force, it fills you with the will to live and to succeed in all you do. Red quickens the heartbeat, ups the ante, and raises blood

pressure. Red arouses and heightens your emotions and passions. Whether these emotions are associated with love and sex, or with anger and aggression, you will notice the effect red has on your highly charged emotions. Red encourages you to be courageous, strong and determined to succeed in all that you do. Red – attention seeking, the leader, the pioneer, the moaner and the drama queen.

Being the colour associated with your root chakra, red also brings you security and grounding connecting you to mother earth and her positive energy. Red makes you alert and aware of all that's going on around you. Red – a colour that stands out in a crowd and can help you to become more powerful, assertive and positive when the need arises. Red will provide you with courage, perseverance and determination to cope with whatever you need to face up to or do. If you are feeling lethargic and finding it difficult to get going, red will motivate and stimulate you into action. It floods you with vitality, enthusiasm and spontaneity. On a physical level, as well as increasing blood pressure and heartbeat, red energises the muscular system and the adrenal glands. It is associated with the base of the spine, hip joints, feet and legs. Red stimulates the digestive process by increasing appetite and strengthens stamina.

Life is a balance, so good health demands a balance of work, rest and play. Colour demonstrates that too much of a good thing will bring about detrimental effects. Too much red will make you restless, always on the go, snacking and impatient. In addition to frustration, anger and even violence, the shadow aspects of red can lean towards an inflated ego, domineering manner and highlight shame and fear of failure. Red is self-aware.

Qualities:

Courageous
Pioneering
Leadership

Determination
Grounded
Energetic
Passionate
Spontaneous
Dynamic
Thinks on their feet

Shadow Qualities:

Me, me, me
Ruthless
Jealous
Scared
Can make knee-jerk decisions
Impatient
Worried
Stressed
Restless
Materialistic
Self-centred
Doesn't listen

Orange – The Humpty Dumpty colour, joyful and happy orange wants to put it all back together again. Orange helps to release the child within, to be creative, to play and to have fun. Orange encourages creativity in all its forms and will keep you dancing and singing and upbeat throughout the day. Orange develops good relationships as it's one of the sociable colours. To share and have fun with others in the inner circle of loved ones and outer friends and work colleague brings much happiness to orange. Being a mixture of red (hot energy) and yellow (optimism), warm orange encourages you to be more outgoing and independent, so that you may release your inhibitions and enjoy life to its full.

Orange can be fearful, holds back, will not communicate what you feel. Orange respects self and others; understands need for space. Joyful and enthusiastic, orange thrive in movement, whether at play or at work. A career sitting at a desk with no variety will create a dull orange. Travel appeals most to orange and indigo. Associated with your sacral chakra, connected to your emotions and feelings (gut instincts) and sexual needs, orange will help you to understand and release pent-up fears and frustrations that you may be holding on to or that are holding you back. Orange is an antidote for depression as it helps to raise the spirits and foresee a brighter future. The orange season is autumn as leaves change colour from vibrant greens and reds into the orange russet tones of autumn. Orange stimulates, is emotional and a good listener. Sometimes dependent and melancholy, leans on others, and can lack self-discipline.

Qualities:

Joyful
Sociable
Enthusiastic
Ambitious
Creative
Independent
Self-confident
Happy

Shadow Qualities:

Lazy
Lack of discipline
Exhibitionist
Destructive
Not a team player
Leans on others

Yellow – Is associated with the solar plexus chakra which is responsible for personal power and opinions, therefore can be open-minded or opinionated. It is very much dependent upon a positive or negative mindset. Colour will break through the despondent and negative thinking processes, when in the hands of a professional colour expert. Yellow is aware of how they are perceived and how others perceive them. Linked to self-esteem, appearances matter!

Yellow is happy, cheerful, uplifting and expansive. Yellow stimulates the mind and intellect, providing one with wisdom, good judgment and also detachment. Yellows do not generally get emotionally involved unless of course the love interest is theirs. Easily adjusts to being centred and focused on the work in hand. They are receptive to new ideas, new opportunities and able to develop new skills.

Yellow can raise and develop your self-esteem, and confidence in yourself and abilities.

An antidote for depression, yellow helps to focus the mind on other absorbing matters, and helps anchor scattered thinking. Yellow will help keep a person motivated. Care does need to be taken though as yellow can overstimulate the mind making it difficult to relax, and may also encourage making changes for the sake of change. Cheerful and sunny, yellow uplifts your spirits and fills you with optimism; making the future look bright, it enhances curiosity and broad-mindedness. On a physical level, yellow energises the solar plexus (the centre of your nervous system), which can often become depleted. It is connected with the digestive system, pancreas, liver and gall bladder. Yellow has a cleansing effect on the digestive system helping to release toxins from the body. It's a good colour to aid weight loss. Drinking a glass of hot water with fresh lemon and honey to sweeten is an age-old remedy to cleanse and clear the system first thing in the morning, and to help alkaline the system.

Qualities:

Uplifting

Optimistic

Cheerful

Focused

Intellectual

Confident

Broad-minded

Shadow Qualities:

Cowardly

Sarcastic

Critical

Chaotic

Pessimistic

Inferior

Devious

Green – Calms the mind and helps you to switch off from all those hundreds of thoughts continuously going through the mind, as you slowly become relaxed. With so much green around, you only have to walk in nature to feel the stress evaporate. The colour of abundance and prosperity in all areas of life, green provides a feeling of expanse and freedom, the opportunity to get away from it all, to recharge those well-worn batteries! The balancing of the heart, head, emotions and thoughts will allow harmony to reign once more. Green promotes acts of kindness, compassion and empathy. The fresh vibrant greens of springtime especially promote feelings of hope, growth and new beginnings.

Green is associated with the heart chakra which is responsible for feelings of love and compassion, both inwards and outwards, linked to self-love. The combination of yellow and blue, it results

in a nourishing colour. Everywhere we look within nature we see many hundreds of different shades of green, creating a calming, relaxing, harmonising effect upon us and all the surrounding colours. When we absorb and breathe in green, its calming influence restores our equilibrium and balance. This healing effect is particularly important in times of stress, tragedy and bereavement, when we find ourselves totally out of balance, desperately trying to make sense of and bring back order into our lives. On a physical level green relaxes the heart, feeds the digestive system, calms the nervous system and relaxes the mind and body.

Qualities:

Balancing
Harmonising
Compassion
Calming
Relaxing
Freedom
Hope
Self-control
Loving
Kind

Shadow Qualities:

Envious
Spiteful
Jealous
Possessive
Extravagant
Spendthrift
Miserly
Stingy

Picky

Sky Blue – Is associated with the throat chakra, therefore creative communication, linked to self-expression. Sky blue is the combination of green and blue; serene, tranquil and peaceful, sky blue evokes images of clear blue summer skies and vast expanses of clear blue/green sea. Think of the large expanses of healing sky blue; relaxing your senses and bringing peace to your mind. Sky blue is connected to communications, allowing you to communicate your message, truthfully, clearly and creatively. If you experience difficulty in expressing your thoughts and feelings to others, allow sky blue to 'unlock' your throat (wear the sky blue chakra silk – see Products) so that you may be heard and understood. Sky blue applies a philosophical approach being a patient and quiet colour. This restorative colour sky blue acts as an antiseptic to our body, cooling and calming any fever and reducing blood pressure – it slows down the heart rate and energy flow in the body, encouraging you to relax the mind and body, allowing time to restore the whole being.

Qualities:

Peaceful
Calming
Serene
Expansive
Creative
Communicative
Relaxing
Loyal
Tactful

Shadow Qualities:

Unfaithful

Emotional
Tactless
Unstable
Snobbish
Superstitious
Aloof
Cold
Unemotional
Lacking empathy

Indigo – Is inspirational and transformational and linked to the brow chakra or third eye, responsible for intuition and insight, linked to self-responsibility. A powerful psychic colour, the colour of the master, guru, yogi. It is connected to intuition and spiritual awareness, encouraging us to learn to transmute our energies to a higher level. Finding time for quiet contemplation and meditating are a 'must' for indigo. Indigo develops your faith in your own intuition and spirituality.

With a strong devotion to duty, honest, reliable and loyal, indigo stimulates the creative spark in us all. Indigo prepares the ground for others to follow their dreams and reach their potential. Powerful indigo transmutes your fears and purifies your thoughts as it forces you to move on. Just like sky blue, but much more powerful in every way, indigo provides healing, cleansing and purifying with its strong antiseptic and sedative effect on the mind, body and spirit. Like orange, indigo will release pent-up fears and emotions, enabling you to move forward in a more positive way. On a physical level indigo feeds the skeletal system, strengthens the bones and energises the pituitary gland and in turn the remainder of the endocrine system. It is also associated with the eyes and ears. Indigo will encourage your love of all things creative and beautiful, heightening and transforming your awareness as you become more sensitive to the subtle spiritual energies surrounding, connecting,

and enabling with your wonderfully creative gifts and talents.
Qualities:

Intuitive
Trusting
Loyal
Sincere
Fearless
Devoted
Creative

Shadow Qualities:

Scattered thoughts
Fearful
Inconsiderate
Moody

Purple – Is associated with the crown chakra, responsible for your spiritual awareness and universal consciousness, linked to self-consciousness. The combination of blue and red, it incorporates the vibrancy and determination of red coupled with the powerful healing properties of blue. Purple encourages us to work effortlessly and unselfishly with the highest intent for the good of all concerned. The colour of spiritual protection and psychic ability, it cleanses and purifies your thought and being. It allows you to cleanse the negative dross which may have attached itself to you or your surroundings. (In class/groups I teach my violet method to space clear, quickly and efficiently, thus restoring peace and calm.) It cleanses the mind and body of negative thoughts, attitudes and habits. Purple enhances your passion for creativity. On a physical level purple is associated with the pineal gland which is light sensitive; this in turn affects the whole chakra system and ultimately the entire body.

Qualities:

Purifying
Inspirational
Unselfish
Cleansing
Patient
Kind
Just
Caring

Shadow Qualities:

Alcoholics
Drug addicts
Addictive personalities
Cold
Lacking empathy
Dictatorial
Judgmental
Dishonest
Lacks integrity
Fanatical
Snobbish
Superior

Magenta – A combination of infrared and violet – Magenta is a colour more accurately created with light. It encompasses the warmth and uplifting energy and ambition of red with the spiritual insights and inspiration of violet. Magenta, like green, restores balance and re-harmonises, helping us to maintain a sense of perspective, through relating to both our earthly and spiritual experiences. Green, however, relates to love on a physical level. Magenta links to the highest form of uncondi-

tional love, with no strings attached. As with red, magenta stands out in the crowd as it promotes dignity and respect through its powerful yet gentle mature and uplifting spiritual leadership. It motivates you to focus your energies and become organised. Magenta helps you to move forward with dignity, releasing any limitations that exist as you embrace change knowing that all will be well. These may include old thought patterns based on past experiences, or old emotions that you clung on to which are no longer relevant, but possibly holding you back from embracing much-needed change. Magenta brings our awareness back to self, highlighting self-respect and harmonising our being.

Qualities:

Releasing
Restoring
Respectful
Balancing
Idealistic
Mature
Motivated
Focused
Protective

Shadow Qualities:

Snobbish
Arrogant
Domineering
Suppressed
Hidden anger
Impatient
Lacking focus

Pink – A combination of red and white, pink provides a gentler

and more calming effect on your emotions than red, with pink being associated with the heart. It promotes unconditional loving acts of kindness, patience and forgiveness. By contrast red provides the intense, hot passions of love and sex, whilst delicate pink is linked with the more sensual, tender feelings of love, affection and romance. Pink is feminine, gentle, nurturing and will soothe away feelings of hurt and distress. Let gentle pink calm and soothe your anxieties and nurture you when you feel unloved. However, pink is not all softness and light; pink is strong, with hidden strengths. It is able to defuse anger and violence, calming the atmosphere and restoring peace. Pink in the positive likes to promote hope and harmony amongst all those in its midst. Pink is also a wonderful colour for the skin and to relax and soothe our tired and overworked muscles. Pink brings to the surface our most sensitive diplomatic and reasoning self by allowing us to see all sides to a situation. The perfect mediator is a positive pink. But don't be fooled as in the negative there is no greater example of bitchiness. A few examples of pink, there are many hundreds more: dusty pink – sentimental, lighter pink – romantic, hot pink – energetic. Coral/pink is the colour of the womb, and the first colour the baby experiences and senses is in this place where it is truly protected. Like magenta, pink can help to gently release inhibitions and concerns, particularly related to life issues.

Qualities:

Nurturing
Loving
Soothing
Relaxing
Kind
Patient
Forgiving

Shadow Qualities:

Oversensitive
Easily hurt
Bitchy
Angry
Spiteful
Vulnerable
Overwhelmed

White – The mantra is: when in doubt leave red out. For white, when unsure, use white, as it contains, combines and reflects all the colours of the rainbow. Associated with purity, transparency and cleanliness, white illuminates everything in its space, making all other colours appear either fresh and vibrant or gloomy, dark and unappealing. White encourages you to be more open-minded, forgiving and tempered as you see with more greater clarity. There are no emotional highs and lows with white. It is very much middle of the ground, steady, reliable, and in the negative, unforgiving. It is the colour of vision, illumination and purity. With white you can begin afresh with a clean sheet; here you can colour in your new dreams and experiences allowing you to move on to exciting new opportunities. White will promote feelings of efficiency, however, too much white can lead towards feelings of emptiness, frustration and isolation. White is associated with being the colour of the peace dove, tranquillity, wanting to unify. It sees everything and everybody as being equal. White is one of the colours associated with spirituality and enlightenment – 'seeing the light'. White presents you with the opportunity to start anew, providing the opportunity to change your life.

Qualities:

Innovative

Fair
Loyal
Illuminating
Pure
Unifying

Shadow Qualities:

Inflexible
Perfectionist
Loss of energy
Loss of identity
Hiding away from life

Black – Is the colour of hibernation, surrender and renewal, before a new cycle of events. Just as before nature displays, her plants hibernate into darkness beneath the soil, black creates a time for you to retreat, to be still, to contemplate, preparing you for new beginnings and new exciting opportunities. Black helps to restore and renew your being every night when you go to sleep, providing you with a fresh new day each morning to start anew. Black is linked to the unconscious mind and that which cannot be seen (darkness), but which is waiting to be formed and revealed. You will experience this when meditating and connecting with your inner self. Out of the initial blackness follows colour as your unconscious mind starts to reveal itself. The opposite to this is a blackout, which refers to a loss of consciousness. Black is solid and provides protection as you surrender into its powerful security. Black absorbs light, so when other colours are placed alongside black they appear stronger, bolder and more vibrant, emphasising their specific qualities. In the Western world, black is regarded as the colour of death and mourning, sadness and black moods associated with deep anger and depression. However, just as in nature, black represents an

opportunity for an initial retreat and renewal in preparation for a new cycle of life.

Qualities:

Innovative
Protective
Solid
Retreat
Renewal
Surrender

Shadow Qualities:

Black moods
Depression
Loss
Insecurity
Agitation

Brown – Is the colour of the earth and the fertile soil ready for planting. Brown promotes feelings of earthiness, fertility and opportunities for new beginnings. Brown is one of the strong grounding colours, connected to security, stability and trustworthiness, ensuring steady growth through practical application and hard work. This in turn leads to self-reliance whilst maintaining a down-to-earth attitude. It's a solid and protective colour that creates a feeling of permanence. Brown promotes deep thinking, consciousness and deep levels of concentration. Self-assured, brown is reliable and loyal in all its undertakings, being moderate in its approach and preferring to remain in the background. Brown strives for financial security above all else. Brown is associated with sorrow, melancholy and penitence (monks dress in brown habits). It can be seen as a colour of the autumn and winter months when plants are dying and decaying

at the end of the seasons' cycle. However, the fertile goodness of brown soil is needed all year round to nurture and sustain good growth. It is the colour of permanence and solidity. However, by wearing too much brown you may cause feelings of boundaries, being stuck, unable to move forwards, lacking self-esteem, racked with guilt and feelings of unworthiness. Brown is recognised as the colour of the materialist, someone who prizes material possessions and financial security. It is the one colour to be associated with 'keeping up with the Jones'. Purple/violet comes a close second.

Qualities:

Down-to-earth
Practical
Trustworthy
Secure
Fertile
Reliable
Hard working

Shadow Qualities:

Sorrowful
Melancholy
Blocked energy
Lethargic
Low self-esteem
Withdrawing
Barren
Self-doubting

A mandala tells a story: it helps release the creative spark that is vital for new ideas to spring forth. You need to become more creative to be more innovative in business. Facilitating the group

process to create a mandala is a unifying and satisfying experience. The Tibetans believe that a mandala consists of five excellences: the teacher, the message, the audience, the site and the time. The circle is a stress-less form that helps us to focus inwards. A symbol of oneness, it represents insight and discovery, completeness and perfection. A bespoke programme tailored to your business intensifies focus on the vision and releases creativity to access new routes to market for your business growth and expansion. Making the session memorable makes it easier for growth opportunities. Improved teamwork (thinking and creating together) is an overall positive and beneficial influence. I am the first in the colour world to work with and within the circle, a method that I developed many years ago and pursued over the years with my interactive practicals to support my findings. The circle is a protective shape, unending and continuous, an ancient symbol of unity and wholeness, the shape associated with infinity, two circles side by side. This is the shape of the earth, the planets, and much more. Circles are replicated in the natural world for all to see. The five elements and circles are found in nature. There are spinning circular patterns in rivers, streams and the oceans. Drop a pebble into water and watch the circular ripples. See the movements of the cloud systems, in the air from tornados and cyclones, and the spinning of flames. These are just a few of the thousands of examples. The word 'mandala' in Sanskrit means circle and centre; the circle of life. We breathe in a circular motion in continuous motion; a cycle of respiration and circulation. Seasons are cyclical and continuous in their movement; the rainbow is a circle – yet we only see half. There are stone circles, crop circles, burial chambers, even mushrooms grow in circles.

Every flower and tree has a circular mandala at its centre. The natural world mirrors back to us the importance of the circular shape. Years back I began working with circles and in the circle with groups. I developed my interactive practicals to incorporate

whenever possible the circular shape. No other shape has the same impact. When I combine colour and circular shape the impact is profound. I believe that it is the only shape to work with and have based my work on the circle. Working with mandalas, pictures and colour under the careful guidance of a colour expert with the appropriate skill set helps people express themselves and find new solutions to old problems. Image language comes before verbal language, therefore by the careful and considered use of colour people liberate themselves from stale outmoded thinking processes, to release new and inspired creative thoughts for the benefit of themselves, the team and the business.

Through a carefully planned process, directing the picture content (but not the colour choice), the facilitator can have a three-way conversation with the person and the picture as the meaning emerges from colour and placement. Real skills are involved to maximise benefits, including interpersonal, and an excellent grasp of colour meaning is most valuable and imperative for a beneficial outcome. The mandala is a circular colour-healing tool used for divining, healing and meditation dating back to ancient times. The circle is the perfect shape to use for colour. Together form and colour unite to create a powerful presence and never more so than in circles of colour. In Sanskrit the ancient language of India, mandala means 'sacred circle'. Hindus, Tibetan monks and Native Americans all use mandalas as a way of evoking spiritual energy, meditation and healing.

Carl Jung used mandalas with his clients and for his own personal growth, and his studies revealed their creation allowed a deep healing to take place from within the human psyche. Mandalas exist naturally within nature where they can be seen in the natural world in corals, labyrinths, snowflakes, shells, water, tree trunks, plants, flowers and the solar system. Also in circular ripples in water as a raindrop falls. Even the human eye is a mandala, to give just a few examples. The Tibetan monks created

the most wonderful vibrant and intricate mandalas out of fine particles of coloured sand. These sand mandalas form part of their spiritual practices aimed to bring peace and harmony in the world. The Navajo Native Americans also work with the sand mandalas along with a number of other cultures. The Navajo translation of sand painting means 'place where the gods come and go'. They have been used in healing rituals and ceremonies by the Navajo men for centuries. The mandalas were always destroyed at the end of the ritual after a number of days when the purpose of the ritual had succeeded. The mandala always depicts natural elements such as mountains or landscape, as the Navajo view the natural landscape as sacred. Navajos believe all their illness stems from being out of balance from nature. The trained shaman will draw the painting, and carry out song and dance for the particular chosen healing ritual. The person who is in need of the healing ritual sits in the centre of the mandala sand painting, and once the sand painting is complete, the chanter takes the sand and rubs it on the person in need of healing transferring the energy of balance and nature. Each colour is derived from semi-precious stones ground finely and mixed with sand to represent a different direction. The ceremony is carried out on a specific area of land that is revered and sacred to them.

Aboriginal shamans create concentric circles on the ground with the purpose of invoking the power and energy of their ancestors. The circles are usually coloured in red and white alternately and mark the spot of sacred ground where the spirits of the great ancestors originate from. From ancients to modern day, the circle holds a special place. The circle is a stress-less form that represents unity, harmony and the cycle of life; the circle is a symbol of wholeness. The combination of colour and the circular shape is powerful and together unite in perfect harmony revealing colour's attributes to best advantage. Working with a circular shape helps us to focus inwards. Colouring a mandala helps to release stale thought patterns and unlock imagination to

allow exploration of creativity through unconscious thoughts and feelings via the interplay of colour and circular form.

Colour and image is powerful and transformational. Mandalas are used to organise people's thoughts, perceptions and responses in ways that can help reveal temporary blockages to bring much relief from the anxiety of not recognising the options to release.

Carl Jung's work with mandalas is well documented. Colour knowledge, intuitive understanding and the ability to accurately interpret a mandala is a proven skill, and when accurate, a medium that is most revealing. Mandalas are used on a one to one basis and with all sizes of groups from small to large. For business seminars I have led teams of people creating and working together on large floor and wall mandalas. The sessions proved to be a hit, great fun and most worthwhile for the team and business. Mandalas can be coloured in during a session indoors or alternatively outside on the beach or ground. Find a suitable outside space where you can create a mandala, mark the centre point with a stone or shell, then gather items from the surroundings. Working around the centre from the centre point, walk in a clockwise direction around the mandala laying down the items as you go; with a clear uncluttered mind focus on the harmony of the circle. When finished, stand back and survey your creation. Look with fresh eyes, relax your gaze and describe what is seen to the facilitator, who guides the session with an expert knowledge of colour and placement.

The skill required to read a mandala is hard won, takes much experience and a raft of colour knowledge to deliver exact and informative usable information. Just as it takes more than a hat to make a cowboy, it takes more than a cursory understanding of colour to be a master. There are many ways to read a mandala as the colour is the vital element. Second is the placement of colour. The first task is to encourage attendees to step back from their creation. The facilitator hangs them on a white background for all

to view. The mandala reading takes place by one of three methods: by assessing the main colours used; the colour and placement of colour; and by focusing on the centre of the mandala then gradually working towards the outside edge reading the colour and placement from a main focus of the centre colours. You will find 160 blank mandalas to copy and work with and further mandala information in my books *Mandalas* and *Colour Therapy A–Z*.

Practical Water Exercise

Working in a clockwise direction is best when working with mandalas as with any intuitive work. This simple exercise that I invented proves the benefits of clockwise direction. Ask participants to part fill two cups with one inch/2 cms of water in each taken from a bottle of still water, return to their seats, and using the index finger stir the water in one cup in an anticlockwise direction for approximately a minute and a half. Place the cups on to the windowsill, take the second cup and stir with the index finger in a clockwise direction for the same time. Place next to first cup on the windowsill and leave the cups for at least an hour and a half. Then ask the participants to take a sip of water from each of their cups; the anticlockwise will taste bitter, the clockwise sweet.

All great discoveries are made by those whose feelings run ahead of their thinking.
Albert Einstein

Chapter 9

Colour Numerology – The Karmagraph

That which is below corresponds to that which is above, and that which is above corresponds to that which is below, to accomplish the miracle of the one thing.
Hermes Trismegistus

Myth of 666

The 666 is often declared to be a negative number combination, yet in reality and to those with the wisdom of the deeper significance of colour and number, it is the numerical equivalent of life. The numerical value of Vav Vav Vav in Hebrew is 6-6-6=9 equivalent to life! Plus, the 6 and 9 curved together create the yin and yang symbol of ultimate balance. Indigo and gold is the most regal and complete colour pairing. Most unusual and highly evolved. Wisdom personified.

Richard Branson

Let us start with a very quick overview of Richard Branson's colour numerology – the karmagraph. A quick overview tells us of the immense abilities of the man, his open nature and business acumen – there for all to see. I very much admire his abilities and one quote of his stands out for me, confirming him as an astute man with integrity. He once said: "I'll only do business with people who have lost everything at least twice, because then they know the value of money." A cursory glance reveals he is a green, with a soul colour 4. The chart equates to gold, violet, indigo with the soul colour green.

With this combination of colours and in this particular order, we see that he has the potential to head companies that will aim to put people first. He is brilliant at seeing gaps in the market and

providing services that people need and want. A loyal business and private man, he stands up for what he believes in. He has a lot of fun yet keeps his feet firmly on the ground. He gives fantastic parties, loves entertaining friends and giving to loved ones. He remembers who supported him to get where he is. Devoted to whatever he starts up, he likes to finish things and to succeed. Rarely will he walk away, sometimes to his personal detriment. The colours and numbers ooze success and likeability. With a natural air of charm, nothing forced, he gets on with everyone and at every level. People will feel at ease being in his company; he will be liked, others recognising he is a pleasant person to be around and want to be in his company.

To map out a colour numerology – the karmagraph chart for yourself, family and colleagues, to reveal health status and the attributes you need to bring in for a smoother journey through life, follow the instructions and details from my book *Colour Numerology: The Karmagraph* containing 160 blank karmagraphs to copy and use. With more information found in my best-selling books, *Colour Therapy A–Z* and *Colours of the Soul*; reprinted many times since 2000 by popular demand, *Colours of the Soul* is now a colour classic.

Calculating Birth Numbers

Take a birth date and reduce to a single digit. Take a birth month and reduce it to a single digit and repeat with the year. Now add the three numbers to find the fourth number: the soul number/colour. Each number is represented by a colour. Starting with:

Red – 1, Orange – 2, Yellow – 3, Green – 4, Sky Blue – 5, Indigo – 6, Violet – 7, Magenta – 8, Gold – 9

Colour Numerology: The Karmagraph is most popular. I invented the colour and number method and hold all rights, including the

method, design and concept. It comprises a circular chart of 9 colours and numbers. The chart is drawn up for all purposes: life events, the individual, group and business.

Using my method, I accurately predicted the birth of a girl for the Beckhams' fourth child, many months prior to Harper's birth, Obama's second term in office, and numerous other pivotal dates and occasions. As inventor of the method I have considerable knowledge in the use of the method as an accurate tool, which can be used to give a colour overview of business, individual personalities and events. It also highlights the abilities of the person giving the colour interpretation, as the karmagraph at first glance may appear simple and straightforward. Don't be deceived; within it there are many layers to be unravelled and discovered.

As a quick overview take the date of importance, such as 10th June 1980. Bring down to single digits by the day, month and year, resulting in 1-6-9, now add the three numbers together to find the fourth number, bringing this down to a single digit, in this case 7. A detailed colour analysis is given. My original chart based on 3 numbers I have developed and furthered to include the 4th number, as the four colour/number reading gives a rounder and more fuller reading and explanation. I have placed importance on the fourth number/colour, by bringing in and working with the positive attributes of the fourth colour, also by recognising the negative attributes and working to eliminate them. This is an excellent way to understand character traits, personalities and personal reactions to the curve balls that life throws at everyone once in a while, making the journey through life so much easier, while highlighting the areas to toughen up where needs be. Working with numerology is not new but working with colour and number in this specific way IS new.

The ancients have used mathematics to solve many problems throughout history. There are a glut of esteemed philosophers and wise people who have based their findings on mathematics.

Ancient Chinese, traditional Feng Shui and counting the five elements are just a few of the more well known. Some recognise the astrological connection between five of the elements and the five planets Saturn, Jupiter, Venus, Mars and Pluto.

Fibonacci in the 13th century was an esteemed mathematician who discovered phi; through a series of numbers he demonstrated the power of the series as a spiral emerging and unfolding from its central point. We see the replication of phi in the waves of the waters and spirals seen in natural forms such as seeds and the heads of flowers or folding of leaves around a central stem; phi pervades the universe.

In 1953 the human DNA was decoded by Francis Crick, James Watson, Maurice Wilkins and Rosalind Franklin. The human DNA was found to be made up of four genetic bases now known by the letters ATGC. The bases form pairs, always known as AT and GC. And in turn permutations of three out of four base groups together form different amino acids, which link together to form the proteins from which all biological organisms build their physical bodies. The total number of possible permutations of the four bases is 64. In 1973 Martin Schonberger discovered that these are exactly the same pairs which are organised into the matrix of the Ancient Chinese *I Ching*, or *Book of Changes*. The I Ching has been used as a reliable reference source for ancient and modern peoples for millennia. Therefore the human DNA code, the genetic code, we link to the Ancient Chinese method of I Ching, used since records began and based on a system of 64 different combinations of the binary systems.

The Jesuit scholars used to teach the I Ching and we see the ancient method being used in today's computer science. The binary system of mathematics is used in series of ones to zeros to form the basis of today's IT. The German scholar Leibnitz is credited with confirming the connection in his groundbreaking work. I Ching is another method that may appear straightforward at first glance, yet the more it is used the more it becomes

clear. The I Ching, like colour numerology – the karmagraph, has many, many layers. The nine is the ultimate completion point of the colour numerology – the karmagraph chart. To the ancients nine also represented completion in the human body. The fontanel at the top of babies' heads closes after nine months and the nine-month gestation period of the human baby provides both a physical and symbolic metaphor. The more we look into the ancient world the simpler our discoveries become and remind us that ancient wisdom cannot be lost.

Isaac Newton when asked how he could see so far into the cosmos replied that he could do so only because he stood on the shoulders of giants that went before him. The past holds much that we can learn from as we move forwards. When we speak of eight we refer to 'as above so below', taken from the Hermes Trismegistus quote: "That which is below corresponds to that which is above, and that which is above corresponds to that which is below, to accomplish the miracle of the one thing." This idea that Hermes introduced all those centuries ago, 'as above so below', refers to the body responding to our thoughts and feelings, and how emotional trauma can manifest in disease.

The ancients knew much of the hidden knowledge and principles of numbers and the numbers 3, 7, 9 and 12 reoccur throughout ancient texts. For many years I have used the 3, 7, 9 principle in my teaching and practicals with much success. There are seven days of the week, four times seven for the 28-day menstrual flow, seven colours of the rainbow, seven notes of the diatonic scale and seven energy centres in the human body recognised as the chakras. There are 12 astrological signs of the horoscope and it was the Babylonian astrologers and astronomers who divided the sky into the band of 12 constellations that we know today as the Zodiac.

The mandala is another popular and revealing way of working with colour and image to reveal the inner person. In a colour session copies of blank mandalas are used, blank copies of

mandalas handed out to be coloured in. They are copied and taken from my book, *Mandalas*, or I may ask for particular pictures to be drawn such as a circus scene, a jungle scene or a street scene. Many struggle with the concept of 'colour out of the lines' when colouring, preferring to neatly follow the curves and stay inside the lines as they colour. Oh the joy when further into the session as the process builds and after encouragement, I watch everyone find their feet confidently colouring out of the lines without being prompted. By guiding the participants from the outset, directing the picture content but not the placement nor the colour choice, discussing the completed project is a three-way conversation between participants, picture and facilitator as the meaning emerges. Real skills of the facilitator are pulled on to maximise the benefits, both interpersonal and creative, that are valuable and help people.

By combining colour knowledge and placement, each picture takes on its own unique meaning, and within the creator sparks a deeper understanding of self while releasing dormant creativity. During the process much fun and discovery takes place, and at the end of the session finished works are placed on display for viewing and interpretation and comment. Giving a quick overview, getting quickly to the nitty-gritty, the heart of the matter, my interpretation of where each participant is at that moment in time (based purely on the placement of items in the picture and the colours) results in surprise and delight from the audience. The accuracy of the information is a great endorsement for colour and my ability. I smile as I witness the surprise factor of the audience, from a starting point of a fun colouring exercise to quickly fast forward to an in-depth colour analysis that nine times out of ten hits the nail on the head. It is a juggernaut hit for many and a memorable moment. I smile as I think to myself, this is just the beginning, but hey, glad I got your attention! Delegates leave the venue passionately discussing their new-found interest in colour. Pure joy. The purpose of my colour sessions is to

release the creative potential within; to empower the individual and to produce the most talented business teams. I do this by showcasing and presenting colour in new and innovative ways. People quickly grasp an understanding of colour's vast abilities almost immediately. After all my years working in my chosen field, I am in awe at the simplistic yet transformational ability of colour for all purposes and for all occasions.

Bespoke colour training programmes are created for every type of business. The colour programme is thought provoking, inspiring, interactive and fun. Even more than that, studies show that the sessions make a marked and positive difference to effective teamwork and communication skills. My programme feeds people's creativity by helping them excel at whatever they are already good at. By taking them through a process of self-discovery and personal development, the colour programme will motivate people to rise to everyday challenges and strategic changes in a positive and productive way. Every type of business will benefit from the colour programme irrespective of age, gender, educational background or preferred learning style. (For Bespoke Training Packages, see Services.)

Birth Number – Colour Interpretations
To discover colour type I combine numbers with colour with great success. To help you interpret your chart, here is a small overview of colour meaning and attributes for each colour. Further and more in-depth colour meaning is found throughout the book and in my other titles.

1 – Red
You are a born leader, with a spirit for adventure; you are passionate about many things but must be careful not to use your energy to excess. You tend to dive into things feet first, which can sometimes leave you in hot water. You love movement and change, and to be seen and recognised for your efforts at work.

You have huge amounts of energy for projects and interests that you feel passionately about. Your strong will can sometimes be used to dominate others, so be careful; channel your energies for the highest good. Initial bursts of passion and energy can lead to burnout, so focus on seeing projects through to completion. Passionate, energetic, engaging, leadership qualities, courageous, attention seeking, aggressive, excited, indebted, adventurous and daring.

2 – Orange

You have a natural outgoing personality that is effervescent and contagious, fun and laughter are key for you. Living life to the full is important to you. You shine at social occasions and love meeting new people. You can bring a light and playful atmosphere to any occasion with your good sense of humour and positive outlook. Work on releasing any self-imposed barriers that may be holding you back, recognise your insecurities and let them go. Talking about your deeper emotions or writing them down will be therapeutic for you. Vital, fun-loving, carefree, happy, exuberant, gregarious, sometimes childlike, moody, lazy, serious and lacking a sense of humour.

3 – Yellow

You have a strong mind and love to absorb information. You have many inspiring ideas, however, you need to work on connecting with your inner voice and tune into your own innate knowledge. You have an analytical mind. Practise following your feelings and intuition more. Your many interests can cause you to jump from one activity to another, or from one person to another. Aesthetics are important to you; you always make a positive impact at social occasions, but often only reveal some aspects of your character. You have a talent for writing and strong organisational skills. Creative, motivated, focused, jealous, lacks the courage to move forward when negative, an active mind and can either light up a

room or be a wet blanket – dependant on mood.

4 – Green

You are warm and open-hearted and have a special love for your home. You have an open door policy. Everyone is welcome, you are good company and a natural humanitarian. You have a love of good food and beautiful things and are happiest when sharing. You are a natural peacemaker and able to see both sides of a situation. Take time out for yourself as you are a natural giver. Spending time in the country will replenish your energy. You have the ability to nurture and encourage others in their personal growth. Fresh, calming, harmoniser, likes to spend, enjoy prestige and all things of good quality. Your moods vary with company and you can be a chameleon. Good cooks usually, enjoy food and can be a 'foodie'.

5 – Sky Blue

You are peaceful and supportive of others and don't like to let anyone down. You have a wonderfully giving nature, but remember to allow yourself time to receive. You give out an uplifting and peaceful energy and others feel good in your company. Speak out more and express your intuitive nature. You are a very sensitive soul. You are a natural speaker with a creative and witty way with words. As a natural leader you can bring healing to many and you are open-minded and excellent at encouraging groups and building team spirit. A paradox, you can either 'talk the hind legs off a donkey' or have learned that conversation is a two-way process. You are creative, adore music and dance, or can be the social wallflower. You can be outgoing and energetic, or reserved and cool; standoffish or tactile, the paradox of the spectrum is sky blue.

6 – Indigo

A natural esoteric teacher, you are able to communicate higher

knowledge in a down-to-earth way. Your intuition is highly developed so write down your inspirational thoughts daily as they will guide you smoothly along your path. You can sometimes feel lonely, however, there is no need to. Remember the many people who will be there for you at the drop of a hat. You are a marvellous and natural counsellor, but remember to set boundaries when helping others, as you can give endlessly to the detriment of your energy levels. Reserved, loyal and protective or moody, distant and serious. Bold and courageous, indigo will protect all they love with a determination never beaten. A forever friend, not a fair-weather friend.

7 – Purple/Violet

You give so much to others without a thought of return. Sometimes you can be a bit of a perfectionist and will make unnecessary changes; stick with your first line of thought and you will always do well. You are gifted and bring many positive changes to people's lives. You motivate and teach others by example and are able to easily link to higher realms for ideas and inspiration. You can be prone to melancholy, especially when you feel frustrated and impatient to move ahead. Slow down, as your mind is very active, take time out to rest. Nostalgic, sentimental, mysterious, regal and sophisticated, or tacky, crass, a gossip and overbearing. Loving and kind, or distant and cool.

8 – Magenta

Blends the spiritual and physical, and it enables you to ground your divine inspirations and put your dreams and plans into action. With the combination of red and violet, magenta stands majestic, demands respect and offers refuge to all who seek peace. It enables you to break free from tired outworn patterns of behaviour, and ways of thinking and being that no longer suit the new you. Emotionally magenta will release you from the chains that bind, giving you a new way of looking at the situation/

problem that you may not have thought of previously. Breakthroughs happen with magenta. Magenta people can help many overcome life's trials and tribulations by offering sound suggestions, opening a new thinking channel for others. Respectful, idealist, workaholic, tireless support to loved ones and friends or dreamer, lazy and distant.

9 – Gold

Has no shadow, gold is the ultimate, gold is completion. A life cycle completes on gold. Everyone the world over understands and accepts the high value of gold, Saints are shown in works of art with a gold halo around their heads. Everyone is working around the circle to complete on the gold. Gold is the ultimate colour/goal as the fourth number. Illuminating, transparent and aspiring to the highest ideals for the betterment and highest good and highest purpose of everyone.

Further Number Information

Two – Is the liberator, the only number to be depicted in the tarot pack. Two can either be the number of division or universality. In the tarot pack the priestess is seated on two pillars, and in her left hand are two keys and in her right hand a book. Do these symbolise our need to study the two in order to obtain the keys that will unlock the golden wisdom?

Three – The three sides of the triangle can represent the ears, mouth and eyes. Three represents the AUM – a sacred sound, the Trinity. The Egyptians allocated three colours to the Gods: Sky Blue – Thoth; Yellow – Isis; Red – Osiris.

Four – Four elements: air, fire, water, earth. Four directions: north, south, east, west. The Cherokee and Sioux used colours for each direction. Red: east, fire and success. Sky Blue: north, cold, defeat, trouble. Black: west, problems and death. White: south, warm, peace and happiness. Interesting reading when you consider today that blue is considered universally to be the most

popular colour, yet as I have explained, there are many negatives that are rarely mentioned today but should be heeded when using blue.

Five – Five elements of ancient wisdom correspond to five colours. Red: fire, power. Yellow: air, give and take. Green: earth, perseverance. Sky Blue: water, adaptation. Purple: ether, spirit. In Ancient Chinese text there are five elements and ten colours. Interestingly comparisons can be made in part to modern day complementary colours. Fire: red/scarlet. Earth: purple/yellow. Air: blue/orange. Water: royal blue/golden yellow. Wood: magenta/green. In traditional Indian yoga and other ancient texts the theory of elements is thus. In plants: the element of water is active. In reptiles: two elements – water and earth. In birds: water, air and earth. Mammals: earth, water, fire and air. Mankind: earth, water, air, fire and ether. The Ancient Chinese count the 5 elements of fire, earth, water, metal and wood as important, incorporated in the tradition of Feng Shui and associated with the planets. They accept the human experience on earth is to resonate with heaven through their connection of the 5 elements and planet connection.

- Fire – Mars – Energy
- Earth – Saturn – Grounded
- Metal – Venus – Relationships
- Water – Mercury – Communication
- Wood – Jupiter – Expansive

Six – The 666 is often declared to be a negative number combination; yet in reality and to those with the wisdom of the deeper significance of colour and number, it is the numerical equivalent of life and the main player in the solar system, the sun. The numerical value of Vav Vav Vav in Hebrew is 6-6-6=9 equivalent to life! There is nothing beastly about 666. Plus, the 6 and 9 curved together create the yin and yang symbol of ultimate

balance. Triple Indigo with gold is the most powerful, inspired and complete colour combination.

The six Buddhist Perfections:

- Red – Generosity and morality
- Orange – Patience and perseverance
- Yellow – Joyful and effort making
- Green – Concentration and harmony
- Blue – Wisdom and integrity
- Violet – Ethical and disciplined

Seven – The seven colours of light: red, orange, yellow, green, sky blue, indigo and purple. Seven main chakras. Seven musical keys. Seven senses – 5 generally accepted with two more to open in majority. Seven ages of man, five score and twenty. Seven major planets. Seven ancient wonders of the world. Seven continents. 4x7 female menstruation. 4x7 cycle of the moon and tides. Seven female orifices. Seven candles on the Jewish candelabra.

Eight – On its side, eight becomes the symbol for infinity, regarded as a lucky number by many cultures. The eight-legged spider is prominent in ancient traditions, the number eight is held as the weaver of life. As above so below. Seen as a symbol for positive energy. The idea that Hermes Trismegistus introduced all those centuries ago, the figure eight represents 'as above, so below'.

Nine – Completion. The 6 and 9 curved together create the yin and yang symbol of ultimate balance. To the ancients nine repre-sented completion. In the human body, the fontanel at the top of babies' heads closes after nine months, and the nine-month gestation period of the human baby provides both a physical and symbolic metaphor. Within ancient Sufi and mystic Christian doctrines the nine holds prominence. The ancients knew much of the hidden knowledge and principles of numbers. The numbers 3, 7, 9 and 12 weave through ancient texts. For many years I have

Colour Numerology – The Karmagraph

used the 3, 7, 9 principle in my teaching methods and practicals with much success.

Twelve – One and two equal three, long held as a sacred number. Twelve contains within it the trinity, the three. The combination of the colours red and orange, the sunset combo, and it is written, the mystery of the twelve is earned later in life, as taught by ancient text. The truth seeker will discover much by researching the deeper significance of twelve. Twelve is important in a lot of religions. Revelations shares much on twelve.

- 12 Disciples
- 12 Sacred hills of Imerina
- 12 Stars on the European flag
- 12 Days of Christmas
- 12 Days of solstice
- 12 Companions of Osiris
- 12 Gods of Zeus
- 12 Labours completed by Hercules
- 12 Knights of King Arthur
- 12 Signs of the Zodiac in the West and China
- 12 Numbers on a clock face
- 12 Hours – the units of time can be perfectly divided by twelve.
- 12 Months in a year
- 12 Cranial nerves in the human body
- 12 Olympians in Ancient Greece
- 12 Sons of Jacob
- The chief Norse God had 12 sons
- In the King Arthur Legend there were 12 rebel Princes and 12 great battles.

The list goes on and on, and is the longest for the number twelve. I have cited just a few of many examples. Globally and in most

179

religions twelve holds significance. When you search you will come to realise the importance of the number twelve. The final and the most important placement of twelve: there are twelve petals in the heart chakra. Love truly is the beginning, the middle and the end.

Chapter 10

Colour Practical Exercises

The second June walked out on to the stage, she held our attention; she had us spellbound within moments. The content is jaw dropping.
Georgina Steel

The Circle

What is colour? How is it formed? How do we see it? Do we see it in straight lines, triangles or in a shapeless blob with ill-defined edges? Colour is traditionally associated with shape and form, and in my experience taken from more than thirty plus years of working with colour, the most important shape and way to work with colour is with circles and within a circle. To extract the very best from any colour work, work with circles of colour and place groups in a circle. Being the first in the colour world to teach and to work within the circle and with circles of colour, I find that the circular shape to be the very best shape to work with my beloved colour.

My interactive practicals are based on circle work My colour cards are circular and the art section of my work involves working in circular motion and with circles of colour. Groups are placed in circular groups or one large circle, and the dancing and movement are in a circular direction.

The circle is associated with wholeness: there is no beginning or end, and it reverberates in total harmony from its centre. The wheel is a circle and the term cycle represents a circle in motion. The circle moves in fluid motion, we even use the term 'coming full circle' to describe the natural flow and completion of a life cycle, be it momentous or insignificant. The tides, the seasons, the cycles of sowing and harvesting, the weeks and months of our calendar, all form circles. To see a rainbow is to view a partially

formed circle which reveals the colours of the spectrum in their perfect order, reminding us the spectrum colours are the key, enabled by the light of the sun, the largest circle in the universe.

To think of colour in a circular shape is profoundly important as it allows us to view colour in its wholeness. When we use colour as a meditation, or are just considering colour in terms of decoration for the home, it is always best to see in the mind's eye as a complete circle. This gives a sense of fluidity and simplicity, and helps us to perceive more clearly the depth of colour we are looking at. Many ancient cultures confirm that the circle shape is held in high regard. The more people live in close connection to the earth and are guided by the natural rhythms and cycles of life, the more settled and in harmony everyone will feel.

When in doubt, I return to the natural world for my inspiration; to cite a few examples: the sun and planets are round, the earth we exist upon is round and the cycle of life is one great circle/cycle from beginning to end. We all began from the one circular cell.

Colour Type

To carry out the following exercise you will need either coloured pencils, coloured ribbons, or a set of silks in the seven rainbow colours: red, orange, yellow, green, sky blue, indigo and violet/purple. Spread the colours out in front of you and glance over the seven colours for a few seconds. Quickly choose one colour; pick it up. Turn over the page to reveal your colour type; you will recognise some, if not all, of the attributes in yourself.

Red

You are a born leader with a spirit for adventure; you are passionate about many things but must be careful not to use your energy to excess and tire yourself out. You tend to dive into things feet first, which can sometimes leave you in hot water. You love movement and change, and to be seen and recognised for

your efforts at work. You have huge amounts of energy for projects and interests that you feel passionately about. Your strong will can sometimes be used to dominate others, so be careful. Channel your energies for the highest good. Initial bursts of passion and energy can lead to burnout, so focus on seeing projects through to completion.

Orange

You have a natural outgoing personality that is effervescent and contagious, fun and laughter are key for you. Living life to the full is important to you. You shine at social occasions and love meeting new people. You can bring a light and playful atmosphere to any occasion with your good sense of humour and positive outlook. Work on releasing any self-imposed barriers that may be holding you back; recognise your insecurities and let them go. Talking about your deeper emotions or writing them down will be therapy for you.

Yellow

You have a strong mind and love to absorb information. You have many inspiring ideas, however, you need to work on connecting with your inner voice and tune into your own innate knowledge. You have an analytic mind. Practise following your feelings and intuition more. Your many interests can cause you to jump from one activity to another or from one person to another. Aesthetics are important to you; you always make a positive impact at social occasions, but often only reveal some parts of yourself to others. You have a talent for writing and strong organisational skills.

Green

You are warm and open-hearted and have a special love for your home. You have an open door policy. Everyone is welcome and you are good company and a natural humanitarian. You have a love of good food and beautiful things, and are happiest when

you are sharing. You are a natural peacemaker and can see both sides of a situation. Take time out for yourself. You are a natural giver; spending time in the green of the country will replenish your energy. You have the ability to nurture and encourage others in their personal growth.

Sky Blue

You are peaceful and supportive of others and don't like to let anyone down. You have a wonderfully giving nature, but remember to allow yourself time to receive. You give out an uplifting and peaceful energy; others feel good in your company. Speak out more and express your intuitive nature; you are a very sensitive soul. You are a natural speaker and have a creative and witty way with words, a natural leader you can bring healing to many. You are open-minded and excellent at encouraging groups and building team spirit.

Indigo

A natural esoteric teacher, you are able to communicate higher knowledge in a down-to-earth way and change people's lives for the better. Your intuition is highly developed. Write down your inspirational thoughts daily and they will guide you smoothly along your path. You can sometimes feel lonely but there is no need to. Remember the many people who will be there for you at the drop of a hat. You are a natural counsellor, but remember to set boundaries when giving time to others, as you can give endlessly, in detriment to yourself; you invented unconditional love.

Violet/Purple

You give so much to others without a thought of return Sometimes you can be a bit of a perfectionist and will make unnecessary changes. Stick with your first line of thought and you will always do well. You are gifted and bring many positive

changes to people's lives. You motivate and teach others by example, and are able to easily link to higher realms for ideas and inspiration. You can be prone to melancholy, especially when you feel frustrated or impatient to move ahead. Slow down, as your mind is very active; take time out to rest, one word of advice: curb your jealousy, violet.

Positive Thinking with Colour and the Breath

The body will make you aware when it needs attention through feelings of aches and pains. The body is not separate from the mind nor the emotions nor spiritual beliefs; it is one part of a cohesive whole. The head stands proud at the top of the shoulders; as man thinks, so he is. Much has been written over the ages on positive thinking, yet today many are not using this simple and very effective method to prise themselves out of melancholy, to give hope, to look forward with a positive mindset to the future. Colour can help focus the mind to hold positive thoughts rather than languish in negative thought patterns. By focusing the breath coupled with imagery and colour, it is possible to train the mind to calm, to destress and refocus. The body and emotions also benefit as the mind calms.

Sitting quietly, close your eyes, regulate your breathing, deep and slow, with all your attention on your breath. Feel the softness of each out-breath as it caresses your face, breathe in as if it is your last breath, deep and long. Try to hold for a few seconds before releasing and continue breathing like this until you feel relaxed and comfortable. Now imagine your favourite colour washing over you as you breathe out. Also breathe it in with every in-breath. The time limit is set by how you feel each time you carry out the exercise. Sometimes you may sit for 5 minutes, other times longer. There is no set length of time. To enjoy and to relax is the goal. Do this each time you feel negative, stressed or when you feel overwhelmed by life. Notice how your thinking processes become clearer, less fogged and less negative.

Gradually over time you will notice the benefits of this simple exercise, and by combining the exercise with more positive thought, the outcome will surprise you. You may also repeat the appropriate words for each colour of your choice, taken from the six Buddhist Perfections, to strengthen resolve. Use blue for sky blue and indigo.

The six Buddhist Perfections:

- Red – Generosity and morality
- Orange – Patience and perseverance
- Yellow – Joyful and effort
- Green – Concentration and harmony
- Blue – Wisdom and integrity
- Violet – Ethical and discipline

Colouring an Egg

Ask the group to draw an egg shape and to colour in using three colours of their choice, on a blank sheet of A4 paper. When complete, give interpretation of the colours that they used and the order placed. One participant on a course mistook my instructions; she heard "draw three eggs". Seeing she had drawn two eggs, I suggested that she use the third colour she had chosen and create an egg encapsulating the other two. When she had finished, this was my interpretation: "This represents two children who are at loggerheads with each other and you are trying to keep the peace between them all the time. It is most wearing for you as you desperately seek a solution." She gasped, "Very true!" Colour truly is amazing when coupled with the spiritual aspects of art therapy, no system is more accurate; it cuts through the crap to expose the truth faster than anything else I have worked with to date. Yet one cannot expect exceptional skills to be attained overnight. Colour is a life-long learning process.

Colour Reading

Choose three coloured pencils from a wide selection. The colour choice relates to that moment in time. The choice of three colours must be quick and decisive.

1st colour – shows energies that you are using at this time

2nd colour – indicates an area of challenge that you may be facing

3rd colour – the colour of the energy to work with in order to meet current challenges

Group Exercise

Split group into small colour groups i.e. red group, yellow group, blue group. Ask them to think of as many colour phrases as they can in their colour, and to nominate someone to write them down and read them out when the exercise has finished. After a few minutes, suggested 5 to 6 minutes, call a stop and ask the spokesperson from each group to read out the colour phrases the group has come up with. Suggest everyone jots down the outcome for future reference.

This simple yet effective colour exercise will confirm to everyone that colour is an integral part of our language and demonstrates how often we use colour in language every day, possibly without thinking about it. By using colour language, are we not reinforcing connections between everyone, as the terminology has to be shared to be understood and conveyed? In business it is important to put in place a cohesive team, to work together on projects, with a common purpose for the best outcome. Colour knits together every team for the benefit of themselves and the business.

Further Colour Meanings

Silver – Much is spoken of gold, yet very little on silver. Silver is another paradoxical colour, which activates the moon energy of

moodiness and despair with the frivolous giggling delight of the silver sheen. The craziness of the moon mood can be seen in all its glory in silver; yet, placed in the right setting for the right purpose silver comes into its own. Moments of genius are experienced in silver. The shimmering silver shafts of light are the dawning of inspiration, the ah ha! moment, when one grasps a thought that leads on to the elusive discovery. With a cool and calming energy, often worn as an amulet, silver is considered in many cultures to have protective properties. Silver corresponds to the element of water, creative genius, connects to the emotions, the intuitive mind and love, with all its ups and downs and emotional excesses.

Gold – With a strong connection to spirituality, gold instils energies of integrity, value and higher purpose. Traditionally associated with the element of fire, gold has a vibrancy and depth that all colours yearn to achieve, yet simply cannot compete. A stand-alone mystical and glorious colour depicted throughout history and ancient text as the very best, and heralded as the ultimate and most desired. Gold is completion, the end goal and the only colour that has no negative aspects. Gold is the aim as we travel through all the colours. Gold can be bliss, and the end of a nine-life cycle as depicted in the colour numerology – the karmagraph chart.

Black – Creates an energy of mystery and feelings of all that is possible. It is intensified when worn with other colours, and intensifies their properties adding strength and power. It stands shoulder to shoulder with red as the sexiest colour. Much is written about the joys of the little black number, a 'must have' in every woman's wardrobe, yet very little on the use of black for protection and healing. Black is also the dark before the dawn and one of the healing colours. Yes, I did say that, a healing colour. There are times when we all turn to black for protection; it may simply be we are having an off day so we hide behind black. During illness, personal tragedy or mental breakdown

wearing black initially protects us from the outside world, while we rest, gather our thoughts and begin to heal. The breakthrough moment is when brighter colours are worn. Much negative comment has been wrongly laid at black's feet. I stand firm basing my findings on many years working and observing. Black has earned its stripes and is a valuable colour in the line-up of colours. Black as part of a fashion wardrobe has its place. Black can be sexy and outgoing or has a sense of hiding away from the world, the choice is yours.

Red – Instils confidence and purpose, encouraging drive and determination. Stimulating passion and the will to move forward in life, red gives us the strength to stand our ground, start new projects and endeavours with commitment and enthusiasm. Red encourages us to let go of anything that may be holding us back, giving us the security we need to look forward to brighter horizons. The key words being leadership, enthusiasm, activity, energy, courage and sacrifice.

Orange – Inspires creativity and sociability. Orange works to clear and strengthen our emotions helping us to laugh and see the funny side of every situation. Orange creates a feeling of warmth, giving us the energy to express our creative potential.

Yellow – Brings in the rays of sunshine, helps us dispel feelings of depression and self-doubt. Yellow enhances our mental aptitude helping us to stay focused and clear thinking. Yellow is an excellent aid for revision or exam as it helps to strengthen the intellect.

Green – Provides balance and harmony, and takes us back to nature reconnecting us to nature and our heart centres. Greens correspond to the elements of the earth, strengthening our inner core and bringing us back to our natural self. Green represents growth and all aspects of life.

Sky Blue – Provides a peaceful, cool and healing energy, which corresponds to the natural element of water. Sky blue heals the inner soul, soothes the emotions and opens the channels of

creative communication. It helps us to recognise and utilise our creative expression within our life's work.

Indigo – Encourages us to slow down and listen to our inner voice, persuading us to adopt a meditative approach to life and its hurdles. Indigo fosters self-reflection and our search for inner higher knowledge.

Violet – Gives us the inspiration and vision for the future, helping us to connect to our spiritual selves, our ideas and creative channels. Violet has a pure fine effect, calming our reactions and soothing away tensions. Violet fosters purity of intention.

Magenta – Combines the physical energy of red with the spiritual energy of violet. It encourages us to break away from unwanted habits and patterns of being that no longer suit us. Magenta encourages us to put into action our inspirational ideas and ambitions. Magentas are excellent for business success and business acumen, as well as enhancing communication skills fostering self-respect. There are few negatives in magenta, yet many higher aspects of this beautiful colour, a combination of red and violet. Magenta will foster truth and self-respect and enhance communication skills and will be heard by a wider audience.

Turquoise – Combine the calming energy of blue with the balance and strength of green and we have glorious turquoise. It stimulates our ability to speak clearly and easily in public at any social occasion, enabling us to communicate clearly and from the heart.

Jade Green – Corresponds to the heart centre, strengthening our ability to give and receive unconditionally. Jade green symbolises the free flow of monetary riches and the notion that whoever gives from the heart shall receive threefold.

Pink – Soft, nurturing, love and self-acceptance. Pink emanates a soft feminine energy that is soothing and comforting and a muscle relaxant. Pink corresponds to our heart centre

enabling us to give and receive love unconditionally. It also helps us to love and accept ourselves along with others.

White – Contains the energy of all the colours. Symbolising purity, clarity and innocence. It has a cleansing, energising effect on the mind, body, spirit and emotions.

Coral – Corresponds to the element of water and is permeated with the soothing energy of the ocean. The word coral is Greek and means 'daughter of the sea'. Coral is the combination of the colours peach/orange and pink bringing together the creative energy of peach/orange with the gentle energy of pink. Coral supports us in following our heart's desire and enables us to bring forward and nurture our creative energies.

Maroon or Burgundy – Is a combination of brown, red and violet. Maroon/burgundy helps us to earth our spiritual wisdom and inspirational ideas. Old souls are drawn to maroon and burgundy coupled with gold. Maroon and burgundy help us communicate spiritual truths and wisdom in a down-to-earth and practical manner.

Brown – Links us to mother earth. It has also been linked to finances and material gain, but it is the soil in which everything grows. It's most positively aligned with growth, growth of self, growth of project. And used in smaller amounts like black in conjunction with other colours heightens the quality of each colour.

Tan – Logical beings who tend to stay in the left brain need to find the balance of the left and right brain. They tend to over-analyse, think too deeply about everything, be intense, but once relaxed, can relax in every situation. Tans symbolise logic. They are analytical, particular, enjoy detail and can be pernickety. Their lesson is to learn to relax, enjoy the ride and if one makes a mistake, say it's okay. and move on. Learn to erase it from the mind and move forward, not keep looking back with regret.

People rarely agree on the shade of colour that they are looking at, yet the effect of the colour will be felt by everyone.

The only difference being the strength of the colour determining the strength of the feelings. As an example, let's look at sky blue. Everyone will experience the feelings of expansiveness and a high percentage of people sigh when exposed to the colour for a certain time. Not everyone will agree on the shade of the colour; some suggest it is turquoise, amethyst, sapphire or give it another description.

Chapter 11

Health, Nutrition & Vitality

There are three things that are extremely hard: steel, a diamond, and to know one's self.
Benjamin Franklin

Numerous studies prove that colour is effective. Blue relieves arthritic pain. Coloured plastic sheets assist dyslexics with their reading. The warm colours known as the magnetic colours stimulate children's IQ when used in the classroom and also keep the elderly alert in retirement homes. Researchers in Germany organised a trial on the effectiveness of blue light for back pain, the theory being that blue light triggers stimulation of pain-killing effects. The study confirmed blue light is effective against pain. It is an established and known colour to ease many ailments, better known for its antibacterial properties. There is much controversy on blue being used near eyes; many are against and some stay with the use of blue.

Solarised Water Using Glass

To make solarised water do NOT use plastic lighting filters, only use coloured glass containers. I have now proven beyond doubt that glass is the most effective and very best material to use when solarising water. Use a clean, sterilised glass bottle or container, in the colour of your choice. Fill it with still mineral water and stand it on the windowsill in direct sunlight if possible for at least three hours. Gargling with blue solarised water daily will ease gum disease, sore throats, mouth ulcers and help eradicate a metallic taste regardless of the cause. Skin conditions are soothed and cooled by bathing with blue water. Supermarkets and health stores sell a variety of drinks in different coloured glass bottles,

and it is possible to collect the whole rainbow range of red, orange, yellow, green, dark blue and violet. Once solarised after three hours, drink daily or use as a wash on affected areas, or gargle. Use daily until results are seen or felt, then decrease usage to alternate days, decreasing gradually over a fortnight to nil usage. There are no known side effects or contraindications. Keep the water in the fridge when not in use.

Blue – The most powerful for pain relief. Sufferers of varicose veins and arthritis in the hands have felt relief.

Orange – Soothes the circulatory system and digestive system, a great antidote to melancholy. It aids the hormonal system and helps build calcium in the body. Exercise combined with the use of orange will support healthy bones and is a great HRT support. Researchers in Israel found after one year of regular exercise bone growth had increased by 10% in the majority of participants.

Red – To increase heartbeat, increase blood pressure, to accelerate the healing of wounds. It aids circulation, tingly feet and arms by giving energy and warmth. It activates the system and raises blood pressure.

Violet – Use for skin conditions, antiviral and antiseptic, eases headaches, use for poultices and swabs for infected areas.

Indigo – Bathe wounds and sore tired eyes with cotton wool balls soaked in indigo solarised water. Drink it to cool the system. It eases chest and lung problems. Antiviral and antibacterial, for cooling of inflammation and skin conditions, and helps clear sinuses.

Yellow – Increases the flow of vital fluids in the body, clearing sluggish systems and helping to move constipation.

Green – A nerve tonic which balances the system and is good for settling nerves, relieve colds, and hay fever. It helps to regulate heartbeat and lower blood pressure.

From this point, armed with colour knowledge, there are examples and exercises that you can choose to put into practice to

help bring changes into your life quickly, efficiently and colour-fully.

Health

Colour has always been an essential part of life and our existence on earth. Colour is all around us, radiated from the sun. Isaac Newton scientifically verified the existence of the presence of colour within natural light by shining light through a prism, naturally dissecting the one white ray into the seven rainbow colours that we know so well. Red, orange, yellow, green, sky blue, indigo, and violet. By taking time out of our busy schedules to walk or sit outside we absorb these colour rays from natural light, regardless of the weather. Without the natural light from the sun, nothing is able to thrive, survive or grow on this planet, including ourselves. Colour is an energy medicine; colour the energy. The Ebers Papyrus dates back to 1500BC. The manuscript is preserved and when unrolled it stretches out to sixty-eight feet. It compromises medicinal prescriptions, some of which are still used today. Red – for smallpox. Yellow – for jaundice. Blue – for colds without fever. Red – for fevers.

Interestingly, the advice aligns with colour and also some complementary practitioners of homeopathy – who use like for like. For posterity, I will pass to my grandchildren this advice: the wisdom of colour, coloured music, movement and aroma. These are the main areas to concentrate upon. Coupled with a colourful balanced diet, fresh water and deep breathing for good health. Over many years I have taught colour internationally. My work is constant from the start, with interactive hands-on practicals, dance and movement to specific music with the added bonus of aroma.

In these times of change, we can choose to hold on to pain or tune into the joy of life. Laughter moves us and shifts energy releasing tension throughout the body, giving us a fresh perspective. In my work I have seen many glorious changes

brought about by the use of colour. Once we accept we are prisms and our health and well-being depend on a daily dose of colour (natural light), we begin to feel uplifted and less tired. To move on to using colour in the many ways outlined in this book, we make a conscious effort to help ourselves. By working with our sensory perception and intuition we can expand over awareness of colours to levels beyond the visual. As we develop our ability to feel colour and resonate with its vibrations, a new dimension is added to our lives. The existence of the human aura is scientifically proven. Everything has its own electromagnetic fields and that field consists of coloured vibrational waves of energy. Colour is the natural harmoniser of the world, and therefore the key to our own natural harmony.

In 1202, Italian mathematician Fibonacci discovered the Fibonacci sequence. Each number being the sum of the preceding two: 1 2 3 5 8 13 21 34 55 89 and so on. Startling parallels are found in the plant kingdom, such as daisies have 34, 55 or 89 petals and marigolds have 13.

Hundreds of years before genetics could prove the significance of his discovery, the universal laws of the physical world have proven mathematical basis. Fibonacci was born in 1170. He was a quiet nature-loving man who spent many hours observing the wonders of the natural world and who listened to his inner voice. He was an inspiration to everyone. By making positive mental change and listening to the inner voice, you begin to make positive changes in your 'health', your relationships and your career. Every day you are influenced by or are influencing others, and when you become aware of the power behind the influence, either negative or positive, you will want to be an influence for positive change. The first step is to start with yourself. The exercises I have invented are one way to do this. Exercising with colour will take you on a journey to discover your hidden assets and abilities, the full spectrum of your potential. Colour pervades every aspect of our existence and connects our inner and outer

worlds. Working with colour is easy to do. Choose one of the many exercises and follow the instructions. Carried out regularly these will bring about positive change. The positive effects are many, and can be seen and felt. How many of us put up with a stiff neck, headache, backache and other ailments, no longer remembering how it feels to be perfectly in balance?

You will rediscover how it feels to wake up in the morning feeling refreshed and ready to start the day. A level of well-being that you had forgotten was possible. Combine the exercises with listening to my CD – *Colours of the Soul*, available digitally. Listen to it regularly. The music is beautifully coloured, each key is in specific colour for health and well-being, the first and original coloured music CD. Bespoke Training Packages are also available. See the Services section at the front of the book.

Off Colour

When we describe someone as being 'off colour', without knowing it we are picking up that they have an energy imbalance which is causing tiredness or a feeling of being unwell. When our colour batteries are low, we feel drained and run-down. When we are in balance, our colours are bright and vibrant, and we feel full of energy and life. We radiate colour when we are positively charged and naturally maintain a balance of well-being and good health.

Understanding the deeper meaning of colour and how we are affected by it reconnects us with our inner light as a guiding force in our lives. Trust your light, your inner voice. We each have gut feelings about most situations. The key is to listen to the cue cards, and if it doesn't feel right, it most likely isn't. In this way, you will always be where you're meant to be, doing what is best for you. Your gut feeling or inner voice only has your best interests at heart. The colour breathing exercises are a great quick fix aid to rebalancing and will ease feelings of angst and stress. They will also help with insomnia.

Physical Colour and Perceptions

On a physical level colour affects our bodies. The red end of the spectrum can tense our bodies while the blue relaxes. Colour affects our perceptions. On a mental level a red room appears smaller than a room of the same size painted blue. How we feel about colour is covered in my work. Red excites, gets the blood flowing, warms us up, whereas blue is cooler and calms us. Red and blue light appear to have the most effect as red increases muscular activity, respiration and heart rate, while blue lowers blood pressure, slows breathing and calms the body.

Scientists in Norway confirmed what we have known about blue for many years, when they undertook a study that found people in blue rooms turned the heating thermostat several degrees higher than those in an identical red room. Another proof that colour does affect the way we feel.

Stress

The Mental Health Association states that over recent years there are more people suffering from anxiety today than ever before. Once you understand and are armed with colour knowledge you can rebalance feelings of anxiety by encouraging feelings of calm and being in control to grow. Everyone knows on some level that colour affects them. You choose clothes to suit your mood, not fully conscious of the reason why; change the colour of interiors to create a home that is lovely and your own special place. In the business world, bright colours are combined for branding and advertising purposes to promote and make the brand stand out from the rest. How incredible! We can manipulate our own and others' feelings and choices through colour. Colour is so powerful and one of our greatest assets that affects every area of our lives. Let's use it to its full advantage for ourselves and our health.

Anxiety, stress and fear can immobilise the body and mind, impacting on the immune system, digestive system and slowing the metabolism. We know the heart rate increases and blood

pressure rises, all placing pressure and adding to a ticking time bomb. We need to recognise these signs and take action before real damage is done. Stress leaves the body open to infection, and the first sign of your body nudging you to take action is usually the sniffles or a headache. If ignored expect to experience shortness of breath, palpitations and ongoing tiredness. Unfortunately, the mind cannot differentiate between the real and the imagined, and there is some research that shows the imaginations of the mind can become a reality. Therefore, the importance of having an uplifted mood rather than constantly worrying is more beneficial for mental and physical health.

The body reacts to what we think, the choice is ours. When life appears to be spiralling out of control and you feel unable to shape your destiny, you have reached a pinnacle point. Even then you have a choice. Support your lifestyle with good nutrition and rest, and use an exercise regime that suits you coupled with elevated thinking, not constantly worrying. The problem with modern life is a lot of people are constantly in stress mode, the adrenals and hormones are overused, nearing burnout in a constant state of fight or flight mode, and therein lies the problem. Shallow breathing is a wide problem, monitor yourself through the day, correct yourself when needs be. By simply changing the way you breathe you will relax the body. Throughout my years of working with people I notice how people who breathe shallowly do so to their detriment. The body needs to be oxygenated. Breathing exercises with colour are simple and easy to carry out.

The considered use of colour can give us clarity of thought and are proven to decrease anxiety levels. The levels of anxiety in the UK adult population have increased to an all-time high. Colour can help hugely. Stress lowers immunity, reduces bone density, and raises cholesterol. It is the cause of many changes in your body and personality. The hormone cortisol makes your muscles atrophy and tricks your body into storing more fat,

therefore you gain weight. Sleep patterns are disturbed and with lack of sleep comes tetchiness, tiredness and an inability to carry out daily tasks which in turn encourages lack of exercise. Too much stress is bad news, or should I say, the lack of managing stress is bad news to your body, your emotions and your mental health.

I believe colour is the most powerful support when used appropriately and consistently. Colour can cut through the turmoil to the root of the problem to support positive and trans-formational change. Throughout this book and in my earlier works there are examples. I set out to explain clearly how to use colour daily to support good health. To know one's self is the end purpose of your journey through the game of life. Listen to your inner voice; take time out to just be, to drink in the beauty of the natural world away from the hurly-burly of life's demands. Once a balance is achieved the result is happiness and contentment, an inner peace that is priceless. It will always be free to walk the rivers and roam in the countryside and bathe in the warmth of the sun. Eat nutritious food and drink fresh water; water will become the new gold, the one commodity no one can live without.

Avoid microwave use; store and cook food in natural materials, glass, wood, steel, copper and ceramics and as an exercise in class proves, stir clockwise when cooking and preparing food. Take 2 glasses of water, one inch/2 cm – stir one anticlockwise and the other clockwise with your first finger. Leave on the windowsill for an hour, then sip both cups. The anticlockwise will taste bitter and the clockwise sweeter.

Stress levels lead to illness. Illness brings enforced change. You can view the change as the potential for positive change and therefore growth. Better still, you can take responsibility for your own health. Take steps to reduce the stresses in your life. The psychological theory is that every generation should sort out the unfinished business of the previous one. The colour way is to sort

out the here and now, within self. Take full responsibility for choice and actions. Carl Jung believed colour and symbol help us evolve spiritually. Colour heals and develops spiritually. Colour heals and develops the whole mind, body and spirit.

Colour seamlessly works with and supports other disciplines, allopathic and complementary. Colour is a two-way process. Each day you choose the colours you wear, but have you thought about the messages you are sending out or why you chose those colours? Colour is a powerful language. Within three to six seconds of meeting you, people have made up their minds. Research proves you also choose a product by colour and design of packaging.

Colours have different meanings worldwide, blue being the most popular choice globally. Is it really a wonder when we are surrounded by blue in the natural world? The sky and oceans in the main blue. We are 70% fluids therefore we must resonate with the 70% water mass covering our planet.

Our inner knowing accepts the importance of colour. Most cannot imagine living in a monochromatic world; how drab and boring and how depleting of your energy. When you are wanting to get away from it all you gravitate towards water or venture inland to green countryside to refresh and replenish. The sky and oceans are blue and the earth sprouts green, bar in the desert where the oasis is revered for the water and the greenery. Workplace stress is on the increase. Anxiety, depression and addiction cited as the top reason for stress at work. Demands on employees are rising, causing overload, with stress-related illness increasing. The decision makers affect us all, yet they are struggling themselves with the financial, legal and accountancy areas most affected. Regular sleepovers are the norm to keep pace with workload and cases. Recent studies show strain at senior levels, with many battling mental health issues. Some illness taking a two to three-month recovery period, it makes sense to attack the issue head on and make the overdue changes. Measures using

colour in the most positive and productive way can be implemented.

Personal Health

When we stand face to face all our energies will be shown to the other. Our expressive self is 'out there'. It is how we present to the world, the source of our human senses are at the front. The back of the body is our hidden shadow. The spine is the single sensor on the back of the body. All our deep inner thoughts build energy in the back. I can best explain what I mean by this example: when couples argue and lie back to back in bed, one or both will feel very uncomfortable with a tingling of the spine or heavy feeling. The most sensitive person won't be able to sleep, and may feel drained of energy. It is best to get up, take yourself away for the night, sleep in the spare room or on the sofa if it is not possible to talk things through to clear the air. If there are arguments with a loved one, resolve by bedtime. Never sleep together without resolving because the negative energy will increase and pass from one to the other, with the most sensitive person suffering the most.

The face also tells a story. We each have a good side that we prefer to show in photographs, particularly to loved ones. The good side is the side of the inner self that we display to the world, created from our thoughts, feelings and desires, and declares all that we believe we are. Whereas, the other side of the face, the side we keep tightly personal and closed to public scrutiny, is our private self and can be the reality of our inner thoughts. I have a theory based on my own personal observation of people over many years (my opinion is not based on a research study, rather a close observation of many people) and led me to conclude that people with a top heavy body type and shape are naturally inclined to think things through carefully and consider before they speak. Whereas the bottom heavy shape body type speak their mind openly, generally not holding back and without

thinking through. In other words, the bottom heavy body type will speak their thoughts, say exactly what's on their mind. The top heavies are careful and considered, thinking through before they speak making it more difficult to judge what's on their mind and their true opinion.

The hands display everyone's emotions and thoughts equally. Held tightly to the body, by the side or clasped together in the lap, shows a tense person, possibly fearful. Whether held out wide and expressive or held at our side, the hands declare to the world our passions, fears, horror and delight. The eyes, the mirror of the soul, cannot hide inner thoughts and feelings. Always look deep into the eyes of the other for the truth. Averting eyes, not looking at you full on, can be a concern, especially when you are asking the other a direct question that requires a truthful answer.

We are a product of our thoughts and feelings, and the body alerts us in so many different ways to where we need to pay attention in ourselves, and highlights matters in our life that may need attention. Sixty per cent of illness is due to people holding on to and not releasing emotional issues and baggage. We may need to review our stance on self-development and health to include an overview of the language of the body – a study of the presenting of imbalances/illness.

Cue Cards

The cue cards are ever placed in front of us on our journey through the game of life, and yet never more so than the body calling out for attention. The following is taken from my own personal observation of clients and students over a thirty plus year period. Chaos will reign in our lives if we allow fear and negativity to rule our thoughts and emotions. We are each master of our own universe, captain of our own ship. Take the helm and steer your life in the direction that is right for you based on sound choices, not fear. The only time in my life when things went

askew was when I ignored my inner voice. We all have an inner voice, that feeling in the gut of the stomach that calls out when people or events are not being sincere or acting in our best interest. It is an inbuilt ability that we must each develop, for happiness' sake, and listen to. Like an unused muscle, the more it is used the stronger it will get.

Love – to give and to receive. Purpose – we all need a purpose, a reason to get up every day. Purpose is fundamental to health. Control – to be in control or to feel out of control; despair, anger and frustration occur when you feel life's events are moulding you, rather than you moulding your own life. Choice – is an opportunity or crisis, from a secure place or to a fearful place. Fear or peace – decisions and choices made from a place of inner knowing and trusting self, rather than from a place of fear and insecurity are the best choices. Happiness – Fun – Creativity. A good work/play balance is needed in life. Fun and laughter is vital and creativity is transformational. This is now recognised more today than ever before. There are playgrounds for adults where no one under twelve is allowed in.

Our journey can be eased and smoother once we listen to our own voice within; call it what you will, intuition, voice within, inner voice, gut feeling, higher self or inner messages, it is identical. The key is to be courageous enough to trust and to listen to your own messages. If something feels right, it most likely is. If it doesn't feel right, it most likely isn't. Simple in theory, more difficult to put into practice, yet possible. Couple this with alignment between thoughts, actions and words. When these three are identical and working in harmony together, then there can be no energy dis-harmony. When we are in alignment and as one. From this harmonious place we are a clearer vessel and more able to hear the inner voice.

The Body
My observations are not a diagnostic tool or meant to replace

medical advice nor replace medication but purely my personal opinion. I do not want to offend, cause angst or guilt or to hurt anyone, it is not my intent. However, I do want to share with you my findings taken from years of observing in the hope that my observations may act as possible cue cards, highlighting where possible changes can take place and benefits be gained.

Example:

- Urine Infections – Who or what is pissing you off?
- Headaches – Trying to retain too much information, get it out, communicate your thoughts or write them down.
- Neck – Wind your neck in, your position needs a rethink, your neck is telling you so. So come back to yourself and your business. Leave others to find their way. Concentrate on your life and self. You cannot control all outcomes.
- Sore Throat – What are you not saying? What are you trying to keep secret?
- Shoulders – Instead of feeling weighed down by life, change your thinking, take ownership of your choices to date. Review and change your direction.
- Back – All back problems (to a greater or lesser degree) – Are you feeling let-down, overloaded and unsupported or are you just giving up?
- "I've had 10,000 ideas that didn't work, I haven't failed," Benjamin Franklin.
- Rethink your strategy and put your plans into action. Your call, defeat or action.
- Teeth – Problems with teeth can highlight security issues. Are you talking too much, and not doing enough? Go within to contemplate your position, then get doing.
- Indigestion – Going over and over old stuff. Let it go, or get help to release old baggage.
- Candida – What are you trying to prove and to whom? Control issues, feelings of being smothered and

overwhelmed.

- Colitis – Are you trying to escape, to do a geographical? Face your problems head-on and resolve issues once and for all, then you can move forward.
- Nausea – Unsteady in your position, unsure of the way forward. When in doubt, don't.
- Irritable Bowel – Speak your truth, get it out, rather than holding it in and then spouting hot air. Say it as it is, at the time.
- Hepatitis – Depriving yourself of feeling deeply. Be open to care and kindness.
- Earache – What have you put out there you wish you hadn't? It is never too late to make amends.
- Gall Bladder – Your temper needs an outlet. Make changes, take up activities and exercise to release pent-up anger.
- Gallstone – Why say yes when you mean no? Or wish you hadn't?
- Diabetes Type 2 – What do you feel is missing in your life? The grass is not greener over the hill. Is too much time being spent wishing and dreaming? Get real, come back to where your energies need to be put and nurture yourself and your loved ones. Trite but true, count your blessings.
- Hypoglycaemia – Enjoy where you are in life, stop pushing yourself so hard.
- Sneezing – Who or what is most irritating?
- Tightness in Chest – Serious pampering of self needed immediately. The feeling of not feeling appreciated, can be lonely. Seek out groups, hobbies, interests that are not solitary pursuits.
- Sinus – Seek a new creative outlet, or get outside in the great outdoors.
- High Blood Pressure – Regular time out from the drudgery of everyday is needed. Start now. Let your guard down.
- Low Blood Pressure – Get involved. Don't withdraw from

life.

- Circulation – Change your thinking, refresh your outlook on life, loved ones are vital to happiness.
- Thrombosis – Stuck – get moving, emotionally, physically and mentally. Reach out to loved ones and give them your time.
- Varicose Veins – No man is an island, gather your tribe around you for moral support.
- Shingles – Communicate how you are feeling, rather than erupt every so often.
- Nail Biting – Why are you eating yourself? Work on losing those feelings of inadequacy, become empowered.
- Alzheimer's – Possibly feel let-down by life, feelings of not having reached full potential.
- Hip Issues – Are you critical of self?
- Constipation – Let the shit go from your life, the past is the past, move on, the ability to let go is precious, clear the clutter and paperwork, refresh your personal 'look'.
- Fibroids – Feeling unsupported by loved ones and life. Never enough time in the day. Make time for you.
- Cysts – anywhere on the body – Feelings of unfulfilled potential in life. Seek out new hobbies and interests. Relight the fire within. Get excited about life once more.
- Pain in the Fingers, Wrists and Arms – Flexibility in thought and action is required, or are you holding on too tight to someone or something? Remember, if it is yours by Divine right, no one can take it away from you.
- Breathing Problems – Are you being stubborn? Or just need space and time away to regather your thoughts and perspective? Make it happen. Communicate your need for space, take control.
- Knees – Losing the ability to move forward in life. Take time out and look again with fresh eyes at career or home life. Reflect on the changes needed and take action.

- Flat Feet/High Arches – Put your foot down, have the courage to be yourself. Take on a 'this is me, take me or leave me' attitude.
- Thinning Hair – Control issues, what do you fear losing? The control over a situation or person? Too much strategic thinking, trying to control outcomes. Look at trust issues.
- Digestive Problems – Review relationships and express your views.
- Ulcers – Put the guilt stick away. Share your secret, release i.e. a problem shared is a problem halved.
- Diarrhoea – Just say it!
- Panic Attacks – Feeling abandoned and alone. Seek support and regain control.
- Black Ring at edge of Iris in the Eye – Barrier is up, will only let people in so close – possible base chakra issues.
- Menopause – The body as we know it is taking a wee pause in life, reminding us to review our life up to that point to assess where we want to go, what we want to do and how we wish to spend our time in the future; as our bodies change so do our needs.
- Erectile Dysfunction – If not a medical underlying cause then look at your thoughts on ageing and perceived unfulfilled potential; let it go and move forward into a new era of your life with excitement and lightness of heart. Each stage of life has its rewards.
- Eye Sight – If what the eyes see is in conflict to what the pineal gland sees, then visual problems will occur. See the reality, not a perceived reality.
- Skin Complaints – Not only look at what or who is getting under your skin, look also at what irritates you, and make those overdue changes.
- Saggy Bottom – Feeling stuck and powerless. Exercise and pull it back, to regain your confidence and power.
- Posture – When confident we stand tall and erect, and emit

energy of being proud to be who we are – enough said.

- Feet and Ankles – Being stopped in your tracks, look at what you are doing in the work arena, why and for whom? Get back on to your true path and 'do it' for yourself first and foremost.

Food – Reducing Intake

Food intake can be reduced with the help of colour by eating from blue plates. This was recently highlighted in the media as a means of reducing food intake, the theory being that by eating from a blue plate you eat less. Green can have the same effect, as food served on a green plate will reduce the amount of food consumed. But is there a catch here – is it simply the colour of the plate that reduces consumption or is the display of the food on the coloured plate acting as a deterrent to eat less, as food appears less appetising? Does food appear less appetising served on blue and green plates. Dependent on food type, vegetables, salads, meat and fish can appear to integrate into the colour of the plates and disappear and look less appetising especially when served to children, also to adults who are picky eaters. As we eat with our eyes before our taste buds are activated the presentation of food is important. Good food nicely presented, clearly defined, separated and displayed on a white plate is the most popular choice. Visually it appears most appetising, and interestingly on a white plate the portion sizes are generally smaller as confirmed by a small study. White china sales continually outsell all other colours globally, but if portion sizes are smaller, why the rise in obesity? Possibly the wrong type of food is being served? Blue, however, is traditionally recognised in colour circles as an appetite suppressant and is recorded as far back as the mid-1800s as such and as a mere passing mentioned further back into history than that. Blue can envelop us with safe feelings as we can sometimes drift off under blue's influence and conversely be kept wide awake, as found by insomniacs who

react both positively and negatively to blue's energy. Blue has the capacity to swirl us into complete indecision, incapable of making a decision or in taking action, unable to decide on what direction to take. Lack of action can result in missed deadlines, yet many alternative shades of blue uplift, inspire and support. So easily forgotten and not often taught, blue can descend us into a melancholy state when used inappropriately and can powerfully disenchant shoppers. It is one of the most formidable colours when used incorrectly.

If you wish to try out the theory using blue or green you can by incorporating a variety of easy methods by bringing the colours into your kitchen and dining space without redecorating or use of coloured plates. Tablecloths, napkins, table settings, glasses, lighting, soft furnishings and candles all play a role in bringing the two colours into your eating experience. Further colours also take their place with pride in the eating arena. Red in a scarlet shade is superb for the elderly to encourage them to eat, and is also good for children who are picky eaters, and adults who have gone off food through illness. Red in a rosy tint gives the appetite a tonic, a boost, and is especially good for those who are not sure what they fancy to eat. It gives them the boost needed and will soon have their eating mojo back.

Fresh Produce

Farming in the UK is changing and fast. For many years farmers have had to diversify to survive as they argue they are not paid sufficiently by the supermarkets or worse their produce is declined in favour of overseas produce. This leaves them without sufficient income to live upon and survive in the farming industry. Coming from a secure traditional place of providing 80% of the nation's produce, they are reeling from the rapid percentage reductions in recent years. Much produce is being flown in from overseas. Soon we shall see milk being brought in at the rate that milk farms have been closing. Add to this the

distancing of the farmer from the seed with huge corporations securing the rights of seeds, it is no surprise farmers are going out of business faster than at any other time in our history. Support your local farmer, seek them out. Ask if you can buy direct; they will either help or guide you to a colleague who can.

Anorexia and Eating Disorders

I understand the subject of eating disorders is deep and complex. I will, however, contribute an overview of my findings from a study I set up with volunteer participants, for interest and discussion. Working through the visible colour spectrum I found that a specific coral orange colour to be the optimum colour choice for sufferers. The study was carefully monitored with test results taken regularly over a twelve-month period. The results showed improvement in all participating volunteers, varying from slight, to an acceptable improvement, and the study proved the specific coral orange to be the optimum colour choice for use to help support those suffering. The colour was found to make a positive difference to everyone who participated, whereas the results from the other colours made a slight to marked difference in a number of participants who experienced no change, no difference. The specific coral orange colour is the only colour that had an effect on everyone.

Nutrition

Food is your medicine, colour is your preventative medicine, essential to support your well-being. Count your colours not your calories. Forget five a day, choose seven, nine or twelve instead.

June McLeod

A little of what you fancy does you good. Red/Orange/Yellow. The most favoured food colours used by food manufacturers increase appetites. Blue and Green are known appetite suppres-

sants with pink being a male relaxant. Traditionally we are told pink is for girls and feminine but it is also known as a muscle relaxant for both sexes. Most are unaware of the effect pink has on men. Blue food is quite a rarity in nature. Studies show that when food is dyed blue we lose our appetite. A recent study that made the news set out to prove food that was presented on a blue plate will reduce the appetite. This knowledge has been with us since the 1800s, and before then – not well documented.

Food choices based on varied colour choice give us a variety of vitamins and minerals, and the current interest in alkaline and acid food groups naturally fit with ancient colour knowledge. Foods coloured red, orange and yellow are known as alkaline foods, green is included in the alkaline section of foods, whereas sky blue, indigo, and violet foods are accepted as acidic.

On food packaging red and yellow have traditionally taken dominance as it is believed that the warmer colours encourage us to buy and eat more. Red can cheapen the appearance of food by the wrong use of packaging. Traditionally the magnetic colours have been used in fast food outlets and restaurants. Numerous projects have shown people sitting eating in primary red, orange and yellow coloured rooms where they ate more quickly and consumed more food than people sitting eating in blue rooms. Cold foods are better received in the warmer coloured rooms and hot food chosen in the cooler coloured rooms. Some data is considered to be flawed, because the colours chosen for the projects were exclusively the rainbow colours in primary colour, rather than a selection of different shades in each colour band.

The use of magnetic colours is being replaced by muted colour schemes, changes on the high street brought about by some of the food chains and retailers aborting the primary colours for more muted colour schemes. Yellow comes into its own as an aid for fluid retention. Starting the morning with a warm water drink made with a squeeze of lemon and possibly some honey to sweeten in a glass of warm water is a time-honoured easy way to

cleanse and refresh the system naturally and great news for the digestive system as it easily and effortlessly flushes through. Yellow is alkaline to the system.

The associations you make with coloured food is mainly dependent upon where you have been raised in the world and your culture. Colour provides you with effective non-verbal communication, the most powerful tool available. Does the colour of the food you choose make a difference to the nutritional value of the food? Is a green apple better for us than a red apple? When you are about to grab a quick bite to eat at lunchtime, stop to consider the colours and choose the most colourful combination.

Practical

It is no accident that we find red and yellow taking colour dominance on food packaging, font and in food restaurants. The warmer colours of the spectrum encourage us to eat quicker and increase our intake with larger portions. Research has shown people in red, orange and yellow rooms eat quicker than those placed in green or blue rooms. We can help ourselves to reduce our food intake by placing coloured stick-on sheets to the fridge door in relevant colours. Yellow will help us to pass fluid; great for those suffering from fluid retention and puffy ankles. Red for picky eaters, convalescents, in need of a tonic, and those who have gone off food following an illness. Orange is a support for those suffering from eating disorders. How does it work? Spend two minutes focusing on the colour of choice breathing in the colour before opening the fridge to choose ingredients. Gradually you will find that over seven to ten days your body regulates itself naturally and your coloured food choices change over time

We spend a lot of time considering the colour of the clothes we wear, the shoes on our feet and our accessories. Our make-up choice changes to match the seasons, and we carefully consider the hair colours that suit our complexion and eye colour. Yet the

most important colours are the ones we eat; the internal fuel that drives our energy and feed good health. What some of us have known instinctively for years is now becoming more common-place. Not only are we what we eat, but also we are the product of the colours we eat.

There is an undeniable link between the colours of food and their nutritional value. We often hear that a healthy meal is a feast for the eyes, with a wonderful variety of colour. Green foods are the most important today with juicing and food awareness at the fore. Super greens have a platform. Grandma was right when she encouraged you to 'eat up your greens'! The light-reacting pigment chlorophyll gives plants their green colour. Green plant foods help to balance your metabolism and feed the nervous system by making you feel more content and calm within. Popeye was right, greens do give you strength. Broccoli is rich in vitamin C, and avocados rich in B vitamins and vitamin E. Is there a difference over a green apple to a red? Yes. A green apple contains more pectin. Green foods are good for the heart and the circulation. Beans, chilli, lettuce, watercress, peas, spinach, leeks, cucumber, Brussels sprouts, asparagus… the list is long for green foods. Take your pick.

Orange is an emotional and creative colour. The Humpty Dumpty colour of the spectrum that strives to put it all back again. Orange foods feed your emotional self and, like super greens, calm the emotions, uplift the mood. Eat apricots, carrots, papaya, mangoes, sweet potatoes, butternut squash, cantaloupes, peppers, nectarines, oranges, mandarins, pumpkin and swede.

Blue/purple foods are less plentiful and seasonal. Blueberries, blackberries, plums, prunes, grapes, aubergines, figs, blackcur-rants, elderberries and purple potatoes. Yellow foods feed the digestive system and cleanse the liver. A morning mug of warm pre-boiled water with a squeeze of fresh lemon and honey, to taste if desired, is one of the oldest and still the best remedy to cleanse and purify the system. Yellow foods help to make us feel

Health, Nutrition & Vitality

more optimistic with clearer thinking. A fog brain will benefit from the lemon drink first thing every day for a week supplemented with yellow, orange and green foods. Lemons, grapefruits, bananas, pineapple, melon, peppers, peaches, sweetcorn, yellow apples, beets, peas and squash fit this category.

Red food such as beets, cranberries, blood oranges, cherries, peppers, beetroot, strawberries, red berries, tomatoes, chillies, pomegranates, raspberries, redcurrants, red plums, watermelon, rhubarb, red onions, red bell peppers and radishes. These invigorate and boost your energy levels, and help to regain your 'va-va-voom'. Red foods are easier to digest and beetroot, another superfood, is rich in vitamins and minerals – a vitality food that is often used as part of a detox plan.

When in doubt, choose white foods. Garlic is renowned for its many health and purifying qualities. Onions cleanse and purify. Parsnips sweeten and are used in many recipes and cooked in a variety of ways. White nectarines and white flesh peaches satisfy the desire for sweet foods. Shallots are the milder sibling of the onion and potatoes a staple to most diets. Cauliflowers are bursting with goodness and fibre, and artichokes are delightful as a snack or combined in a salad with other ingredients. Mushrooms prove to be a staple for most. White foods satisfy and nourish on every level.

There are more foods in each colour band than I can list here. Have fun discovering them, but more importantly eating them! The more colours you choose to have on your plate result in more vitamins and minerals, and count colours not calories. Fresh foods contain antioxidants and phytochemicals which protect against or suppress many illnesses. And if you are bored drinking plain water eat more watery fruit and vegetables to top up your liquid levels, such as cucumber, melon, citrus fruits, soft fruits and tomatoes. Eating these foods daily can be equivalent to two to three glasses of water a day.

Health and mood depend to a large extent on the quality of

the food you eat and how you process and absorb the nutrients. Everyone has a unique digestive and metabolic rate. Over time you become wiser to what food types suit your system better than others. The one area most fail is the rate at which food is eaten and chewed. Again, Grandma is right: Chew, chew, chew.

Most people should be able to get all the vitamins, trace elements and minerals they need by eating a varied and colourful diet. Dark green vegetables are rich in carotenoids that help combat heart disease. White and light green vegetables are rich in vitamin C. Red, orange and yellow vegetables contain antioxidants which can help fight infections and the effects of ageing and help protect against cancers.

Food groups that link to the primary colours of light are red, green and blue-purple. To stay healthy, we need to eat a variety of fresh foods from each of the seven main food colours, red, orange, yellow, green, blue, purple and white.

Each colour plays its part to strengthen and correct imbalances in our energy systems, boosting and strengthening the immune system. Coupled with daily doses of natural light and deeper breathing. To feel better and more energetic is within the reach of everyone.

The mind-body connection is well circulated and true. Great minds from history are consistent in their message. You are what you eat and think. Positive uplifting thoughts combined with good nutritious fresh food, eaten in a relaxed atmosphere, aids a good digestion and good health. Negative feelings are stored in the body, mainly in the red, orange and yellow chakras, affecting the digestive and hormonal systems. Eating plenty of greens and a colourful diet will help to reboot and rebalance your system.

The lower three chakras are the seat of fear, anger, guilt, self-esteem, self-worth, self-respect, trust, vulnerability and creativity. With unresolved issues and emotional imbalances, the digestion or hormonal systems will not function at optimum level. But help is at hand because colour is extraordinarily

powerful and quickly gets to the root. The wonderful thing is that you can eat and think yourself to a healthier you. With colour most things are possible.

Each colour has a part to play in correcting imbalances in the energy system. Be as creative with menu planning as your imagination allows. Colourful food is most appealing to all ages and good nutrition is vital for us all and need not be a chore. The aim should be to get as many colours on a plate as possible. Count colours not calories.

A glance at a few vitamin and colour connections:

- Red – Vitamin B
- Orange – Vitamin C & A
- Yellow – Vitamin D
- Green – Vitamin C, E & K
- Blue – Vitamin F
- Purple – Vitamin A

Eyes

The eyes speak with an element of truthfulness surpassing speech. It is the window out of which winged thoughts often fly unwittingly. It is the tiny magic mirror on whose crystal surface the moods of feelings fitfully play, like the sunlight and showdown on a still stream.

Henry Theodore Tuckerman

The soul has a faithful interpreter in the eye.

Charlotte Bronte

The US National Eye Institute found people with the highest levels of lutein in their diet have the lowest risk of muscular degeneration and blindness. Leafy green vegetables, yellow peppers and squash are some foods with the highest lutein content. Pumpkins are full of vitamin A for vision with reliable

oranges coming in a close second. To support the 'eat up your greens' theory, a research paper states chlorophyll the chemical which makes plants green has anti-cancer properties. That goes to confirm that you are what you eat. The more colours you eat daily, the better your health, nutrition and preventative medicine.

People with lighter eye colour are more sensitive to light, a result of having less pigment in the iris to protect from sunlight. Darker eyed people are more protected and also gain by reacting physically quicker, albeit a second or two, to lighter eyed people. Research confirms light eyed people did better with physical tasks that involved throwing or hitting balls in sport, whereas the darker eyed people were better at defending.

An interesting study on eye colour came from Norway. If both parents have blue eyes then their children will have blue eyes. If both parents have brown eyes then less than ¼ of the children will have blue eyes and more than ¾ will have brown eyes. So therefore the brown eye takes precedent and is most dominant. A higher proportion of blue eyed people prefer partners with blue eyes. Brown is the most common eye colour. On meeting, the first thing we notice is the eyes; some have soft eyes that you can melt into or a hard steely look. When people don't look you in the eye it feels most uncomfortable and gives an air of shiftiness.

Only 2% of the global population has green eyes. Scandinavia and Northern Europe is where you are most likely to find green eyes.

At a national meeting for opticians it is alleged a professor stated, "If you are in a country with high levels of ultraviolet, your eyes will age faster, you will almost certainly exacerbate that risk with low energy light bulbs. I would like to urge the manufacturers of these light bulbs to get rid of them." Halogen and LED lamps provide no ill effect. Ultraviolet rays were first discovered in 1801 by Johann Wilhelm Ritter.

Public Health England advises households to evacuate the room and leave it to ventilate for 15–20 minutes should a low

energy bulb crack/break as they contain mercury. If the glass is broken the toxic substance could be released into the air. You are advised to wear sturdy gloves while wiping the area with a damp cloth and picking up the fragments; these should be placed in a strong bag then sealed. Take it to the council dump and place in a specialist bank. Councils do not collect hazardous waste in normal collections. The professor has stockpiled a lifetime supply of the old-fashioned light bulbs because he believes low energy bulbs could lead to blindness.

Another expert in skin disease believes that their use may cause multiple skin problems and even skin cancer: "Light is a form of radiation, the shorter the wavelength the more energy it contains. The most damaging part of the spectrum is the short wavelength; light at the indigo/violet end of blue. Incandescent bulbs did not cause problems, but these low energy lamps emit high peaks of blue and ultraviolet light at their wavelength."

Does eye colour have any effect on others? None; apart from a personal preference of eye colour and the eyes expressing the innermost thoughts. The eyes are the most expressive part of the face and speak to us. The eyes can open in wonder, close with anger and suspicion, harden, soften, laugh and cry. A few have taken eye colour and tried to apply colour knowledge to no real avail. Not based on any research, the information is for fun purposes only.

Brown eyed people are grounded. Green eyed people are spiritual. Warmer eye shades are trustworthy. Blue eyes are loyal. What we do know is that the eyes are the mirrors of the soul, expressing in pure form the thoughts at that moment. We also know eye colour is genetic. We are programmed to identify the human face, especially the eyes.

The sun's wavelengths, which we perceive as colour, have important influences on our health. The body absorbs sunlight through the eyes and skin. Light enters the eyes through the cornea and pupil. It then passes through the lens and clear gel in

the back of the eye to focus on the retina. The retina nerve cells are sensitive to light in the photoreceptors. Light stimulates in the photoreceptors a small electrical charge that travels along the optic nerve to the visual cortex in the brain. There are two types of photoreceptors: the rods and cones. The rods allow us to see in white, grey and black and in dim light. They also let us see on the periphery of our vision. The cones provide detail and, when the light is bright enough, colour. There are three types of cone: one allows us to see blue, another green, and a third red. When the red and green cones are stimulated equally we see yellow. Each group of light wavelengths entering the eye allows us to see approximately 7,000,000 different colours or hues. People who are colour-blind do see colour but they cannot tell the difference between pairs of colours. Difficulty distinguishing between red and green is most common and more rarely blue and yellow. Colour blindness is an inherited condition and affects males more frequently than females. Light messages from the retina stimulate the hypothalamus, part of the endocrine hormonal system of the body, and this affects both our physical and emotional well-being. It is not only the human eye that can detect colour. Some species see all colours; some only a few and others none at all. Colour vision is classified according to the number of different types of cones in the eye. Humans are trichomats with three kinds of photoreceptors. Bees are believed to be trichomats also. They have two types of cones sensitive to the ultraviolet range of the spectrum, which humans cannot see. A recent study on bees showed they preferred blue, violet and yellow flowers. Sunlight on the skin can affect the body clock and influence some hormones, the production of vitamin D, testosterone and the immune system.

Sunlight helps with numerous skin problems and wounds heal quicker producing a pigment to protect the skin from too much strong sun. Light passing through the hypothalamus, the pituitary gland, the pineal gland and the lymphatic system influ-

ences every body system down to the cellular level. Hence we all feel better when the sun shines! The season, the time of day, the amount of cloud and pollution all affect the colour wavelengths, which reach our bodies and affect how we feel. We see and sense colour through our eyes, skin, hands, and feet. It is possible to develop this sensitivity in order to identify colours by touching them with our hands; natural pure silks are best for the exercise. Many blind and poor sighted people are able to distinguish colours in this way. A former case study using this method can be found in my first book *Colours of the Soul* under Janet's story.

Dyslexia

Dyslexics experience a visual disturbance, a wiring malfunction, which affects reading. It is not the same as having a vision problem, eye problem or brain problem. Coloured overlays used with great success by dyslexics make a significant improvement to their reading ability allowing the text to be read without a struggle. It keeps the words stable on the page. People with dyslexia experience the words moving on the page, making reading a difficult chore. The coloured overlays stabilise the text allowing an enjoyable positive reading experience. Unfortunately, they do not work for everyone, but there is a wide choice of colours to choose from. The colours of the overlays offered at time of writing can be found in the following colours: rose, gold, lavender, green and turquoise, produced and owned by the Irlen Institute. Personally I would like to see coral added to the range as I believe coral can fill a much needed gap.

It is said 17% of the population suffer from dyslexia in the UK. In Europe the figures are lower. Specific background colours are helpful for reading onscreen for dyslexics and also larger print. They find it problematic to track words across the screen as letters and words jump around; they suffer headaches and eye strain as a result. Sensitive to bright lights and some suffering with blurred vision, the need for a solution is imperative, and

with most jobs expecting a computer-based working practice, the world of work and study for dyslexics is marred with continuous hurdles and frustrations.

It is easier to read from a pastel background rather than a white one – easier on the eye and helps them to define the words better. Visual stress is experienced from the glare of the computer screen, phone and e-book reader. Never has there been a stronger argument for choosing the traditional hand-held book over an e-book reader. The coloured overlays can help in a simple and effective way to improve lives when working on computers as part of everyday life.

Coloured overlays are offered in the first instance by optometrists or eye clinics, with a further option of tinted filters in glasses or tinted contact lenses, to reduce light sensitivity and any conceptual difficulties. The choice is a personal one. Whatever is chosen, do continue with the eye exercises to support your choice. Dyslexia is not a condition to grow out of, but it can be helped and improved with exercises, tools and understanding.

Eye Exercises
Simply rolling the eyes daily back and forth, side to side, then in circular motion, first one way for a few rolls, followed by the other direction. Do this whenever time permits and especially when eye strain is felt. Cupping the eyes in the palms of the hands for three minutes to rest them, and finally, by resting them on the green of nature for a minimum of five minutes (green is the most restful colour for the human eye), twice or three times daily. Keep your focus on whatever you are looking at that is green, a leaf, tree or bush, and don't avert your eyes. Best to conduct this exercise outside rather than look through a window.

The Face
You notice certain living things more than furniture and fittings, so you notice people and plants before anything else. We each

have a 'good' side and 'not so good' side. You will often hear people say 'photograph me from my good side' as they present what they deem to be their good side. My observations lead me to believe the good side portrays your outer persona, the side that you display to the world. The not-so-good side portrays the inner you, your inner self. There are differences between the two in everyone, and when observed closely, the differences between the two are usually marked.

Sunshine

We need a regular dose of natural light and sunshine to boost the immune system and top up the systems in the body with natural goodness. Numerous studies prove that the human body needs sunlight as every system in the body benefits. Interestingly today we are seeing the rise of rickets in children. Our bones benefit from sensible sun exposure and we all know that our mood lifts when the sun shines. Sunshine is the natural happiness tonic. We absorb light directly through our skin and eyes, and we are nourished from natural light, the food we eat, the fluids we drink and the air we breathe. Our food and oxygen in the main is vitalised by sunlight. A new understanding of the important role sunlight plays in our lives is thankfully re-emerging. With the coal and oil supplies depleting, there may be no alternative but to turn to the sun as a way to fuel our homes, for our lighting systems and our heating systems. We are more aware nowadays of the effect of light deprivation with a large number of people suffering from SAD, seasonal affected disorder, during the winter months.

When working or studying under artificial lighting some of the effects of unnatural light causes fatigue, headaches, eye strain, muscle aches and is the precursor for many illnesses. SAD can affect people of any age and research shows it commonly starts from teens up to the age of 30–35. It was thought that more women suffered from SAD than men but that has been proven to

be questionable.

In the light industry, light intensity is measured in lux – the Latin word for light. So on a summer's day here in the UK we may have up to approximately sixteen hours of daylight at 100,000 lux. In winter on a dull day, an eight-hour day will only give us 5,000 lux compared to indoor lighting that rarely sees 500 lux, so you can see the vast differences. So wherever you are, spend your day wisely and get out into the natural light for part of the day. In winter, daylight will help increase your levels. Some of the typical symptoms of SAD are craving for carbs and sweet foods, weight gains, loss of libido, sleep problems, irritability, anxiety, feeling melancholy, feeling despondent, lethargic and not being able to carry out everyday duties. Much research has proven that people can lead a happy normal life and beat the Monday morning winter blues by ensuring that they get enough natural light every day, topping up more in winter. We feel so much better in the summer. Everyone feels happier and lighter. The sunlight permeating our skin gives us a colour bath; our inner batteries are being energised up to give us heightened mood and more energy. We know this today as the seven rainbow colours that feed the seven chakras. When we stand in natural light we become a natural prism; as the sunlight shines on to our skin it is refracted into the seven colours, feeding each chakra which in turn boosts our energy and our mood.

The natural world provides us with an endless array of light and colour. It is accepted that light is vital to life; without sunlight no life on earth can exist. Not so well documented is that even the oxygen we breathe comes from the sun's radiation. When we look at a rainbow we observe the visible spectrum of light. Sunlight makes us feel good by uplifting our mood and stimulates the production of vitamin D in the body. It is also a great steriliser – many bacteria are sensitive to sunlight. On a base level, the dog's blanket hung out on a summer's day to relinquish doggy odours is an example. As an antibacterial agent it is

used in the form of ultraviolet light to disinfect medical areas as well as to treat wounds and infections.

In the 1890s it was discovered that rickets could be cured by sunlight. The production of vitamin D in the body is a necessary ingredient for absorption of calcium from the diet. We now understand the importance of vitamin D for maintaining good healthy bones and the body's ability to absorb calcium and phosphorous. The Nobel Peace Prize Winner Niels Finsen of Denmark found that lack of sunlight is the cause of tubercular skin lesions. In 1903 he was awarded the Nobel Prize for being the first person to successfully treat skin tuberculosis with ultraviolet light, and eventually he used red light to prevent scar formation from smallpox.

In the 20th century, Auguste Rollier, a Swiss doctor studied the beneficial effects of ultraviolet light. High in the Swiss Alps he devoted himself to curing TB with sunlight. At a height of 1500 metres, with the combination of the cool air and the Swiss rays, he found maximised healing. "The air is transparent and easily traversed by the sun's rays, which pass without absorption."

Many have recognised the healing power of the sun with great discoveries made. Science created penicillin in the late 1930s: our first antibiotic. Sadly, the healing power of the sun took a back seat and was forgotten by many. Yet today, through sheer determination of a few and word of mouth, we are enjoying a revival of colour knowledge and understanding. Sunlight contains the seven colours of the rainbow, the seven colours of the chakras. Sunlight is colour. Colour is the body's life force and is vital to life and good health.

Today the beneficial aspects of sunlight are played down, yet taken sensibly sunlight is good for us. Some of the benefits of sunlight are as follows: as a hormone regulator, stress reliever, metabolism support, boosts to the immune system, uplifts the mood, allows the production of vitamin D in the body, assists weight loss, increases sex hormones, helps treat skin conditions

such as psoriasis, is antibacterial and helps fight infection. We all need a regular dose of sunlight for good health. It is accepted that we absorb light directly through our skin and eyes, and we are nourished by natural light, the food we eat, the fluids we drink and the air we breathe. Food and oxygen in the main are vitalised by sunlight; a new understanding of the important role sunlight plays in our lives is thankfully re-emerging.

Colour as a Self-Healing Tool

The mentioning of self-healing can stir different emotions and bring up all sorts of thoughts in people. A connection is usually made to new age, 'hippy type' thinking when self-healing is mentioned – sad but true. The fact is that you can help yourself and support treatment you are having with colour and exercises laid out in this book. I hope that what I share will give you food for thought. When we use colours for healing we are using different vibrations that feed the chakra system that in turn feeds the body. When the physical self and the spiritual self become blocked it causes disharmony in the body. To right an imbalance or blockage, colour is used to alter the course of energy. This is much like the Eastern Chi method. Colour energy can be directed to each of the chakras for self-healing.

By rebalancing the chakra system colour energy flows to the centre of them and in turn rebalances the organs related to the centre/chakra. An illness or accident can be interpreted as a cross-roads in life, a choice to be made, an opportunity for change. Or it can be perceived as a crisis and therefore you remain in the same situation, or worse fall into melancholy.

If we take time out to be still and listen to our inner voice, the way forward and purpose in life can sometimes become clear. The chakra centres each represent a part of ourselves and it is possible through simple exercises to confirm which chakra may need attention. You can direct colour energy to each of the chakras for self-healing through colour exercises. It is said 90% of

illness is people holding on to emotional baggage and problems. Once it is accepted, there is always a choice; the choice to take the reins and responsibility for your health. You may begin to look at your way of life and nutrition and make the appropriate changes that are needed. You need a reason to get up and to get going in the morning. If you don't have one, create one. Create a purpose.

An Easy Chakra Exercise

Standing barefoot on the grass and facing the sun, imagine your feet are growing roots that are going deep into the earth, grounding and anchoring you to the earth. Feel solid on your feet. Once comfortable, begin to consciously breathe in the colours one by one, starting at the base chakra, the red centre. Spend at least seven breaths on each colour and as you breathe in the red, yellow and orange imagine that you are pulling the colour up from the earth. On each in-breath bring the colour up from the earth and direct it to each appropriate chakra. Green draw in horizontally into the heart centre. Sky blue, indigo and violet draw down from the heavens, above your head. When you have completed the exercise and just before you open your eyes, flush yourself through with white light by imagining drawing white light into yourself from above. Feel the light soaring through your body touching every part of you as it flows through and down your body back into the earth.

Triangle Exercise

Another practical I created for my students' well-being is the triangle exercise, bringing directed light to the pineal and pituitary glands via the third eye through the triangular shape. This supports the system: an excellent and easy way to uplift, feed the chakras and benefit from the colour light rays. Facing the early morning sun, create a triangle shape with thumbs and first fingers of both hands placed together. The tips of the fingers and tips of the thumbs together make the shape of the triangle. Rest

the thumbs on the bridge of the nose, tilt your face towards the sun and allow the sunlight to shine on to the third eye. Close your eyes when you feel the warmth of the sun on your third eye and relax for ten minutes, allowing your body to drink in the light.

Chakra Colour Meanings

Red – Become self-aware. How do you feel? How does this or that affect you? Continually monitor how you feel during the day, about everything. Gradually and over time it will become second nature and you will not have to think about how you feel, you will know, register and therefore become self-aware.

Orange – Respect yourself and your boundaries. Be clear on what you expect of yourself and of others. Nurture yourself above and before anyone else. Me, myself and I are the most important people in your life. Without your caring for yourself and respecting your needs, exhaustion will reign, leaving you unable to give your time or care for others.

Yellow – Value yourself, value your opinions, your thoughts, your being. Express delight at how nice you are. The only approval to seek is your own. Empower yourself. Relinquish the people pleaser, the need to be liked and start appreciating yourself.

Green – The loving of self. Self-worth is the ultimate goal. Yes, loving the wobbly bits too. To be in full acceptance of who you are and what you can be, without judgment or guilt etc. Have fun along the way attaining your goals and seeking new adventures.

Sky Blue – Be creative! Have fun creating whatever takes your fancy, just do it. The fine work, rest and play balance must be adhered to for good health. Your creative expression is most valued and feeds your soul. You do not need to be a great artist to paint, a great needlewoman to embroider or a great craftsperson to have fun with crafts. No excuses, get on and do – enjoy and have fun.

Indigo – Take your foot off the pedal, slow down and begin to

assess what it is you want to do for you. Hardworking and embroiled in what you can do for others brings no long-term satisfaction. The most important person in your life looks back at you in the mirror. Take responsibility for your own enjoyment and leisure time, and stop giving away your power, allowing others less informed to take over. Stop shouldering responsibility. Grab life by the horns, travel, explore and enjoy the experiences. Be selfish for once in your life.

Violet – By not accepting there is a spiritual aspect to yourself, you do yourself a miss-service. The natural world is the seat of spirituality. Take time out to rediscover the joys of time spent in the slow lane outside in nature. Reconnect to the inner you.

Use colour in the way most comfortable for you. The above gives you an overview of the areas each colour covers. You may recognise a part of you in more than one colour. If so, work with these colours. Also refer to the colour personalities section (in Chapter 5) for more information on colour in relation to self.

Suggested ways to introduce the colours lacking: 'The Chakra Silk Collection' is a new design and colour selection to wear your colour choice daily in an easy to wear scarf, as part of a fashionable wardrobe and to bring balance to the chakras. See Products.

We all need to spend time in natural light, every day. Much research has been done on the healing powers of sunlight and how natural light affects us in specific ways and helps us maintain health.

The ancients know of the importance of light and it is well documented how many tribes and cultures worldwide worshipped the sun. In Buddhism the light radiating from another is seen as a mark of advanced spirituality. The Jewish tradition celebrates the festival of light every winter which lasts for eight days. The festival is called Hanukkah. Hindus celebrate the five-day festival of light – Diwali. At the Diwali festival the colours people wear are glorious. The colours we wear everyday

tell so much about us. They tell our own story, of our personality, our health and emotional well-being. This includes our thoughts, likes and dislikes, how we relate to others and our self-esteem. An astute and experienced colour professional can tell all this and more from the choice of colours worn. It is the most powerful non-verbal communication.

Not only will colour reveal everything about ourselves and others, it is used by the knowledgeable few to affect the public acceptance and face of business. Recently we saw a brilliant burst of colour on the fashion stage. In the UK and parts of Europe people are living through one of the worst stages of austerity in history. Out came the fashion world in a blaze of colour to heighten mood in the populace. Every high street is now radiant with prints and colour. It is well documented that magenta is my favourite colour, and how I wished colour a comeback, following what seemed a long colourless, monochromatic phase in fashion. When I saw first-hand magenta on the catwalk, I was thrilled. The show was brilliant, with magenta centre stage flanked by metallic pinks, violets and blues. To soften the blow of austerity, to uplift the mood and to raise the feelings of hope and looking towards a new day and a new dawn of happiness, the colours said it all and conveyed their message to everyone. Every fashion house followed suit, and suddenly the high street is ablaze with glorious colour once more, from fashion, cosmetics, shoes and accessories – colour to be seen everywhere. Hurrah!

The natural world is there for us all to enjoy and to get out into. To relieve the many mounting pressures of everyday life it is a wonderful release and balancer excellent for well-being and health. Today we need the natural world more than ever, as it seems that technology has taken over our lives. I cringe when I see many people outside, hypnotised by their phones, oblivious of the beauty surrounding them, with faces staring into the screen.

I am convinced most sleep problems arise from the technology

that surrounds us all. Sleeping close to computers, telephones or any electrical equipment will damn a good night's sleep. Sleep is most important to sustain a healthy immune system.

Healthy Home

A healthy home is vital for good health and longevity. I have helped many clients through the complicated process of identifying the causes of sleep deprivation and an unhealthy environment, by identifying the source of the problem through an in-depth survey. Identifying the cause and sharing my findings to suggest ways forward. In some cases a house move is the only action to obtain a result, to take them away from the source. Health is a combination of many factors that are in our control and there are solutions to most problems. The vital components are: a healthy environment at home and work, good nutrition, restful unbroken sleep, a work/play balance, copious amounts of fresh air and water combined with healthy thought processes. All of these contribute to good health.

Finland is a beautiful country with so much natural beauty for the people to enjoy with forests and water, yet most workers are highly stressed. People have a summer house on the lakes with basic amenities they can escape to for a few weeks each year; the norm is for a few weeks rather than most weekends. An escape into the natural world is a sanity support. The natural world is our greatest stress buster; all ages benefit from being outside. We are free to walk the rivers, the countryside and by the sea. There is no cost involved. The choice is ours. To look at it another way, we are all prisoners of this wonderful planet of ours, as none of us can get off, yet some have a greater freedom of movement than others, with the freedom to travel to many and varied places while others are confined by circumstance to their local area and country. Yet we each have choices. We can choose to become a part of the great outdoors, or not. For health and well-being the choice is simple: fresh air, sunshine and relaxation in nature. We

are naturally tribal beings. We like to belong to a tribe and one of our greatest fears is loneliness and isolation or of not belonging. The elderly in homes suffer from a reduced immune system, and research shows when they suffer from little or no touch their immune system goes down. We all need to belong and we all need touch and a hug. Ancient tribes know the value of touch, yet we have lost touch with the basics. The whole tribe will visit the sick to hug them, instinctively knowing the value of a heartfelt hug. We need to be held, hugged and loved, and to give love to thrive. We need to be loved and to give love in return. The body is a wonderful miracle. Once we listen and learn to recognise the signals and cue cards, the body will tell us all we need to know to stay happy, healthy and well.

One of the systems by which the body demonstrates the value of giving and receiving is through the respiratory system, by the automatic motion of the breath, the continuous in and out process, reminding us to give and receive in equal measure to regain balance. Love is the beginning, the middle and the end. Love is the fundamental foundation and cause to every emotion, thought and feeling. Love or the lack of love is the basis or beginning. To recognise and address love in our lives, love of our self and love of our career, love of our home, love of our family can alleviate so much pain, discomfort and illness.

We know the value of a mother's loving cuddle as many studies show babies thrive once they are out of incubators and held in their parents' arms. To love self is the first step towards accepting self, warts and all. At the first sign of feeling sorry for yourself, remember to do it in style, wallow in it, then motivate yourself to come out of it. Take time out to eat well, sleep well and repair. Be good to yourself. And finally, a little of what you fancy does you good, how true! In a cholesterol study they found 75% was attributed to loneliness and stress and just 25% from food. The medical profession has had little success in lowering cholesterol, and it seems that we are going round in circles. Every

week we read of foods that are supposedly not good for us, yet if we stay with food grown naturally, cooked from its raw state (as it is grown and reared), then we can't go far wrong by following what our body fancies.

Making choices based on colour, by choosing from a varied array of coloured fresh produce, we can be sure that we are choosing a balance of vitamins and minerals at each sitting. We should avoid food that is processed, tampered with or has sugar added to support a healthy immune system. The farming industry has taken quite a knock in recent years, traditionally we have grown 80% of our fresh food; in recent years this figure has declined rapidly and continues to do so. Yet home grown food is proven to be the most nutritious, as the time frame from farm to plate is far shorter than foods picked, cold stored and flown or shipped for miles. The sad fate of farmers is dictated by the shopper; until we demand and choose home grown produce the decline will continue. Sadly, quite soon it will be too late, and once it's gone it's gone. Farms are being closed down and farming land sold at a tremendous rate across the country.

Chapter 12

Music & Movement

If music be the food of love, play on.
Shakespeare

Sound creates form, colour is sound intensified. Sound is the second oldest form of healing, colour being the first. Studies show babies pick up atmospheres through the sounds they hear while in the womb. Sony conducted research to show how sounds played to babies in the womb did affect their behaviour. Calm pleasant rhythmic sound soothed the baby whereas loud clashing music had the opposite effect. Further research concluded that babies from one year to eighteen months were able to identify and remember the sounds they heard in the womb. Music heals the mind, body and emotions and supports enquiring minds, therefore by playing certain types of music such as classical pieces to babies in the womb and to continue following birth you will feed and nourish all aspects of the growing child, while keeping them calm, focused, whilst supporting the desire to learn and to communicate. Music frees your inner selves and inhibitions, and you feel the urge to get up and move to music that you enjoy listening to. The body comes alive with music.

As you dance do you consider the benefit of music and movement on your body and mood? Music is an important part of my work and I have invented new ways of working with groups to benefit everyone. No boring introductions in my classes! I get people off their seats and moving to a personally selected track of music at the start of each session to help the group gel and dissolve any inhibitions. To encourage a group to have fun while moving to music relaxes any tensions and nerves;

people noticeably relax as they laugh their way through. Then the real work starts. Music heals, lifts our spirits and helps us to relax and renew.

Ancient cultures have long attributed positive health gains to playing the right music, at specific times for particular results. The function of music in Chinese and Japanese cultures was to reflect the balance of energies, the harmonies of heaven and earth, as shown by the yin and yang symbol. The symbol reflects the perfect balance and interaction of vibrations in a healthy existence and known then, long before the modern new age thinking that diseases stem from imbalance. Yogis share their knowledge of the importance of sound on the human body through exercises. Breath work is used to prepare students for the exercises. The 'Aum' is well known. The nasal cavity inside the nose is an acoustic chamber; classically trained singers have long placed much importance on the area. Indian mantra yoga teaches that there is a small chakra, the base chakra, where the centre of all sound is found. In the head, the roof of the mouth can be used as a sounding board. Gently raise your tongue to the roof of your mouth while making a sound, then release your tongue. You will hear differences in sound as the roof of the mouth passes the sound up through the brain positively. This affects the higher mental and emotional centres of the brain. Music – singing together has been used for thousands of years to unite, celebrate and even before engaging in fighting. Tribes sing together to celebrate birth, marriage or before a hunt to provide plenty of food for the tribe, and to muster courage, strength and determination to win the war. This was most famously depicted on the big screen in the film *Zulu*. You heard the voices of the Zulu before you saw them coming over the hills. The sound is intimidating.

The mother singing her baby a soft lullaby, children happily singing together at pre-school, groups and communities singing together raises everyone's mood. It unites the group and the

positive vibrations created will clear the atmosphere. For more than thirty years teaching my beloved colour, I have begun every group by standing in a circle and singing together. At first I only knew it felt good, for me, and the feedback from the first few groups was good, and the atmosphere in the room clearer. Once I began researching why this was, I understood far more. Subliminal messages played in a mall while you shop is well publicised. The use of 'coloured' music is not so well known or discussed. My own coloured music CD *Colours of the Soul*, an album of tracks and information, produced in London a few years ago, is the first of its kind to combine coloured music with interesting colour information. I collaborated with professional musician Jeff Cutmore to bring to the market the very first authentic colour CD. It takes the listener through the colour spectrum key by key in a very beautiful way. The CD has fourteen musical masterpieces with specific exercises to support well-being and self-development and is available digitally. Pure vibration is sound, and when created as music in colour compositions, the music has a powerful effect on mind, body and spirit, whilst boosting every cell in the body.

CD Research Results

- Proven to lower blood pressure and calm the heartbeat
- Volunteers enjoyed a more restful sleep, and in some cases, regulated their disturbed sleep patterns
- Snoring decreased – 20% stopped altogether
- Hyperactive children benefitted – it had a calming influence
- It aids patients' recovery, quicker healing, and less convalescence
- Results overall – positive in all ages and for many conditions

Many cultures over the years have suffered for their love of

music; they have had their musical instruments taken away from them or music limited. Their masters believed that by banning music and taking their instruments away they could disempower the people. Without their music some felt so low that they risked their lives and tried to escape. Some did succeed taking their music with them to share and blend, and today there are many musical scores from traditional tribes that overlap and in part are identical. For the ones left behind, they found the courage and strength to make their own instruments and play them wherever they had the chance.

During both wars in many prisoner of war camps, music and singing kept people alive with hope in their hearts; they knew if they could summon the energy to sing together, spirits would be lifted for another day. Music is truly the most wonderful tonic and a therapy in its own right. I play a vast range of different types of music to accompany the movement and practicals. Steel drums are a personal favourite, supposedly invented on the island of Trinidad around the time of World War I. The roots of the instruments can be traced back to the African slaves placed on the island by the Spanish and French plantation owners in the 16th century; their music was the major link back to their native roots. The playing of the drums brought the people closer and gave a happiness and joy so different from the mundane and struggles they endured daily in their hard life. In class, music chosen with care and in the appropriate setting will support cohesive teamwork and bonding in every group. The sequences of music and colours form the basis for a balanced equilibrium in the individual and the group dynamic.

Throughout history attempts have been made by various scientists to prove that musical pitch and tone are linked with colour. One of the first scientists to attempt this was Ptolemy a second century astronomer, later followed by Sir Isaac Newton and Einstein to name a few. Colour is different frequencies of vibrating light, as each chakra relates to a different colour. It also

corresponds to a different sound vibration. Each chakra is related to a different area of the body and linked to a feeling or state of mind. When we listen to music this vibration affects that energy centre and in turn affects how we feel on all levels. Each musical key corresponds to a different colour, vibration and chakra. For example, new age music in an F key corresponds with the colour green and the heart centre, hence the emotions are affected by music in the key of F.

We know that all sound resonates in the head and affects the pituitary gland, which is the leader of the endocrine system. Sound has the capacity to change our mood, our thinking and change the chemicals in our body. If we regularly use a particular sound it often creates positive changes in our emotional self: the way we think, perceive and interpret our physical self. That's why music has such a strong transformational effect on all of us. We know what type of music we love and adore, and what music we can't stand.

Harmonious music can actually rearrange the substance of our body, our mental, thinking or emotional body that has been distorted by negative thoughts, words, feeling and actions. It brings the 3 lower body chakras into alignment: the red, orange and yellow. At the same time it expands harmony in the space and into a wider area. If we play harmonious music every day it will raise the energy level and the vibration in ourselves and our environment and the people who enter that environment. It is a great way of cleansing and rebalancing ourselves. In many cultures history tells us that sound has been used to change and move energy. I cite an example that we can clear an energetic blockage when shaking the part of the body where energy is blocked i.e. sore backs improve with gentle movement and exercise; combined with music and movement the benefits increase and improvement is fast tracked. Movement and music can help heal, there is no doubt, a powerful tool available to all of us.

Harmonious music can change our habits and release a lot of emotional dross and bad memories. The stringed instruments calm the emotions, the wind instruments affect the mental body, and the drums, gongs and tambourines affect the lower red, orange and yellow chakras, the physical body. Everything created from smaller cells to the solar system has a keynote of its own. Every planet including earth has its own sound and we each too have our own sound. If we can get in touch with it this would help us to harmonise our physical, mental and emotional body. So therefore, it is vitally important to play the music that you personally love and on a regular basis and enjoy it. Choose your own enjoyable music to uplift your spirit and feel happy.

Colour and Music

How they affect us on the physical and emotional, linking to the seven main chakras in the body.

- Red – Key C
 Red corresponds to the base chakra, the lower body, our thoughts and feelings about our place in the world. It grounds us, activates us, gets us moving, raises our blood pressure and speeds up our circulation.
- Orange – Key D
 Orange corresponds with the sacral chakra, navel and reproductive organs, our emotions and creative energy. It warms, energises, comforts us, nurtures, humours us and gives a platform for spontaneous laughter.
- Yellow – Key E
 Yellow corresponds with the solar plexus between the ribcage, digestive system and your self-esteem. It gives us clear thinking, stimulates the mind, cleanses the body and acts as a glorious natural antidepressant.
- Green – Key F
 Green corresponds to the heart chakra, the heart itself,

relationship issues and feelings of love for our self and others. It balances, calms, regulates, keeps us focused and encourages our return to build links with nature.

- Sky Blue – Key G
 Sky blue corresponds with the throat, our creative expression and ability to speak the truth. It soothes, clears, calms and allows us the ability to speak up, and speak out, and speak the truth.
- Indigo – Key A
 Indigo corresponds to the brow chakra, the eyes and our intuition. It slows down our heart rate, calming us mentally, relaxes our body giving us restful sleep.
- Violet – Key B
 Violet corresponds with the crown, the brain, our connection to the universe and our spiritual self and our higher mind. It inspires us to achieve higher and more, pushing evermore upwards. It acts as our body's anti-inflammatory, making us more inquisitive about our spirituality and our higher self.

Movement

Ancient postures and principles are used and expanded in my method. Movement is an integral part of my teaching, encouraging free movement to bring people into each chakra and colour. Breaking down the restriction of body language, coupled with the mysteries of breath and colour. I have created exercises with all this in mind, to purge the past and recognise the different atmospheres in the body. It's an experiential movement and journey through the senses via colour, music, movement and the chakras. The cutting edge interactive movement and creative work I have invented and developed is widely used today in classes and workshops around the world.

Chapter 13

Babies & Children

Colour absolutely affects our lives and our children's development. When colour is chosen with a purpose we create a balanced, harmonious environment where children can claim their birth right and reach their full potential.
June McLeod

Our first experience of colour takes place in the womb – a warm glowing coral/peachy pink created by natural light permeating the human tissue – it is no coincidence that it is the colour of unconditional love as in most cases the mother's body is creating a being unconditionally. As children, we attach associations to colours, which become part of conscious reality. As we grow older, we attach feelings, memories and meanings to the colours in our lives. This results in colour becoming significant in our subconscious, and thus all of our experience being 'coloured'. Colour is affecting us all of the time and on many levels, from the moment of conception to death. Our senses are being bombarded and yet we fail to recognise the meaning of such a subtle yet powerful influence. We use colours to describe how we are feeling – 'seeing red', 'blue with cold', 'green with envy', without giving a thought as to how or why a particular colour correlates to our state of being. Every time we are 'in' a particular colour, we are engaging in colour perception.

Colour has a profound impact on our unconscious mind, affecting our moods, often determining whether we respond positively or negatively. All of us have experienced feeling uplifted and energised when contemplating the beauty of nature, e.g. a red rose or a pink sky at dusk. Conversely, a different shade of colour can dampen our spirits and create a feeling of

disharmony. Once we understand the effect that colour has on every aspect of our lives, we can then begin to use that knowledge for our overall health and well-being. The healing power of colour can serve to enhance our relationships, create an oasis of calm in ourselves, our homes or a hive of productivity in the workplace. Colour is the golden key that unlocks our full potential to experience health, happiness and self-empowerment.

Babies

Babies are happier when surrounded by calming soothing pastel shades, and these new little people have a lot of adjusting to do. They thrive in a calming environment. Avoid busy patterns and strong colours in their rooms, as this will encourage hyperactivity and restless nights! Newborns are very sensitive to colour; this includes the colours that you dress them in. Avoid brightly coloured hats for newborns in particular. Opt for pure white or cream for the head as the fontanel at the crown of the head is extremely sensitive. From eight to ten weeks, pastel colours can be introduced.

Children and babies adore coral orange, with peach coming through as the firm favourite. We all associate smells and tastes with happy memories; the same applies with colour. For babies in the womb the first colour introduction is peach from the light permeating the mother's skin. Peach reaffirms and reassures. It is a safe support colour for babies. Decorating a nursery, I experimented and chose to use a delicate shade of peach on the ceiling ensuring that baby be calmed by the colour when lying in the cot looking up.

Colour at Home

Children naturally soak up every opportunity to have fun with colour, whether it's painting, dressing up in colourful clothes, helping to prepare multicoloured fruit salads or helping to plant flowers in the garden. There are many fun ways that you can

introduce colour to your little ones. When children are encouraged to be creative with colour they not only benefit from having a fun time, but they also receive a colour treatment that works to rebalance and energise their entire being on every level.

Dance with Colour

Put on some lively music that your children enjoy, clear a space, grab a set of coloured ribbons, lay them out and let your child choose the colours that they are most drawn to. Choose a coloured ribbon for yourself and begin dancing freely around the room to the music, moving the ribbon in the air as you move. You will find your little ones will need no encouragement to join in with the ribbon dancing and will lap up this opportunity for free colour expression!

Hyperactive Children

If your child suffers from tantrums, hyperactivity, sleepless nights, tummy ache or night fears the following exercise will be of use:

Use four coloured crayons or pencils (never felt tips) in the following colours: pink and light blue or orange and dark blue. These colour combinations are the calming colours of the colour first aid kit and will encourage a calm response in your child. Keeping the colours in pairs lay them out in front of your child and let them choose a set of colours they are drawn to. On a large sheet of white unlined paper (minimum size A4) encourage your child to create individual circles with the colours. You will find they will become quickly absorbed with the exercise. Whenever your child is upset and restless this simple exercise will have an instant calming effect. You will also note that their breathing becomes easier and more regular. They may let out a sigh or two as they become more relaxed and their whole emotional body regains calm and balance.

Toddlers

Colour can be used very effectively to stimulate intellectual development from toddler age onwards. However, toddlers can only take short bursts of time in loud colourful environments, such as mother and toddler groups and play centres. Bright primary coloured environments can be beneficial for short periods of time, but not for full days. Too much exposure to strong colours will bombard their senses increasing hyperactivity, frustration and restlessness. Keep the décor in their rooms a calming pastel backdrop to primary coloured toys, equipment and soft furnishings. In their bedrooms encourage the full spectrum of colours to be introduced via toys and equipment. Brightly coloured toys can then easily be moved or stored to create a more restful atmosphere for quiet times.

Within the colour spectrum red, orange and yellow are considered 'magnetic' colours. They make a strong impact, are warm, energising and uplifting. Blue, indigo and violet are 'electrical' and are cool, soothing and calming. Green lies in the middle of the spectrum. Being neither warm nor cold it creates balance. We often retreat to the green of nature when we need space, calm and a sense of peace. Using green within décor will help to create a feeling of harmony and balance.

Soft Coral & Peach Tones

A great way to use colour in toddlers' rooms is on the ceiling. Lie the child to spend some time before sleep looking upwards. Using a soft coral/peach/pink shade on the ceiling will create the feeling of a safe and secure space; a womb with a view feel. Our first colour association is formed in the womb, where we are surrounded by warm nurturing tones created by the light permeating the mother's skin, a soft gentle light infused coral/peachy/pink. As with all colours there are many different shades that create different moods, changing the atmosphere within a room. For specific advice on application of colour for your child, a full

survey by a qualified colour consultant is recommended.

Children's Nutrition

Thank goodness we do not live in a black and white world, how bland and drab life would be! Colour brightens our life and more importantly keeps us safe and well. Colour guides us to choose the freshest healthiest foods to eat. When fruit and vegetables glow bright with freshness and vivid colour they not only attract us they also stimulate our digestive juices. In a black and white world we would never see the lacklustre dull colour signifying that it is past its sell-by date. Fresh produce loses its shine of health and freshness. Green mould grows on bread and brown bruises are seen on fruit past its sell-by date; there is even green on meat. Colour is vital to our safety, well-being and survival. Children love colour; colourful food is no exception. If their plates are bursting with fresh coloured goodness, they will usually demolish every mouthful. Meal times can be a mouth-watering display of colour to delight and appeal to their every sense. Be creative; use as many colours in each meal as possible and involve toddlers and children in the preparation of food because children love to be involved and are far more savvy than we give them credit for. Left to their own devices they will choose healthy options. Let them choose the colours they are drawn to. The more involved children are in the preparation of their food the more likely they will want to eat it. We are told to eat five a day and to choose from a variety of different coloured foods. Children will naturally do this when encouraged to make their own choices and especially if they feel involved in the whole choosing, preparing and cooking process. Great fun can be had in the kitchen by parent and child. The kitchen can be the first bonding area for parent and child.

Children's natural state is to be happy, healthy and living in wonderment of each day. Let's allow them to reach their full potential by feeding them colourful natural food with as few

additives as possible. We need to consider getting back to basics and growing a few items ourselves. For example, a simple herb garden or a raised salad garden is simple and easy to prepare and get the children involved. Tomatoes can be grown in anything almost, carrot tops grow in saucers on windowsills, and don't throw those wellies away, fill them with compost and plant a tomato plant in each one, hang the wellies on to the fence to keep them away from slugs and snails yet within your child's reach for watering. A fun wellie display can look great along the fence; bright and happy. Try lettuces and cucumbers as well as they are also easy to grow. Almost any container will hold small plants that will be bountiful in their harvest; the glee when children pick their harvest for the first time is well worth the initial effort in getting started. With a selection of home grown foods to sample, fussy eaters will be a thing of the past! The fun and closeness brought about by educating children on how food grows, where food comes from, to picking and preparing fresh produce daily. Cooking fresh produce, delicious vitamin packed meals together that the whole family can enjoy, is such fun and we all know that a healthy child is a happy child.

As the new going out is now staying in we are turning more and more to preparing our own food with home cooking being very hip. We all like to think that we are just as capable in the kitchen as any one of the many celebrity chefs. Coupled with austerity measures our innate culinary skills are being forced to be used, which is all good news for family life and getting us back to basics. Time spent with parents is often a treasured time of happy memories. These might include time spent in the garden growing things, then in the kitchen cooking and eating. These special experiences are an important building block in a child's formative years.

Chapter 14

The Three Learning Styles

The following chapters are of interest for everyone and also for those who are trainers or who may be considering training. I want to share with you my methods and show how colour can be incorporated into every training session easily and effectively by using my proven methods.

Presentation Tips

The prerequisite to make a successful presentation include: confidence, control and engaging your audience, in other words: good preparation. A sound knowledge of the subject is required with depth of conviction, your passion and your enthusiasm. You need to convey information in an interesting and entertaining way. People learn and retain more when they are enjoying themselves – when they are having fun, so intersperse the presentation with some humour. Establish and develop your own credibility. Create a safe comfortable environment. Relax, smile and enjoy yourself because when you are enjoying yourself your audience will enjoy what you are presenting.

Preparation

When preparing for your presentation or training session take time to think carefully about your audience, your aims and identify the objective of your presentation, i.e. to demonstrate, to inform, to inspire, to persuade and entertain. What type of presentation are you training for? Workshops – is it going to be in an informative way; a creative way; is it going to be a participative way?

Your audience's expectations – What do you feel they want to get from your presentation? Your aims – what you want them to

achieve. Once you have thought carefully about all these things in advance – about your presentation, delivering it and also your venue – it will help you create a presentation that hopefully will achieve its full potential and achieve the purpose that you set out. Think of your presentation in three parts: a beginning, a middle and an end. And for each subsection of your presentation, break it down into three. This keeps everything in easy manageable chunks and allows breaks to be slotted easily into your schedule. Then relax and enjoy!

Image and colour language comes before verbal language, so I start at the beginning to help to release the potential within each person. Research has shown, in an environment overseen by an expert with the appropriate skill set, that people are inspired. They can find their voice, find new ways of dealing with work-related issues, become more proficient in their job, more creative at problem solving with improved levels of self-confidence and self-esteem. A trainer needs to understand and work with an audience in the delivery of their subject by recognising and integrating the three learning styles, otherwise much information is lost. The three learning styles are visual, auditory and kinaesthetic.

Visual Learners
Are likely to:

- Find the mind can stray during verbal activities
- Observe more than talk or act
- Enjoy reading
- Memorise through images/diagrams
- Doodle
- Notice details
- Gaze out of the window – it doesn't mean they're not listening. It means they are trying to retain it in their own way.

To help visual learners the trainer can:

- Use visual aids
- Encourage attendees to use visual strategies
- Write important information on display
- Use body language and facial expression

Auditory Learners

Are likely to:

- Enjoy talking
- Like to read
- Enjoy music but are easily distracted by noise
- Have more difficulties with writing activities
- Talk to self aloud or hum
- Memorise by steps and sequence

To help auditory learners the trainer can:

- Encourage the audience to study aloud
- Provide discussion and group times
- Plan oral sessions
- Emphasise important information verbally

Kinaesthetic Learners

Are likely to:

- Like physical rewards
- They move or fidget most of the time
- Are tactile
- They enjoy doing, more than writing or listening
- They love to be engaged to try new things

To help kinaesthetic learners the trainer can:

- Use games, role-play and other active strategies
- Provide variety in each session with breaks
- Let students use large muscle movements e.g. working on a large scale

A Great Trainer

- Learns from others
- Is open-minded and prepared to try new things
- Shows empathy for others
- Tolerates uncertainty
- Is constantly questioning things (including him/herself)
- Is professional
- Respects confidentiality
- Is playful
- Has an understanding of how the brain works

An understanding of how the brain works can help students/attendees retain information more effectively. During a session of any length this can also help retain information more effectively. When learning new information a session should never last longer than an hour. It is then really important to have a fluid balancing break. Attendees need opportunities to recap and talk about what they have learnt. However, when carrying out intuitive and creative work, we need to settle into longer periods, which is why the creative art sessions often need longer.

During a colour session of any length we are most likely to remember:

- The beginning of a colour session
- The end of a colour session
- Bits in the middle that are different or repeated

Three main elements of delivering a colour session are:

- Pace
- Volume
- Dynamics

Thinking about 'how' to incorporate all of the above elements to satisfy the three learning styles at the planning stage and before facilitating, a colour session will ensure everybody benefits fully from the session. When seeking a venue for a session, consider the lighting in the room, seating arrangements, room acoustics and visibility. Establishing a supportive learning environment requires careful consideration and awareness of CRIN: Confidentiality, Respect, Individual Needs.

Chapter 15

Health & Safety

Today the Health and Safety guidelines are precise and aim to support self-employed and employed alike in the secure knowledge of being protected and covered by insurance and the law. Set an example to attendees by taking health and safety seriously and putting into place procedures for safe travel, use of venue and general well-being. When working alone ensure that someone else is aware of venue location, travel arrangements, and be especially aware and careful when arriving and leaving a venue alone.

Training Venues

Obtain and familiarise yourself with the health and safety, first aid and fire procedures applicable to the training venues that have been identified to run workshops and courses. Relay information at the beginning of the workshop or course to ensure that, in the event of an emergency, all parties know how to respond. Ensure all training venues provide a supportive, confidential, safe and healthy environment for attendees. Toilet facilities and refreshment areas and adequate security should exist at the training venue, so that students feel safe and secure during their training.

Risk Assessments

As part of your duty of care, ensure that the rooms being used, including refreshment and toilet areas, are properly assessed for any possible risks. Any potential risk arising from furniture, equipment and tools used should be clearly highlighted to attendees, to ensure that they are aware of such risks to prevent accidents. It should also be ensured that all special needs, disabil-

ities or learning/language difficulties, which any attendee may experience, are taken fully into account when carrying out risk assessments. All records must be dated, signed, filled out correctly, filed in hard and soft copy and, importantly, accurate with full details and time.

First Aid

It is recommended that trainers attend a basic first aid course unless they already use a venue where a qualified first aider is on duty at the time of workshops and courses. Take a first aid box to all workshops and courses to deal with minor accidents. Keep a record of any incidents in case there is a need for future reference.

Monitoring and Audit

Obtain feedback at the end of the workshop or course, including those aspects relating to health and safety, to keep on file. Continually monitor and audit the health and safety arrangements and practices to ensure the highest standards are maintained when carrying out training.

Miscellaneous

Please note Health and Safety regulations may differ in different countries so please ensure that you are fully aware of your local legal responsibilities.

Chapter 16

Lighting

Lighting is vital to complement the colours used in décor and for good health and eye sight. Remember that professor of ophthalmology who has stockpiled a lifetime supply of old-fashioned light bulbs because he believes low-energy bulbs can lead to eye problems. And the other professor, the expert in skin disease, who believes that their use may cause multiple skin problems. What are we discussing lighting for? Is it important? If you think you can do your job in the dark or in dim candlelight, then no. However, if lighting is relevant to your work, then the type of lighting you have is very important. There are obviously things to consider:

- Style of lighting
- Type of lighting
- Function of lighting

Answering yes to any of the above would mean that lighting is an important factor to discuss. Daylight unarguably is the most natural and economical source of light. It is recommended in many studies that one hour in natural, unfiltered daylight can have many health benefits. In moderation sunlight boosts your energy levels and helps natural sleep patterns. Particularly use for babies and also those who travel a lot to alleviate jet lag. Importantly though, it is because of the varying reaction of the rods and cones over the retina in different types of light that our perception of colour changes. In fact, the human eye can detect around 7,000,000 colours. These benefits are not a new discovery as sunlight has an ancient legacy of healing. Heliotherapy or the use of light to treat medical conditions is thousands of years old.

Herodotus wrote, "Exposure to sun is necessary to help people overcome failing health." In winter, spring and autumn, he recommended the patient should permit the rays of the sun to fall upon him. In summer this method should be used moderately because of the excessive heat. This was the precursor to the therapeutic use of full spectrum lighting as in the case of SAD or Seasonal Affective Disorder.

Without light nothing can live on this planet earth; light sustains all life. All the colours of the spectrum are contained within light and we instinctively feel uplifted when we are bathed in natural light. Natural light as we know can be broken down through a prism to the seven rainbow colours. Our bodies need sunlight to stay in good health physically, emotionally and mentally. Sunlight contains all the colours of the spectrum that feed our bodies and our minds, and these help us to maintain good health and remain balanced on all levels. Moderate sunlight is essential for the production of vitamin D and needed to aid calcium absorption in the body. Many studies show how sunlight boosts every system in the body, including the immune and endocrine systems, and provides relief from a variety of disorders, hormonal imbalances, psychological disorders, eating disorders, depression and skin disorders.

Long hours spent working indoors under the wrong lighting can lead to light deprivation, which has significant effects on health including stress, fatigue, lack of concentration, hyperactivity in children, and weak teeth and bones. Taking daily walks in nature, whatever the weather, is a good and natural way to boost our light intake. Absorbing light through the eyes without sunglasses has been proven beneficial in moderation. Do not look directly at the sun, go about your activities and be mindful of taking off sunglasses at times during the day. With a direct influence on the hypothalamus, the hypothalamus controls the nervous system, stimulates the hormonal system via the pineal gland and regulates our metabolism.

Incandescent Lighting

We know that the traditional bulbs we have used for years are being phased out. These have been used either in single or multiple fittings, spotlights or tracker systems. They don't last long in comparison to newer bulbs. They use more energy and get hotter than others. The new alterative to these bulbs are the energy saving bulbs – which last about 10 times longer and use roughly 80% less energy.

Fluorescent Lighting

There is no doubt that this type of lighting has developed since the 1940s when it was first introduced. It is seen to be more efficient than incandescent bulbs e.g. a 36-watt (4ft/1.2m) tube bulb emits the same light as 4 x 60 watt old bulbs.

Full Spectrum Lighting

Full spectrum is not a technical term when applied to a bulb but a marketing term implying that the product emulates natural light. In current fluorescent lighting a red object will look muted; however, in full spectrum it will be closer to its true colour. There are many manufacturers of full spectrum lights that claim to be the best and closest producer of natural looking light. This is no surprise as clearly they are in a market, competing for business too. These are excerpts taken from the 'Lighting in the Workplace' workshop.

Available on request, an informative, engaging and interactive workshop with handouts and comprehensive learning materials.

Chapter 17

Beauty, Complementary Therapies... and the rest

My exclusive colour silk treatment, that I created and developed, is outlined in full details with full instructions and diagrams to support in my book *Colour Therapy A–Z*. Coupled with full lesson plans, handouts, diagrams, colour exercises, practicals, readings and in-depth colour information for all who wish to share/teach colour information.

The Beauty and Complementary Therapy market is worth multimillions and increasing year on year, I am including here some examples on how my colour methods can be integrated into every beauty and complementary therapy treatment for the benefit of the client and the therapist. Beauty is an area where colour should be used far more. I have set out examples of how and where I think colour can be integrated most effectively. The examples given here and in my books can be tweaked for many uses. My silk treatment, however, must not be tweaked nor changed. It took many years to fine-tune and much research and testing. I am confident that I have created the very best colour silk treatment available, proven by the many student and client testimonials that I have received.

From the very start, people have been surrounded by the natural beauty of the world they live in. Since then, we have striven to find ways to capture how to enhance ourselves to more closely resemble the simple, yet effortless glow that nature creates and provides as an example of beauty. New products are continuously being researched and developed, promising to bring us ever closer to this goal. Lotions and potions aside, it isn't always the ingredients that matter but 'how' they are used.

A top chef would surely be able to create something

appetising and pleasing to the eye from even the most basic of available produce, as the training he/she underwent prepared for this eventuality. The knowledge gained from study and experience absolutely plays a part in the desired outcome. This is also true of beauty treatments. If you know how to give a relaxing, enhancing treatment, with correct technique, then the client is going to feel the benefit. Let's go back to the chef. Big news, he/she has discovered a 'secret ingredient', one that is guaranteed to make anything he/she creates from now more appealing to the eye, palate and please even the most hardened critic, plus lasting beneficial effects. In beauty the 'secret ingre-dient' is my method, and I want to share this 'secret ingredient' with you.

Okay, so what is so special about my method that could make all the difference when giving a treatment? Just think for a moment of the world around us. Now imagine it without any colour, grey, dull, lifeless. Ugh, exactly my point! Colour adds something to our lives that we don't necessarily understand or can put our finger on. It's something that most of the time we don't realise until it's no longer there. Though when it is there, we feel better, brighter, more like the person we want people to notice.

My method is the conscious use of colour to promote balance and well-being for yourself and your clients. The brilliant thing is that not only would you be passing on the beneficial effects of colour to your clients through the treatments, but the added bonus is that you are also receiving the benefits from the colour. The immediate questions that are probably in your mind now are: So how do I use colour? How do I know what colours will help people?

This is where I come in. The information in this book and in my best-selling books *Colours of the Soul* and *Colour Therapy A–Z* contain much valuable colour information and practical advice for you to learn and follow. There is also the CD, *Colours of the*

Soul, available digitally, with further information that you can play in the car or when quiet to top up your knowledge base. The solid knowledge of my method I will share with you, coupled with your reading of the books, will give an invaluable grounding, help you understand the content, and afterwards as you implement the information.

The integral practical sessions of my method allow you both as an individual and as a beauty therapist to experience the power and beauty of colour and see for yourselves how naturally and positively my colour method can be included in your treatments and your training.

A consultation form is required, and an enquiry with your insurance company will inform you of your cover. I have chosen beauty to demonstrate, although my colour method, format, treatment method and silk treatment method that I invented can be tweaked and used in any setting and for any purpose in health care, allopathic or complementary, from acupuncture to yoga. The fundamentals of my proven method do not change.

Beauty and Colour Course

On request is an informative, engaging and interactive workshop with handouts and comprehensive learning materials. The digital CD *Colours of the Soul* and the books *Colours of the Soul, Colour Therapy A–Z, Mandalas* and *Colour Numerology: The Karmagraph* are required reading.

The following is an example for your information:

Day One

- Welcome
- Using my method at the opening of every course/ workshop – move and stretch to music
- Discuss the day
- Share colour information

- Use interactive practicals, discuss
- Break
- Discuss colour
- Practical exercise
- Colour skills
- Lunch
- Mandala
- Mandala history and purpose of use
- Colouring in a mandala – 160 blank mandalas are found inside my book *Mandalas* for you to copy and to use in class
- Interpreting a mandala – see detailed explanation in the *Mandalas* book, also *Colour Therapy A–Z* and *Colours of the Soul*
- The main colours and their effect on mind, body and spirit
- Warm down

Day Two

- Welcome
- June's unique move and stretch to music
- Recap on yesterday
- Any questions session
- Discuss using colour with beauty treatments
- Handouts
- Break
- Discuss contraindications
- Advise. No medical diagnosis should be given to the client, unless qualified to do so.
- Minors must be accompanied at all times
- Students to work in pairs giving and receiving colour treatments
- Lunch
- Continue giving and receiving colour treatments
- Ensure everyone understands how to give a colour

treatment and explain the procedure to client

- Discuss client's own choice of colours and the meaning
- Wind down

Facial

- Client and therapist dressed in white
- White towels, blankets and sheet on couch
- Fresh water available for client
- Temperature constant – warm therapy room
- Consultation card/form – health information and facial skin analysis
- Colour discussion with handouts
- See listed products at front of book. The highest quality silk is packaged in a set available for purchase, wholesale, to sell on or retail per set.
- Colour meanings
- Client remove clothing around neck and shoulders
- Client lies on back on couch. Place silks on appropriate area of the body (see *Colour Therapy A–Z* – silk treatment).
- Follow my silk treatment procedure as set out and clearly explained, with diagrams in my book *Colour Therapy A–Z*.
- When complete, remove silks and replace with green silk
- Facial
- Eye and lip cleanse, face cleanse
- Massage face, neck and shoulders – see example *Colour Therapy A–Z*
- Face mask, cover eyes
- Write up notes and aftercare recommendations using colour
- Remove mask
- Moisturise

NB. Take care to remove silks with hands free from oils or lotions to prevent marking.

Manicure/Pedicure
- Client/therapist dressed in white
- White towels, blanket and sheet for couch
- Consultation form/card
- Client chooses silks displayed, from my full set of chakra silk collection
- Explain meanings of colours chosen and why
- Client sits on couch or chair, make comfortable and warm
- Soak the feet, nail shape and cuticle work. Remove hard skin.
- Client lies down on couch on back to receive silk treatment
- Lay silks on body
- Follow my silk treatment procedure
- Remove silks and replace with green
- Sit client up if necessary to paint nails
- Write up notes and aftercare recommendations using colour

Eye Treatments
- Do not start working with colour until after completing any eye treatment
- Set up as before
- Client lies on back on couch
- Perform eye treatment
- At the end of eye treatment, client chooses 3 silks
- Explain meanings of colours chosen and why
- Lay the silks on body
- Follow my silk treatment method as before
- Write up notes

You may consider having a leaflet or flyer typed ready to hand your client at the end of treatment with suggestions of home care advice, to continue using the colours chosen to prolong the benefits of the treatment for a week post treatment. Include

further suggestions as to how the conscious use of colour can be incorporated into daily life. My colour method is proven and of huge benefit, taking treatments to a higher more exciting level with the added bonus of the proven benefits of colour making a more effective and lasting impact on clients' well-being. I invented my colour and silk treatment method many years past, a proven safe method, as relevant and as effective today as it has ever been. As well as being highly beneficial for the client my method and silk treatment are most enjoyable to receive, with the therapist also receiving a colour boost at the same time. For your convenience, full details and diagrams are available in my books *Colour Therapy A–Z*, *Colours of the Soul* and *Discover Your True Colours*. Another format to cement the information is found digitally on the CD *Colours of the Soul*. Bespoke and relevant training packages can be created for every business; refer to the Services section in the front of this book.

Chapter 18

On Closing

The best voyage is the voyage home.

The future will be predictably unpredictable! Wherever we are going, we are going there fast and going through the biggest changes in the shortest time in history. I believe colour and the natural world will serve as the anchor and steadying influence we so sorely need as we soar through. Colour is the foundation on which to springboard from, as everything is colour and everything resonates with colour.

The opening of the heart energy has begun. The evolution of the heart is compassion, family, friends and community, and this includes the business community. All will become more important in our lives as we speed into the future; people will pull together. Little is spoken about the reality of the darker side of the heart energy. People don't change unless they have to; usually it is trials, tribulations and disasters that force this change, making people work together to resolve issues.

As for our higher selves, the ego traps our personality while colour releases it; its very simplicity can make this hard to understand. Sadly, many only reach a fraction of their intuitive potential and what is possible. With colour knowledge and daily practice, everyone can reach their fullest potential, whatever that may be, remembering that we each have our own glass ceiling, and once reached, we can only widen our intuitive abilities.

Trust your inner voice. I have never found the slightest discrepancy from following my inner voice, yet there are no end of problems when I don't.

Encourage and develop your creativity. Everyone can be creative. Find your specialism and take what you discover into

the workplace. Creative skills are transferable. Creativity and innovation go together like strawberries and cream. Seek out the natural world where nature offers the perfect space to rest, recuperate and to be inspired. The divine presence can be found in nature.

Fresh air and sunlight is the golden gift to mankind, coupled with nature. Get outside and become a part of the natural world, there for everyone to enjoy and to benefit from, where upliftment of mood, inspiration and well-being is supported and nurtured. Anchor yourself in nature, as the great change of times has begun; now more than ever let the natural world support you and your loved ones. Water will become the new gold and shortages increase within the food chain. Become proactive by providing at least some of your food by growing your own; working with the natural rhythm of life, learn about colour and colour combinations from your time spent in nature. With all of its trials and tribulations it is still a beautiful world with much to be rediscovered.

We are surrounded by exquisite and beautiful colour combinations in the natural world. A master class in colour, drink it in.

June McLeod – 2014

Colour knowledge is transformational but ultimately only useful when made practical in your daily life. Live it, use it and feel it, and only then will the secrets of colour give themselves up to you.
June McLeod

May your choices reflect your hopes, not your fears.
Nelson Mandela

BOOKS

O-BOOKS

SPIRITUALITY

O is a symbol of the world, of oneness and unity; this eye represents knowledge and insight. We publish titles on general spirituality and living a spiritual life. We aim to inform and help you on your own journey in this life.

If you have enjoyed this book, why not tell other readers by posting a review on your preferred book site? Recent bestsellers from O-Books are:

Heart of Tantric Sex
Diana Richardson
Revealing Eastern secrets of deep love and intimacy to Western couples.
Paperback: 978-1-90381-637-0 ebook: 978-1-84694-637-0

Crystal Prescriptions
The A-Z guide to over 1,200 symptoms and their healing crystals
Judy Hall
The first in the popular series of four books, this handy little guide is packed as tight as a pill-bottle with crystal remedies for ailments.
Paperback: 978-1-90504-740-6 ebook: 978-1-84694-629-5

Take Me To Truth
Undoing the Ego
Nouk Sanchez, Tomas Vieira
The best-selling step-by-step book on shedding the Ego, using
the teachings of *A Course In Miracles*.
Paperback: 978-1-84694-050-7 ebook: 978-1-84694-654-7

The 7 Myths about Love...Actually!
The journey from your HEAD to the HEART of your SOUL
Mike George
Smashes all the myths about LOVE.
Paperback: 978-1-84694-288-4 ebook: 978-1-84694-682-0

The Holy Spirit's Interpretation of the New Testament
A course in Understanding and Acceptance
Regina Dawn Akers
Following on from the strength of *A Course in Miracles*, NTI
teaches us how to experience the love and oneness of God.
Paperback: 978-1-84694-085-9 ebook: 978-1-78099-083-5

The Message of A Course In Miracles
A translation of the text in plain language
Elizabeth A. Cronkhite
A translation of *A Course in Miracles* into plain, everyday
language for anyone seeking inner peace. The companion
volume, *Practicing A Course In Miracles*, offers practical lessons
and mentoring.
Paperback: 978-1-84694-319-5 ebook: 978-1-84694-642-4

Rising in Love
My Wild and Crazy Ride to Here and Now, with Amma, the
Hugging Saint
Ram Das Batchelder
Rising in Love conveys an author's extraordinary journey of

spiritual awakening with the Guru, Amma.
Paperback: 978-1-78279-687-9 ebook: 978-1-78279-686-2

Thinker's Guide to God
Peter Vardy
An introduction to key issues in the philosophy of religion.
Paperback: 978-1-90381-622-6

Your Simple Path
Find happiness in every step
Ian Tucker
A guide to helping us reconnect with what is really important in our lives.
Paperback: 978-1-78279-349-6 ebook: 978-1-78279-348-9

365 Days of Wisdom
Daily Messages To Inspire You Through The Year
Dadi Janki
Daily messages which cool the mind, warm the heart and guide you along your journey.
Paperback: 978-1-84694-863-3 ebook: 978-1-84694-864-0

Body of Wisdom
Women's Spiritual Power and How it Serves
Hilary Hart
Bringing together the dreams and experiences of women across the world with today's most visionary spiritual teachers.
Paperback: 978-1-78099-696-7 ebook: 978-1-78099-695-0

Dying to Be Free
From Enforced Secrecy to Near Death to True Transformation
Hannah Robinson
After an unexpected accident and near-death experience, Hannah Robinson found herself radically transforming her life,

while a remarkable new insight altered her relationship with
her father; a practising Catholic priest.
Paperback: 978-1-78535-254-6 ebook: 978-1-78535-255-3

The Ecology of the Soul
A Manual of Peace, Power and Personal Growth for Real People
in the Real World
Aidan Walker
Balance your own inner Ecology of the Soul to regain your
natural state of peace, power and wellbeing.
Paperback: 978-1-78279-850-7 ebook: 978-1-78279-849-1

Not I, Not other than I
The Life and Teachings of Russel Williams
Steve Taylor, Russel Williams
The miraculous life and inspiring teachings of one of the
World's greatest living Sages.
Paperback: 978-1-78279-729-6 ebook: 978-1-78279-728-9

On the Other Side of Love
A woman's Unconventional Journey Towards Wisdom
Muriel Maufroy
When life has lost all meaning, what do you do?
Paperback: 978-1-78535-281-2 ebook: 978-1-78535-282-9

Practicing A Course In Miracles
A Translation of the Workbook in Plain Language and With
Mentoring Notes
Elizabeth A. Cronkhite
The practical second and third volumes of The Plain-Language
A Course in Miracles.
Paperback: 978-1-84694-403-1 ebook: 978-1-78099-072-9

Quantum Bliss
The Quantum Mechanics of Happiness, Abundance, and Health
George S. Mentz
Quantum Bliss is the breakthrough summary of success and
spirituality secrets that customers have been waiting for.
Paperback: 978-1-78535-203-4 ebook: 978-1-78535-204-1

The Upside Down Mountain
Mags MacKean
A must-read for anyone weary of chasing success and happiness
– one woman's inspirational journey swapping the uphill slog
for the downhill slope.
Paperback: 978-1-78535-171-6 ebook: 978-1-78535-172-3

Your Personal Tuning Fork
The Endocrine System
Deborah Bates
Discover your body's health secret, the endocrine system, and
'twang' your way to sustainable health!
Paperback: 978-1-84694-503-8 ebook: 978-1-78099-697-4

Readers of ebooks can buy or view any of these bestsellers by clicking on the live link in the title. Most titles are published in paperback and as an ebook. Paperbacks are available in traditional bookshops. Both print and ebook formats are available online.

Find more titles and sign up to our readers' newsletter at http://www.johnhuntpublishing.com/mind-body-spirit

Follow us on Facebook at
https://www.facebook.com/OBooks/
and Twitter at https://twitter.com/obooks